TREASURES OF ASIA

ARAB PAINTING

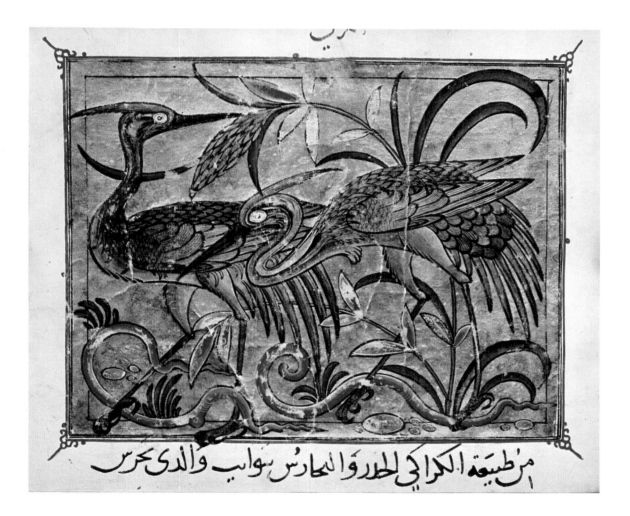

TEXT BY RICHARD ETTINGHAUSEN

Former Curator of Near Eastern Art at the Freer Gallery of Art, Washington, D.C.

SKIRA

RIZZOLI
NEW YORK

Color plate on the title page:

Book on the Usefulness of Animals (Kitâb Manâfi` al-Hayawân) of Ibn
ad-Durayhim al-Mawsilî: The Herons. Probably Egypt, 1354 (755 A. H.).
(98×132 mm.) Ar. 898, folio 80 recto, Library of the Escorial, Spain.

*

© 1977 by Editions d'Art Albert Skira S.A., Geneva
First edition © 1962 by Editions d'Art Albert Skira, Geneva

This edition published in the United States of America in 1977 by

*R*IZZOLI INTERNATIONAL PUBLICATIONS, INC.
712 Fifth Avenue/New York 10019

Library of Congress Catalog Card Number: 76-62898
ISBN: 0-8478-0095-4

PRINTED IN SWITZERLAND

TABLE OF CONTENTS

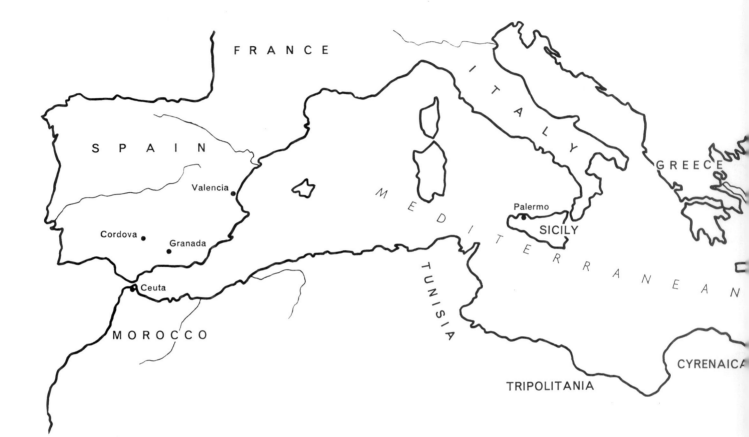

Principal Centers of Arab Painting

The vast area shown here, extending from Persia to the
Pyrenees, represents the furthest limits reached by the
Arab Empire at the height of its expansion (c. 800-
1000 A.D.). The places located on the map refer to the sites
and cultural centers where the works mentioned in this
book were discovered or produced.

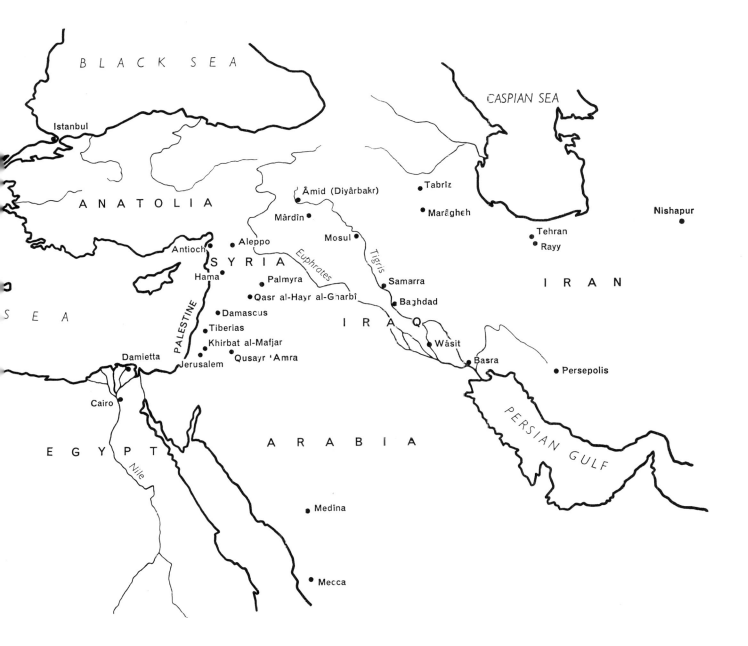

BLACK SEA

Istanbul

CASPIAN SEA

ANATOLIA

Âmid (Diyârbakr)
Tabrîz

Mârdîn
Marâgheh
Nishapur

Antioch
Aleppo
Mosul
Tehran

SYRIA
Euphrates
Tigris
Rayy

Hama
Palmyra
Samarra

SEA
Qasr al-Hayr al-Gharbî
Baghdad
IRAN

Damascus

Tiberias
IRAQ

Khirbat al-Mafjar
Wâsit

Damietta
Qusayr 'Amra
Basra

Jerusalem
Persepolis

Cairo

PALESTINE

EGYPT
ARABIA
PERSIAN GULF

Nile

Medina

Mecca

ARAB PAINTING

THE first reaction of many who hear of this book will be to ask: Does Arab painting really exist? And if it does, what is it like? Even when the prospective reader has the book with all its color plates before him, and can no longer be entirely incredulous, he may still be puzzled about the exact nature of "Arab painting." Indeed, both words of the title require some explanation.

What is meant by "Arab"? The term has had a long history since it first appeared in an inscription of 853 B.C. in which the Assyrian king Shalmaneser III spoke of one rebellious Gindibu the *Aribi* whom he had defeated in a campaign. Since then the word has had increasingly wide usage, but with connotations that have changed from time to time so that it has become a rather ambiguous term. It referred, for instance (and still does to some extent), to the Bedouin nomad in the desert in contrast to the sedentary population; or to the inhabitants of the Arabian Peninsula and some of its marginal areas; or again, in modern times, to a group of nations in Southwest Asia and North Africa whose tongue is Arabic. None of these meanings apply here. The word "Arab" will be used in this book (as in other historical accounts) rather in its wider meaning, to refer to the universal civilization of that medieval empire that had its origin in a new Arab religion—Islam—which first became a military and political force in Arabia, and was to a large extent held together by the medium of Arabic, the language of its divine worship, administration, scholarship, and poetry.

In spite of these Arab contributions in its origin, the civilization of this huge realm was soon extensively developed by the intellectual power and artistic skill of men of other constituent ethnic stocks—Persians, Egyptians, Berbers, Turks—most of them Muslim, but also of other faiths. The vital point is, however, not the ethnic connection, as we might think today, but that there existed a strong feeling among the Muslims of the Middle Ages, whatever their origin, a definite consciousness of belonging to a divinely ordained "Arab" civilization. This is perhaps most poignantly expressed by the great scientist al-Bîrûnî (973-1048) who came from a marginal region, Khwârizm (in the present Soviet autonomous Karakalpak Republic), and who said: "Our religion and our empire are Arab and twins, the one protected by the power of God, the other by the hand of Heaven. How often have tribes of subjects congregated together in order to

impart a non-Arab character to the State! But they could not succeed in their aim." Arabic, the language of religion and science, was to him the most important medium of cohesion and he expressed his devotion to this vital element in his civilization by saying that he "would rather be reviled in Arabic than praised in Persian."

This book deals specifically with painting, which is one of the products of the huge melting pot in which pre-Islamic and later art forms were fused and recrystallized to constitute new styles with a definite character of their own. These pictorial creations were at first truly "Arab" in the narrower sense of the word—fulfilling the demands of patrons hailing from the Arabian Peninsula and living in Arabic-speaking regions—but they soon became the achievements of a more multinational and polyglot civilization. The various styles developed were employed in a widely varying manner by the vast Muslim majority; yet they were dynamic enough to affect the arts of other religions living within the "House of Islam." After the fall of the 'Abbâsid Caliphate in 1258 they continued to be the formative influence in the arts of the successor states in Arabic-speaking countries such as Egypt, then under Turkish rulers (from the late thirteenth to the eighteenth century), and they even played a significant role in thirteenth and fourteenth century Iran. The core of this artistic world consisted, however, of the Arabic-speaking countries; indeed it may be assumed that the non-Iranian Islamic styles never had a chance to flourish creatively in Iran and other eastern parts of the caliphate, since there the pictorial traditions developed at the Sasanian court (third to seventh century) were too well entrenched and an anti-Arab feeling prevented any artistic climate which might have led to a further fruitful development of the "Arab" styles. The area dealt with in this book is, therefore, mainly Iraq, Greater Syria, Egypt, and, to a lesser extent, the other areas between Spain and Morocco in the west and the Iranian plateau in the east. The period covered extends, generally speaking, from the late seventh to the fourteenth century.

The term "painting" is here used in its broadest sense. It includes not only frescoes and paintings on the usual foundation materials such as wood, parchment, and paper, but glass and stone mosaics and figural pottery as well. For the pictorial arts of other civilizations this basic definition would suffice. Here, however, it needs some further explanation. This is necessary because of the widely held notion in the Muslim and Western worlds that the Islamic religion, being of an anti-iconic nature, made figural representations well-nigh impossible.

The Koran gives no direct support for such an assumption. Even in its most specific pronouncement it speaks out only against certain heathen practices, among them the use of images, apparently of a religious nature and hence regarded as idols (Sûra v, 92). However, the *Hadîth* literature dealing with the traditional sayings and practices of the Prophet Muhammad, in its various codifications dating from the second half of the ninth century, is quite outspoken about this hostile point of view. Its attitude is made apparent when it calls makers of figured pictures "the worst of men." Here the owning of pictures with figures is put on the same level with the keeping within one's house of a dog, a despised, unclean animal, which likewise impedes the entry of the angel of

mercy; or it is compared with other low practices such as tattooing or the taking of interest. Human and animal figures are less severely prohibited when they occur in what are considered to be degrading contexts. They are specifically allowed on carpets and pillows, since stepping, sitting, or leaning on them are deprecatory acts. The only themes more generally permitted are trees and objects in which there is "no living spirit." The meaning of this latter expression becomes clear from judicial texts based on such *Hadîth*; they suggest that beheading and other forms of mutilation which destroy the viability of the represented figure make these designs permissible. These texts indicate also that the possession and use of figural paintings are only slightly less objectionable than making them.

Statements of this nature and the Koranic language in general give some indication of the reasons for this negative attitude. In the Koran the word for "to fashion or form" *(sawwara)* is synonymous with the word for "to create" *(bara'a)* and God Himself is not only called a creator *(al-bâri')* but also a *musawwir*, which is the common word for "painter." The artist, in making something lifelike, is thought to compete blasphemously with God; on the Day of Judgment, in retribution for his presumptuousness, he will be punished severely for being unable to comply with the divine command to blow the breath of life into that which he has created. It is also said that such pictures distract one from prayer. The fact that a picture might possess magic, even supernatural qualities, and thus be worshipped as an icon, was at first not explicitly expressed; but as Islam conquered many regions where images were imbued with a transcendental meaning and often venerated as sacred objects, such considerations could not be excluded.

Certain historical conditions undoubtedly induced Islam to adopt such an attitude. Several other ethnic groups speaking Semitic languages have held similar beliefs about the "graven image, or any likeness of anything that is in Heaven above, or that is in the earth beneath, or that is in the water under the earth" (Exodus, xx, 4). Furthermore the material culture of Arabia in the time of Muhammad was not highly developed. As in other groups in a specific stage of development, there apparently existed no clear differentiation between a living creature and its representation. It was believed that the image was identical with the delineated being, and that the artist was potentially able to—or at least intended to—make the image not only lifelike but actually living and had then certain powers over it. Indeed, a more detached consciousness of paintings and with it an appreciation of figural representation appear only two hundred years after the Prophet's death. Finally, as often stated in the Koran, Muhammad regarded himself only as an ordinary human being whom God had selected to bring His message. He did not claim to be a performer of miracles or to be endowed with supernatural power. Unlike Buddhism, Christianity and Manichaeism, Islam, therefore, never developed a sacred iconography centered around the life of the founder of the religion. Instead the divine message itself in its written form was elevated to an exalted position, and instead of holy images, sections of its text were used in the decorative schemes of buildings.

It will be clear that the canonical position as outlined above gave no scope to the figural painter, but rather directed the artistic drive generally toward calligraphy, or floral

and geometrical design, which indeed are characteristic of Islamic art. However, there were certain forces which counteracted, or at least alleviated, the basically antagonistic attitude. The Islamic empire had fallen heir to vast regions where the customs and beliefs of Oriental and classical antiquity had prevailed for many centuries if not millennia. Some of these customs and beliefs had to be eradicated in view of the new message of salvation; but others, and painting was among them, managed to live on, though in changed form. This was possible because from the beginning the lay mind, in contrast to that of the strict theologian, distinguished between two spheres of action, the sacred and the secular. While the layman observed rigidly the prohibition of the figural image in the first, he was ready to disregard it up to a point in the second. In this attitude he was abetted by many factors. First, there was a minority opinion expressed by certain theologians who held that only the making of representations of God was forbidden, not those of secular significance. This point of view does not seem to have gained wide acceptance, at least in the pertinent theological literature; and it did not develop into the more positive attitude found in certain Persian writers who accorded to the figural arts a didactic value even from a religious point of view. But it may be assumed that this more lenient interpretation of the law helped to create a climate which permitted the painting of figures and animals, at least in certain times and places.

There were also conditions of a social nature in the Muslim East which made figural painting feasible. One lies in the strict partitioning of the substantial domestic structures into a public part, where the master of the house receives male guests, and the *harîm* or private quarters, where his wife or wives live with the children and which is inaccessible to outsiders. Any figural decorations, whether they were on the harîm walls or in books kept there, could not be detected. And indeed in certain cases the first males who ever saw them, aside from members of the household, were the excavating archeologists.

Another group of buildings where figural painting was generally employed, though such decorations were officially still forbidden, were the public bathhouses. The painting of such structures was a tradition that went back to pre-Islamic times. It seems that the nudity of the bathers and the activities customary therein were thought to demonstrate a suitably disrespectful attitude toward these paintings; in any case, the setting would have precluded their receiving any worshipful appreciation. Such premises were thus not rigidly off-limits to the figure painter.

The last point to be made within this category is especially significant. The chief patron of painters was the ruler, whether the caliph—that is, the "successor of the Prophet"—or in later times the sultan, the actual wielder of political power. In neither case were the actions of an autocratic, even despotic, regime checked by any ecclesiastical organization or even a clergy, because neither existed. Indeed, Islam adjusted itself to the all too frequent excesses of its rulers by holding that an objectionable government was preferable to none at all. Hence, notwithstanding certain exceptions, especially in the face of revolt, each and every command of the ruler, even if it was contrary to the Muslim law, was executed. In the perspective of Ibn Khaldûn, the greatest Arab historian, this is what happened: "The lawgiver Muhammad censured (the wielders of)

royal authority and... blamed them for their enjoyment of good fortune, their senseless waste, and their deviations from the path of God." But "from the necessities of life and a life of austerity, people progress to the luxuries and a life of comfort and beauty. They come to adopt the customs and (enjoy) the conditions of their predecessors." To these "conditions of their predecessors" belonged figural painting, which soon enough appeared in the palaces of the most powerful of all people, the rulers.

There were also certain other reasons which grew out of the intellectual climate of Islam, for having figural compositions. Already under the Umayyads, the first dynasty of Islam, certain scientific works of the Greeks and Copts were translated into Arabic. This eagerness to incorporate the thoughts of the ancients into the Muslim world was particularly strong in the ninth century, but the custom of copying or seeking inspiration from Greek or Syrian books continued for centuries. This meant that certain ancient texts which had been illustrated in the original were illustrated also in their Arabic versions from the old pictorial models, though these were usually more or less Arabized. This applies to some literary works, and more specifically to scientific literature, where illustrations explaining the text are particularly appropriate, sometimes even necessary.

Whatever may have been the specific reasons for the painting of one or another type—and more will be said about these later in the pertinent sections—one finds in Islam, as elsewhere, the usual dichotomy of law and custom. However, the awareness of the existence of such a dichotomy, as far as figure painting is concerned, was lost. This is for instance demonstrated by Ibn Khaldûn, who in his extensive masterwork the *Muqaddima* (finished in 1377) never refers to painting when he discusses architecture and book production. This waning of interest in and subsequent loss of awareness of the phenomenon was due to the progressively iconoclastic trend in Arabic-speaking countries (arrested only in fairly recent times) and a decline of artistic ability in the Arab regions under Ottoman rule—an unhappy combination that brought picture painting practically to extinction. Because of this, the impression gained ground that the well-known passages of the canonical law expressing a hostile attitude had been operative at all times and throughout the Arab world. It is one of the tasks of this book to put the historical record straight and to demonstrate the range and character of a unique and splendid art which esthetically speaking can hold its own with others produced in the Middle Ages.

From what has been said it will be clear that the material available for this book was limited. Some of it is the result of still rather rare explorations or excavations which brought to light a few monuments with paintings. More numerous are the illustrated manuscripts discovered in libraries. Here again it is symptomatic that less than half a dozen volumes with figural paintings are known to have been preserved in libraries of the Arabic-speaking world. They survived rather in Turkish and Western institutions, to which a limited number chanced to come in past centuries. Many of them are in a deplorable condition. Pigments are flaking off; they are marred by water stains, foxing, and smudges; or mutilated by iconoclasts who have cut off or destroyed heads of figures,

as well as by childish scribbles and inept attempts at restoration, the last being the most recent of such unhappy assaults. Still, enough has been preserved to give us a vision of a long-vanished art which by its very existence in the face of virulent opposition showed its vitality. However, not enough monuments have been excavated or documented manuscripts discovered to give us any clear picture of the historical development, especially of the growth of regional schools. This difficulty is increased by the co-existence of two (or more) stylistic trends in many groups of paintings. Happily, this lack of scholarly data does not interfere at all with the esthetic enjoyment, or the impact that Arab painting makes on Western man.

In writing this survey the author was fully conscious of having the unusual privilege of presenting his subject for the first time in book form. However, there have been a good many earlier investigations of specific periods or of certain monuments and manuscripts. A number of these are masterly achievements, and the writer is greatly indebted to the work of his predecessors. He feels all the more obligated to them since the nature of this book, with its wide appeal, makes it inappropriate to acknowledge in every instance the sources of information. These will be obvious to his fellow historians, while to the general reader the frequent quoting of scholars would be meaningless or even annoying. A bibliography at the end of this book, although limited, will direct the reader to the more important of these previous investigations.

For specific information about certain questions the writer wishes to thank warmly Ahmed Ates, Harold Glidden, André Grabar, Oleg Grabar, Ernst Kitzinger, Giorgio Levi Della Vida, Hellmut Ritter, Franz Rosenthal, Barbara Sessions, S. M. Stern and Kurt Weitzmann.

The author is also grateful to the directors and curators of museums and libraries who kindly permitted the study of material under their care and later on its inclusion in this book. The friendly support they have given this work will certainly pave the way for a better and wider appreciation of this little known art.

Early Phases of the Pictorial Arts

1

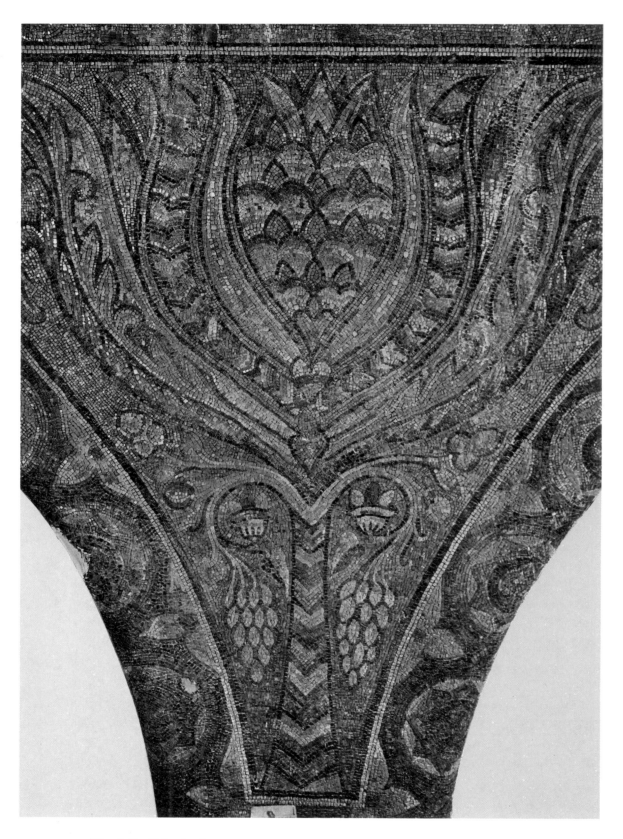

Floral Motif in the Sasanian Manner, 691. Mosaic. Dome of the Rock, Jerusalem.

THE PROCLAMATION OF UNIVERSAL POWER

THE UMAYYAD MONUMENTS (691-750 A.D.)

IN the early seventh century Muhammad received his divine call to be Allah's messenger to his Arab countrymen. He was to warn them, with revelations in Arabic derived from a heavenly book, of the forthcoming Day of Judgment which could be successfully met only by following the new moral concepts that he was preaching as the last of the prophets. But before he died in 632 some of his statements and actions indicated that he felt himself to be "the warner for the worlds" (Sûra xxv, 1), and that, besides being the new religion of the Arab tribes, Islam had a wider mission beyond the frontiers of Arabia.

The caliphs created through many military campaigns an Arab-Muslim empire that later enabled the new message and way of life to find world-wide acceptance. Within fifteen years the Arab armies conquered Iraq, Palestine, Syria, Egypt, Iran, Cyrenaica, and Tripolitania (633-647), taking over famed old towns and creating new ones. For once the countries of Sasanian Iran and a large portion of Byzantium came under one rule.

In 661 the capital was moved from the more primitive world of Medina in Arabia to Damascus in Syria, an age-old historical city and more recently a center of Roman and Byzantine civilization. Also for the first time, a dynasty was to rule the empire until 750; these were the Umayyads who had been an aristocratic family from Mecca. After counteracting the secessionist tendencies of whole groups and provinces their major task was the consolidation of the empire which only in this period was ruled by Arabs for Arabs. To strengthen the inner cohesion a process of Arabization was initiated. One of the new policies was to make Arabic the language of administration, to create an Arab-Muslim coinage and to postulate altogether the pre-eminence of the Arab and Muslim aspect of the new state vis-à-vis the claims of the older civilizations and especially of the more ancient religions now thought to be superseded by Islam. The world-wide expansion of the state was again resumed after the centrifugal elements had been checked. In 670 Northwest Africa was conquered; Constantinople was besieged, though never taken; in various movements Islam entrenched itself in the Transoxiana; in 711 both Spain and Sind in Northwest India succumbed, and in the 730's the Arab armies were in France. The caliphs in Damascus represented a truly universal power.

It is against this background, here briefly sketched, that the pictorial records of this civilization should be understood.

The earliest pictorial representations created in the Islamic civilization are still extensively preserved on the inside walls of the Dome of the Rock in Jerusalem, the first major construction, built in 691 by order of the Caliph 'Abd al-Malik (685-705). This consists of a large cupola above and two ambulatories around a rock outcropping. Tradition had it that the building commemorated the spot from which the Prophet began his ascension. Oleg Grabar has, however, shown that at that early time the rock did not yet have this religious association and that certain aspects of the monument's decorations tell a different story.

The glass mosaics covering the spandrels and soffits of the ambulatories and the drum of the dome show a great variety of vegetal motifs. There are realistically rendered trees and leaves with fruits; then, much more widely used, formal vegetal arrangements in which vases and cornucopiae also occur. These two features, and even more the ubiquitous acanthus, of the big leafy type and that in the form of graceful scrolls, clearly demonstrate the continued use of classical art forms, a not too surprising fact since Jerusalem had been conquered from the Byzantines only a little more than fifty years earlier. More unusual is the very extensive occurrence of compact vertical plant compositions which are dominated by one or more ponderous hybrid flowers of enormous size, a type of design developed by stone-carvers and silversmiths of Sasanian Iran. Iranian motifs had appeared in the pre-Islamic art of Syria, but rarely in such profusion and with forms so clearly unclassical. Another characteristic feature of this ensemble is the rich use of jewelry designs made of mother-of-pearl and semiprecious stones and applied to the vegetal motifs. More surprising and therefore more revealing about the meaning of this decoration are the various crowns—Byzantine and occasionally Iranian—, the diadems, breastplates, necklaces, and hangings on the sides of the arcades facing the central rock.

There is no doubt that these mosaics are a major artistic achievement and their effect is also sumptuously impressive. They were, however, much more than mere decoration. They had to satisfy the religious and esthetic demands of the caliph and appeal to the Arabs and newly converted worshippers. The use of purely vegetal forms to the exclusion of animated figures shows a conformity, even in this early sacred building, to the newly emerging, artistically restrictive attitude of Islam. But the elaborate trees and floral arrangements must also have had a positive value so as to gratify the senses of the many Arabs who had only recently emerged from the deserts. The opulent richness of design, with the addition of jewels applied in many places, must have appealed greatly to the artistically untrained sense of the new masters. To many they must have represented the most resplendent luxury, while to others the trees, fruits and other floral patterns may have evoked the pleasing sensation of fertile lands or of an oasis, channeling these feelings into a religious direction.

There is also, however, a proclamatory aspect inherent in these lavish mosaic decorations. They were, after all, applied to a building that pre-empted ancient hallowed positions, having been erected on the site of the old Jewish temple, and on a spot connected by legend with the sacrifice of Isaac by Abraham, the Biblical patriarch whom the Arabs regarded as their ancestor. It is at the most conspicuous places in this shrine that the

Illustration page 23

Illustration page 18

Illustration page 21

ruler of a new empire had representations of crowns and other imperial jewelry suspended around the sacred rock. In doing so he wished to demonstrate the defeat of the two great enemy powers of Byzantium and Iran, just as he later on showed his devotion as a Muslim by sending his own insignia of imperial power, two sunshade canopies as ex-votos, to the Ka'ba in Mecca. This deliberate display of royal tokens of victory is made even more obvious by the inscriptions, which not only proclaim the principles of the new religion and its universal mission, but in addressing themselves to the believers of the ancient religions attack vigorously the dogmas of Christianity, especially its Trinitarianism.

There is yet a third aspect of this decoration: its appeal to the new converts who understood it in its pre-Islamic setting and who tried to place it in its new context. The determined attempt to outdo the splendor of the churches could not have failed to impress

Vase with Acanthus Scroll, 691. Mosaic. Dome of the Rock, Jerusalem.

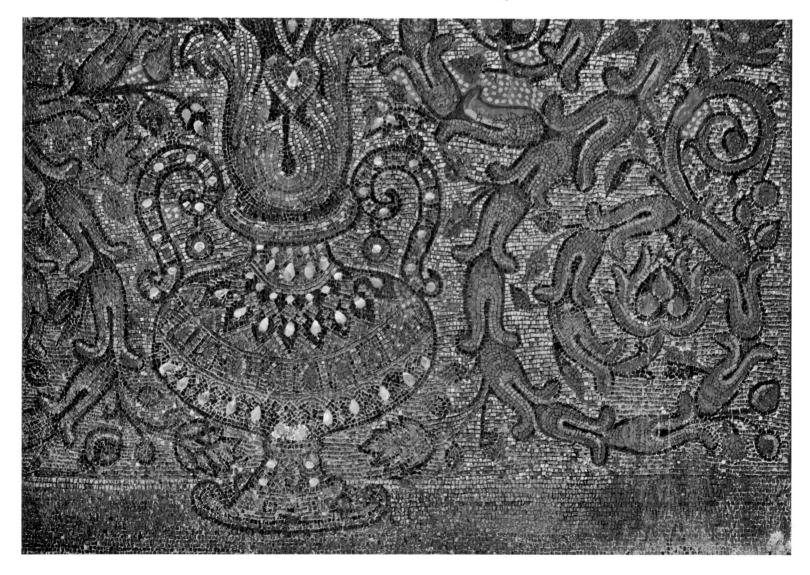

them, even though they were more sophisticated than most of the Arabs. But the decorative repertory, restricted though it was, was also sure to conjure up certain associations. In particular, its most unusual feature within an otherwise formal display—the seven realistically rendered palm, olive, and almond trees and the tufts of tall reeds—must have evoked connotations that such designs had in a Christian environment. There they would most likely have been regarded as symbols of paradise, but as this celestial region was, according to the visions of the new faith, now populated with beautiful houris or pious wives, such an interpretation was no longer possible. There was also the connotation of an image of the earth as it occurs in certain Byzantine churches, for instance that of Nikopolis. If such an iconography was indeed meant here, it appears only in a minor role. However, such a symbolic theme is not unlikely, in view of the fact that it recurs in a more developed fashion in the decorative repertory of later Umayyad structures. In any case, seen historically the decoration as a whole has a new world-wide aspect, for it combines Byzantine and Iranian motifs and applies the mosaics—a Byzantine type of decoration—in the manner of Sasanian stuccoes. Thus, the underlying intent of the decoration seems to have been not only to dazzle the viewer, but even more to proclaim the victory of the final form of divine revelation, and possibly also to demonstrate its world-wide dominion.

THE GREAT MOSQUE
AT DAMASCUS

The Umayyad period reached its apogee during the reign of 'Abd al-Malik's son, al-Walîd (705-715). His armies penetrated to points further to the east and west than had those of his predecessors, while internally the caliph conspicuously displayed his imperial aspirations by an extensive program of public buildings, including great monuments in the centers of the caliphate. Thus he constructed a mosque in his capital, Damascus (706), another in Medina, Muhammad's burial place and Islam's erstwhile political center (706-710), and a third in Jerusalem, the holy city of the two older religions (709-715). In addition we know from literary sources that he decorated the sanctuary in Mecca with mosaics. Of these monuments the Great Mosque in Damascus is the most important for the history of painting. Unfortunately, its enormous expanse of mosaics has suffered greatly from earthquakes and fires, so that today they are found only in patches here and there in the courtyard area and, to an even lesser extent, in the interior. Some of these mosaics are restored in part while others are medieval replacements; in spite of all this damage, enough is preserved to give a vivid impression of what once must have been a magnificent display.

Certain motifs in the repertory in Damascus, such as acanthus leaves rising from cornucopiae or vases, or realistically rendered trees, are the same as in the Dome of the Rock. There is, however, a new feature—architectural representations—and this is now the predominant theme. These pictures of buildings appear either as small groups or within landscape settings, as in the large panoramic scene on the west wall of the portico, the chief remaining glory of the mosque's decoration. Here many groups of buildings of different types are to be seen between eight huge trees and near a large river-like expanse of water that flows in realistic fashion, sometimes agitated by the onrushing waters of a

Illustration page 25

Illustration pages 24-25

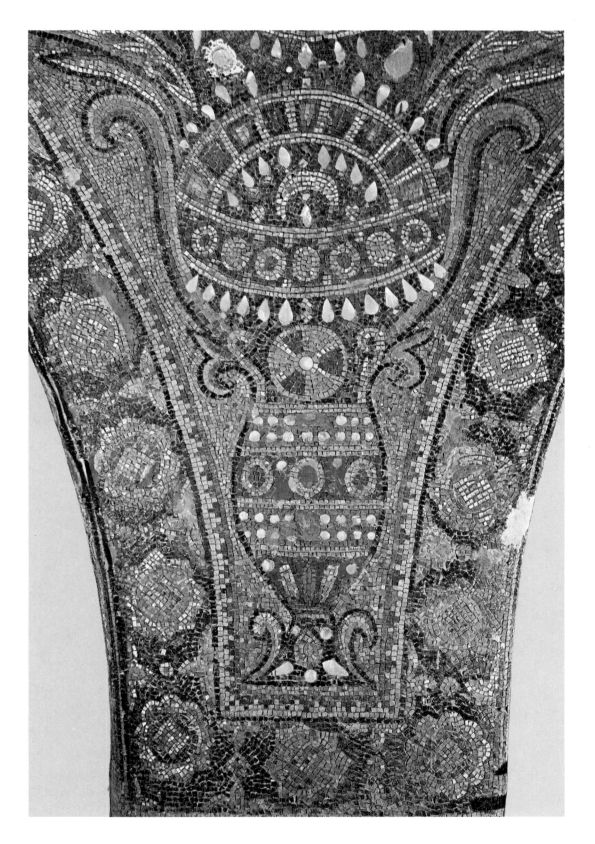

Jar with Floral Motif and Crown, 691. Mosaic. Dome of the Rock, Jerusalem.

tributary, then more calmly running with just enough force to have eaten away sections of the embankment. Here and elsewhere three types of buildings can be recognized. First there are the palaces, represented as highly ornamented, two-storied structures. The one Illustration page 27 here reproduced is found on a spandrel between two arches on the west portico. It shows in the lower story a high, semicircular hall with a shell roof and above it an open gallery, the two stories being covered by a conical roof decked with long leaves, of which the projecting tips turn up and inward. To the right and left of this imperial pavilion, cleverly filling an irregular space, are examples of private buildings, which also appear in clusters Illustration page 25 in the great panoramic vista. These little houses have flat, bracket-supported roofs or gable roofs and small windows just below them. In the manner of naturally grown villages they are loosely standing one next to the other, winding up a hillside which shows some

River Landscape, detail: Hippodrome, c. 715. Mosaic on the West Wall of the Portico, Great Mosque, Damascus.

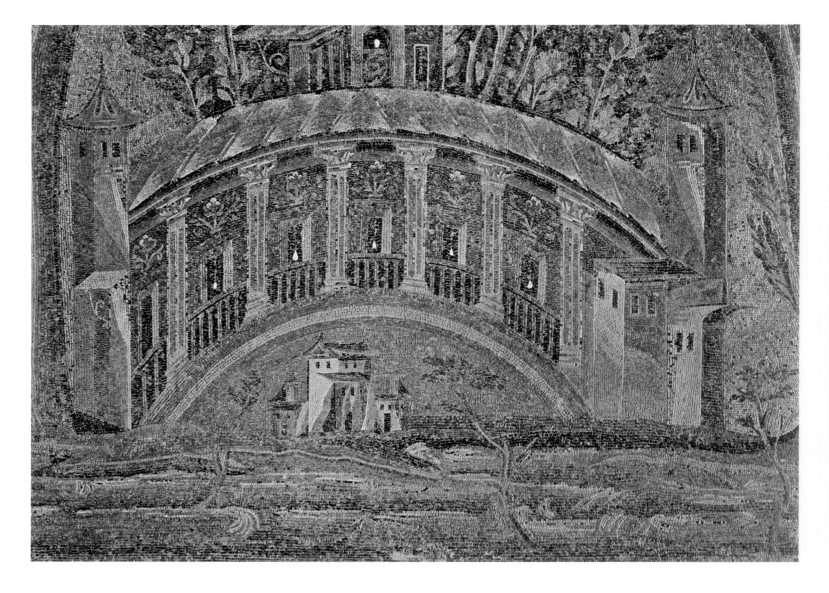

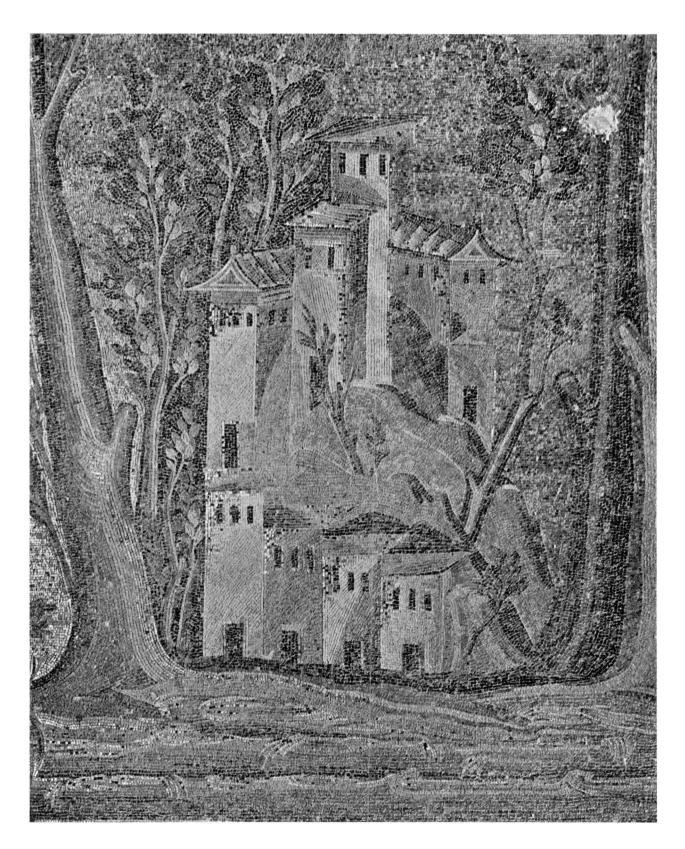

River Landscape, detail: Village, c. 715. Mosaic on the West Wall of the Portico, Great Mosque, Damascus.

Illustration page 27

Illustration page 24

rock outcroppings and a few trees. Unlike the palace pavilions, which are in strict frontal view, these little groups show the houses at an angle, following the contours of the country in an unconcerned natural movement; also, instead of the rich display of such decorative features as the columns, pilasters, balustrades, and acanthus scrolls seen within the imperial structures, one finds only irregular patterns of light and shadow on these simpler cubic forms. The third type of architecture is represented by the open-roofed gateway on the right of the spandrel design and, more imposingly, by the large hemispherical hippodrome in the large river scene. Although these varied types of buildings stem obviously from different prototypes, they are nevertheless skillfully combined. They form ever-changing ensembles of a cheerful, imaginative nature. Even the basic naiveté and awkwardness in coping with the problems of foreshortening and spatial perspective do not impair our enjoyment. Technically, too, they reveal great skill. Marguerite van Berchem, who made the first close analysis, has observed that there are at least twenty-nine different colors used, including thirteen shades of green, four of blue and gold, and three of silver.

The concept and rendering of the buildings, like the representations of trees and the formal arrangements of acanthus leaves, is of classical derivation. A border with the major monuments of a town appears in a fifth century mosaic of Antioch, and from the second quarter of the sixth century the topographic theme occurs on the floors of many churches, especially in Transjordan (Gerasa, Mâdabâ, Mâ'în, etc.). The ancestors of the informally grouped, high buildings with flat or gabled roofs, all crowded together and rising one above the other, are the architectural renditions in Pompeian-type frescoes such as those found in a villa of Boscoreale (first century B.C.). Another feature of Pompeian paintings were landscapes with a body of water in the foreground, except that these harbors, rivers, or lakes were given a greater illusion of depth than in the expanse of water in the big Damascus panorama. On the other hand, the two-story structures and public edifices are related to the architecture represented in Byzantine churches, as those in the mosaics of the Church of St. George in Salonica (fifth century A.D.). Even the unusual feature of the roof-covering turning into leaves has late classical and early Christian prototypes: this detail stems from the misunderstood acroteria on pictorial renditions of circular temples *(tholoi)*. On the other hand, an ubiquitous feature in doors, a chain ending in a pearl pendant, seems to reflect the still existing Near Eastern custom of covering the doorways with strings of beads that cut down the glare without impeding the circulation of air. The mosaics have only reduced such a glittering curtain to one or two strands of larger and more luxurious proportions.

Unlike the mosaics of the Dome of the Rock, to which they are stylistically and technically closely related, the Damascus wall decorations show no Persian influence. This may be explained by the reports of Arab historians that mosaic workers had been sent by the Byzantine emperor at the caliph's request. This information had been doubted by earlier critics, but the evidence that, in spite of continuous seasonal warfare, courtesies between the two courts continued just as did commercial activities, has now made it more likely. Such an official collaboration would also explain the purely Western orientation of the Damascus mosaics.

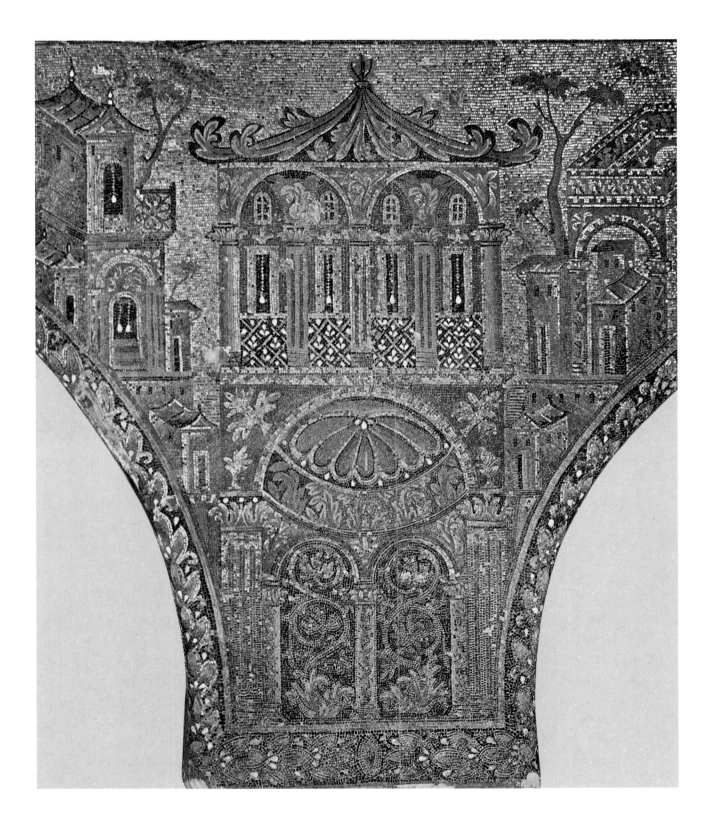

A Palace Pavilion (center), a Private Dwelling (left) and a Gateway (right), c. 715. Mosaic.
Spandrel Decoration on the inside of the West Portico of the Courtyard, Great Mosque, Damascus.

There is, however, no doubt that these workmen performed their task according to Muslim requirements. All representations of human beings or animals are rigidly excluded, although similar architectural or nature compositions in churches usually showed such figures. But how should these buildings and panoramic scenes be explained? One earlier interpretation has it that the city along the river represented Damascus itself, as it lies along the banks of the Barada River; but even if this should prove to be the case, it would not explain the many other representations of edifices found throughout the mosque. According to another authority, the scene represents the "City of God" as derived from classical and post-classical landscapes of Paradise. Contemporary or near-contemporary Arab texts do not support such an interpretation, and it is hard to see, in any case, how such a decoration would have fitted into the imperial program of the Umayyad caliph. The clue to the interpretation is probably provided in about 985 by the geographer al-Maqdisî, who as a native of Jerusalem might very well have known the precise meaning of these mosaics. He writes: "There is hardly a tree or a notable town that has not been pictured on those walls." He thus seems to have regarded these representations as comprising a picture of the world shown in the two aspects of architecture and nature. Ibn Shâkir, a fourteenth century author, corroborates this when he states that the mosaics "represented all known countries," and he even identifies the Ka'ba in Mecca, a building of such unique character that no other structure could have been so designated by a Muslim. As already pointed out, architectural compositions are also a theme of contemporary Christian ecclesiastical decoration, where, as Ernst Kitzinger has put it, there is expressed the concept "of bringing the aspects of the physical universe into the confines of the Church." This idea could not have been transferred, however, from the one religion to the other without internal dislocation of an economic nature. The fiscal policy of the early caliphate rested on the higher tax payments of the non-Muslim populations, so that a program of mass conversion to Islam would have undermined the finances of the empire. It is the secular state—and the Umayyads felt themselves first and foremost the leaders of a state rather than the promoters of a religion—which is now the world-controlling force. The mosaics of Damascus thus seem to imply that the whole world, under the aegis of the caliphs, has entered the "House of Islam"; even the churches which are found in the various villages and towns have a place in this empire, although the artists had to omit the offending crosses.

There is yet another aspect that distinguishes these scenes from similar architectural vistas in Christian mosaics and manuscripts. In those, Jerusalem and many other towns and cities are shown with crenelated walls, high towers, and strong gates; indeed, this is their foremost aspect. This defensive element is missing in Damascus. Everything is open and peaceful. By choosing the "idyllic" iconography instead of the "realistic" symbol, as church art had done, a new and challenging message was proclaimed: the Arab empire has conquered the whole world and now with the teaching of Islam the Golden Age, the paradise on earth, has arrived. One can hardly imagine a more impressive manifestation of the universal power of the new state than we find offered in these mosaics of the capital's main mosque.

In 1898 A. Musil discovered an Umayyad bath and a mansion in the desert about fifty kilometers east of the northern tip of the Dead Sea. After he had made two further trips, the third in the company of a painter, the Academy in Vienna brought out a large publication with color plates which for the first time presented to the astonished world a large assembly of figural paintings from an early Arab palace. Many of the frescoes found in the bath were then still recognizable, but with few exceptions they have since become so blackened by the smoke of Bedouin campfires and so disfigured by graffiti that most of them have become invisible. However, the still-existing details, together with the plates of earlier publications, give us a better insight into Umayyad secular art than do any of the other palaces since discovered. Yet it must also be readily admitted that the significance of many aspects of these paintings still escapes us.

In their general appearance the Qusayr 'Amra frescoes presented two surprising facets. There was first an unusual variety of subjects in a vast expanse of paintings which left no part of the walls and ceiling above the wainscoting undecorated and even covered the lower section with painted imitations of draperies. Secondly, a rather abrupt change from subject to subject is obvious, a tendency toward a division into many units which continues to characterize much of later Arab painting. Many of the themes were appropriate to the purpose of the building or referred to the special interests of the Umayyad family, and in spite of Persian elements and others possibly from Central Asia, the artistic concepts and repertory are to a large extent derived from later Roman or Byzantine painting. Very extensive were the hunting episodes leading to the final butchering of the antelopes though apparently without showing the actively participating master of the hunt; also present were scenes in a bath, athletic exercises and wrestling matches, many nude women in various pursuits, and family groups. A series of small pictures of different building activities formed a vivid reminder of another Umayyad predilection. More unexpected were Greek mythological personifications of Speculation, History, and Poetry, whose Greek designations seemed to indicate that the original owner knew this language. There was also a dome with a scientific rendition of the stars in the tradition of late classical dome decorations, often in an imperial setting, but hereby also introducing astral symbols just as in a Sasanian hunting scene on a seal in the Cabinet des Médailles, in Paris; and, for good measure, there were ornamental designs of figures and animals in a diaper system or in scrolls. These frescoes seem at first glance to be merely of a decorative character, yet even so some of them were most revealing. For instance, in view of the low esteem in which the Arabs of tribal origin held manual work, the scenes with busily engaged stone masons, carpenters, and other artisans made it clear that they were not painted for their own sake, but to indicate Umayyad objectives. The iconography followed, however, Byzantine precedent as figures engaged in building operations are shown in proximity to a representation of the enthroned Juliana Anicia painted in the frontispiece of a Dioscorides manuscript written for her before 512; in this case the princess had wanted to express that she had constructed a certain church in Constantinople (Vienna, Nationalbibliothek, Cod. Med. graec. 1). A different aspect of Umayyad mentality is disclosed by the picture of the starry sky

in the domed caldarium of the bath. Many earlier pagan and Christian vault decorations had depicted allegorical representations of the sky and heavens or visionary images of celestial regions. But instead of a painting of either of these two types, the artist chose a scientific version so that even at this early moment of Islamic history a direct and rational approach to natural phenomena was taken, hereby setting a norm for later times. This scientific attitude towards an iconographic problem does not, however, exclude the possibility that this dome decoration also had a magic function, namely to assure the good fortune of the lord of the mansion.

Illustration page 190

Besides these various subjects there existed also two other scenes, now unfortunately destroyed, which were even more revealing. At the end of the central aisle of the large entrance hall, probably used for receptions or gatherings, there was a fresco of an enthroned and haloed figure with two attendants shown in the manner of the Byzantine Cosmokrator. Below him was an aquatic scene with a boat manned by four nude figures; in the water were large aquatic monsters and a water bird. The blue area all around the throne apparently indicated the sky, which was further characterized by a frieze of birds. The Arabic inscription above the enthroned prince was already too much destroyed in Musil's time to permit an identification. It is quite likely, however, that it was the caliph himself who was represented, just as in certain other Umayyad mansions similarly imposing effigies were placed in strategic locations. The other, even more

Illustration page 190

surprising, scene was in the left aisle of the entrance hall. It showed six kings in strict frontal view, placed so that the more important rulers were in the first row and the lesser ones in the back. Greek and Arabic inscriptions designated four of the figures as the Byzantine emperor and the Sasanian Shah of Iran, with Roderic, the last Visigothic king of Spain, and the Negus of Abyssinia standing behind them; historical inference established the two others as the Emperor of China and a Turkish or Indian ruler. This scene supplied at once a range of dates for the buildings, because Roderic became king only one year before he was killed in battle by the Umayyad armies in 711, which must be regarded as the earliest possible date, while the end of the Umayyad dynasty in 750 indicates the latest. It also became obvious that this unusual and topical painting served a definite purpose. As a result of the research done over a period of more than fifty years by Max van Berchem, Ernst Herzfeld, and Oleg Grabar the precise meaning of the scene has become gradually clearer. The fresco represented a symbolic scene derived from Persian iconography in which the kings of the world greet their master. These kings had all suffered defeat at the hands of the caliph in the early part of the eighth century; however, while they are seen standing at an appropriate distance before the enthroned ruler, the painting does not stress the defeat in the usual stark dramatic manner of the Sasanian and Byzantine triumphal scenes. Instead the kings are shown with the same gesture of acclamation with which, in the *Codex Rossanensis* or in the mosaics of S. Lorenzo fuori le mura and Santa Cecilia in Rome, the apostles meet Christ. The act of defeat has therefore been transmuted into a new relationship. The caliph regards these rulers as members of "the family of kings" of which he is the commanding member; while the six rulers recognize his overlordship and submit to it, the now-friendly

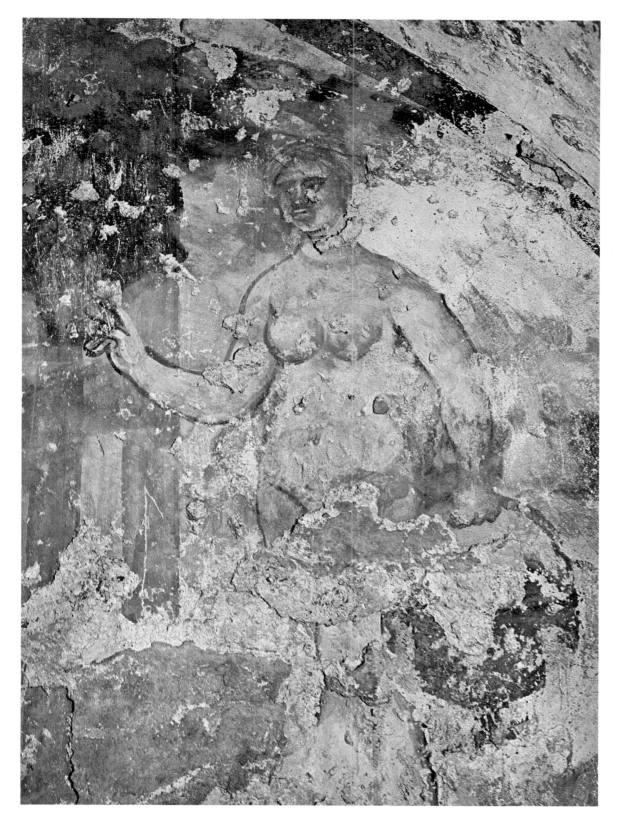

Bathing Woman, second quarter of the eighth century.
Wall Painting on the South Side of the Tepidarium in Qusayr 'Amra (Jordan).

association of the caliph with the representatives of long-established dynasties serves him, too, since it legitimizes his much newer regime. While the scene is of a conciliatory character it is nevertheless another conscious assertion of the caliphal power. The crass, even clumsy inclusion of an Eastern theme in an otherwise purely classical ensemble makes the purposefulness of the fresco even more evident. A similar intention is probably contained in the Cosmokrator-like representation of the enthroned figure. Might not the central and most important painting have expressed the idea that the caliph was ruling the earth, which was thought to be bounded by the ocean, designated by sea monsters, and beneath the all-covering sky, symbolized by birds? Such a cosmic setting for a ruler with surrounding birds occurs on a Sasanian silver platter in the Teheran Museum and the same idea is still to be found on thirteenth century Persian luster pottery, and also occurs (at least in connection with the representation of water) in the frontispiece of a thirteenth century Arab manuscript.

Illustration page 190

Illustration page 31

The analysis of the nude female figures throws a revealing light on another characteristic of the Qusayr 'Amra paintings. In their feeling for plastic forms, play of light and shadow, and natural movement these figures show their dependence on the Roman tradition; however, in their physical aspect these massive feminine forms reflect a concept of beauty that is far removed from the classical age. Indeed, the stress on heavy breasts and narrow waists has led to the assumption that these figures are dependent on Indian models or secondary Central Asian versions of Indian prototypes. While Eastern influences existed in Umayyad art, the more vital factor is the mental attitude which prompted the Umayyad patrons to accept such a canon of beauty. We cannot understand these paintings without realizing that these physical types are no mere exotic importations, but faithfully reflect the Arab concept of female beauty as it can be reconstructed from the amatory preludes to the ancient Arabic odes. In these love lyrics one reads that the ideal Arab woman must be so stout that she nearly falls asleep; that she must be clumsy when rising and lose her breath when moving quickly; that her breasts should be full and rounded, her waist slender and graceful, her belly lean, her hips sloping and her buttocks so fleshy as to impede her passage through a door. Her legs are said to be like columns of alabaster and marble, her neck like that of a gazelle, while her arms are described as well-rounded, with soft delicate elbows, full wrists, and long fingers. Her face with its white cheeks must not be haggard, her eyes are those of a gazelle with the white and black of the eyeball clearly marked. This ideal of beauty was not only that of the Bedouin poets. It had the same appeal at the courts; the same features occur in a letter listing all the qualities of a captured Arab girl whom an Arab king sent to his Persian overlord. This description corresponded so perfectly to the Shah's desires that he had it preserved in his archives. Yet there is one deviation from a straight pictorial response to purely physical sensualism. The deep-set eyes, with their rather mournful glance into the infinite, reflect another type of painting known to us from Coptic and other Christian representations that revealed a pronounced tendency toward the spiritual and unworldly. Admittedly this tendency did not affect Islam as it did Christianity. However, while there never arose in Islam a negative attitude toward

the body, the strict sense of propriety with regard to women in public life caused the female body to be amply clothed as long as it was the butt of every man's gaze. This rule was enforced even when the female figure was painted on walls or in manuscripts. Only in paintings which decorate the harîm do pictures of nudes or semi-nudes appear.

In the Qusayr 'Amra paintings the human figures show a certain clumsiness in spite of their ultimate dependence on late classical prototypes; the representations of the animals reflect a much keener sense of observation and are truer to life. This is the case both in the hunting scenes and in the more decorative animal pictures. The greater ability to portray animal life is already a notable feature in ancient Oriental art and it remains characteristic for later Arab painting.

The fact that the Greek inscriptions show omissions and mistakes and, furthermore, were first given in outline with the color added later indicates that the artists were not at home in the Greek language. Since they were able to render the Arabic inscriptions directly on the wall and reproduced certain words phonetically, they must have been Arabic-speaking and were probably of local origin. Some of them may not even have been of the Muslim faith: one of the inscriptions has strong Christian overtones.

The final question pertains to the owner of this structure. The Caliph al-Walîd has to be ruled out, not only because of the modest dimensions of the building, but also because of the inscription which refers to a prince *(amîr)*, probably a member of the Umayyad family. This may very well have been either the future al-Walîd II or the future Yazîd III, who ruled very briefly as caliphs during the years 743 and 744. Both lived for many years in the desert and al-Walîd was even known to have understood Greek well. It may thus be assumed that the paintings date from the reign of the Caliph Hishâm (724-743).

QASR AL-HAYR AL-GHARBÎ ("THE WESTERN QASR AL-HAYR")

Qusayr 'Amra is not the only residence built at that period in or near the desert. Most of the Umayyads disliked life in the city, which they thought crowded and unhealthy; they therefore built for themselves many castle-like structures, usually combined with bathhouses and hunting preserves, at the edges of the cultivated lands of Syria and Transjordan. Indeed, after al-Walîd no Umayyad caliph resided continuously in Damascus, and many of the princes likewise lived in these mansions, which had the double function of estate headquarters and hunting lodges. Besides Qusayr 'Amra two other Umayyad structures have yielded pictorial records, Qasr al-Hayr al-Gharbî and Khirbat al-Mafjar.

Qasr al-Hayr al-Gharbî, an elaborately constructed and richly decorated chateau lying on the road from Damascus to Palmyra, was excavated in the 1930's by Daniel Schlumberger. It dates from the reign of the Caliph Hishâm and was probably built around 730. It contains, in addition to several remarkable fragments with human heads, two large frescoes on the floor of the rooms that housed staircases. They are on the whole very well preserved though now somewhat faded; only the parts near the beginning of the stairs have lost most of their decoration. Certain details of their design, especially the abrupt changes from areas of light to dark color, indicate that these frescoes imitate

mosaics, which took more time to apply. Such copying in another medium was not uncommon then or earlier, as the imitations of marble incrustations from Roman times on indicate.

Illustration page 35 The first painting follows the classical tradition of the area. In the center is a large circular medallion with the bust of a female figure that holds a cloth with various fruits. This marks her as Gaea, the goddess of the earth, who, owing to her chthonic connection, is here as in other instances shown with a snake around her neck. Around this roundel is a large rectangular field, which is in turn surrounded by a frame containing scrolls enclosing bunches of grapes. Set in the floral growth of the field are two creatures with bare human torsos and hindquarters (here not shown) consisting of snake-like tails, turned three times and equipped with fins. Schlumberger called them, quite rightly, "marine centaurs." The animals on the other side, which is badly worn, are two foxes, one of them eating grapes, two cranes, and possibly a dog pursuing another animal. The only element of this design that is not thoroughly Roman or Byzantine is the pearl frame around Gaea, but this Persian feature had long before become popular in Syrian works of art; however, by the enclosure of tiny floral patterns within the pearls it has been given a form that did not exist in its homeland.

Illustration page 37 The second fresco is entirely different in style, composition, and content. It consists again of a large rectangular area, this time divided into three bands of uneven height, the whole framed by a border of quatrefoil rosettes. In the top register two musicians, a female lutenist and a male flutist, are turned toward each other as they stand in arcades. Below them a young man on a horse, shown in flying gallop, pursues gazelles, one of which lies mortally wounded on the ground, while the other looks back at the hunter, who is aiming an arrow at it. In the much damaged third scene (here not shown) a dark-skinned servant seems to guide a big-horned animal to an enclosure of which he holds the large key in his left hand. The ribbons on the neck of the animal indicate that it has been tagged for the imperial hunting preserve.

Everything in this second painting, from the main figures to such secondary motifs as the border, the vegetal pattern above the arcades, and the floral arrangement and vessel in front of the musicians, indicates that it is of Persian derivation. While the prototypes for the musicians and the hunter could have been designs on such easily movable loot as Sasanian silver bowls or vases, no Persian object is known which has a scene analogous to the third motif. It could have existed, however, as a painting, and hunting in a royal game preserve is depicted at least on a Sasanian rock carving. In any case, owing to the total loss of early Persian painting, this fresco is the closest and most complete example we have of the Sasanian type of painting.

Since the tripartite fresco was derived from an extraneous source, it probably reflects more readily the intent of this decoration than does the first. As in nearly all Sasanian art, the three topics pertain to the royal court: in the center a young prince or courtier on a hunt; above, the court musicians, and below, the replenishing of the royal hunting preserve. Although such topics seem very appropriate for what was probably a royal or princely residence, there is still the question of why such foreign subjects were introduced

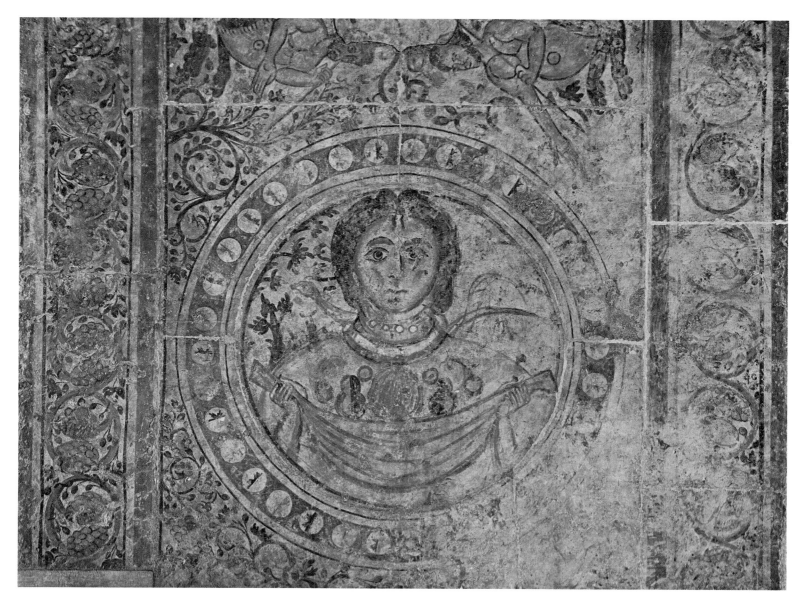

Gaea and Marine Centaurs, c. 730. Floor Fresco from Qasr al-Hayr al-Gharbî (Syria).
National Museum, Damascus.

in preference to similar but indigenous themes. The reason must have been that these
Persian motifs expressed more readily the idea of royalty. Indeed, owing to this connota-
tion the façade of Qasr al-Hayr presented the relief figure of a prince—most probably
the caliph himself—clad in Persian garments and with a Sasanian-type crown. This ready
acceptance of Persian models was, however, caused by a specific historical situation to
which H.A.R. Gibb has drawn attention. The Umayyad caliphs at various times had made
great efforts to conquer Constantinople and vanquish the Byzantine Empire, but these
efforts had failed. At the same time the center of gravity of the caliphate had moved to the
east, and especially to Iraq, which had been part of the Sasanian Empire and the site

of its capital, Ctesiphon. For these reasons the very same Caliph Hishâm, during whose reign this chateau was built, "deliberately broke away from the ambitions of his predecessors to organize the Arab Empire as the future heir of Byzantium and began the process by which the administrative center gradually moved eastward."

The artistic efforts of this time clearly reveal the new orientation toward the east. This new predilection is further corroborated by a statement of the Arab historian Mas'ûdî. In 915 he saw a history of the Sasanian kings in which each of them was portrayed with his characteristic garments, crown and royal ornaments and he also informs us that the Caliph Hishâm was interested enough in this detailed, illustrated account of a defeated dynasty to have it translated into Arabic and rendered in a richly illuminated manuscript. This, too, was obviously due to the new sense of being related to the long-established dynasty.

Illustration page 35

Since the second fresco reflects an imperial policy, one naturally asks whether a similar tendency can be established in the first. Since it follows a well-known type of decoration with regard to style and iconography, one could, of course, easily regard it, like so many others, as a mere floor decoration. Still, it might be more than just a coincidence that one finds here the earth, represented by Gaea, juxtaposed with the encircling ocean, represented by the marine monsters. The possibility cannot be ruled out that what we have here is not merely another cosmic representation, but one that, considering its location in an Umayyad residence, may well have implied that the world now lay prostrate under the feet of the dynasty. But quite apart from the question as to whether or not the native artist used this iconography according to official directions, this specific meaning was certainly clear to the new converts from Greater Syria.

KHIRBAT AL-MAFJAR

During the excavations between 1935 and 1948 of this large palace compound near Jericho, likewise built during the reign of the Caliph Hishâm, the excavators, R. W. Hamilton and D. C. Baramki, found about 250 painted fragments and a large number of well-preserved mosaics. The paintings were found in the palace proper and in the large bath establishment. Although the majority of the paintings, especially the figural and architectural subjects, have Roman and Byzantine affiliations, a number of decorative designs imitate textiles of Persian and possibly Central Asian origin. The latter were found particularly in the palace, a fact that indicated not only a continued interest in Oriental themes, but again a decided preference for them in a royal context. Unfortunately, all the fragments are so small that they permit only an identification of the themes and certain general deductions about the styles used.

Illustration page 39

Dazzling as the many mosaics are, nearly all of them had geometric designs in the Roman-Byzantine tradition, although they proved to be immensely rich and more varied. There is only one figural mosaic, which is placed in the audience chamber of the large bathhouse, decorating the raised apse. This was not the only mosaic in that sumptuously decorated room, for the main rectangular area showed one of the usual geometric mosaics with the same pattern as that used for the raised bench which surrounded it. Hamilton thought the figural mosaic represented a carpet, because it seemed to have a tasseled

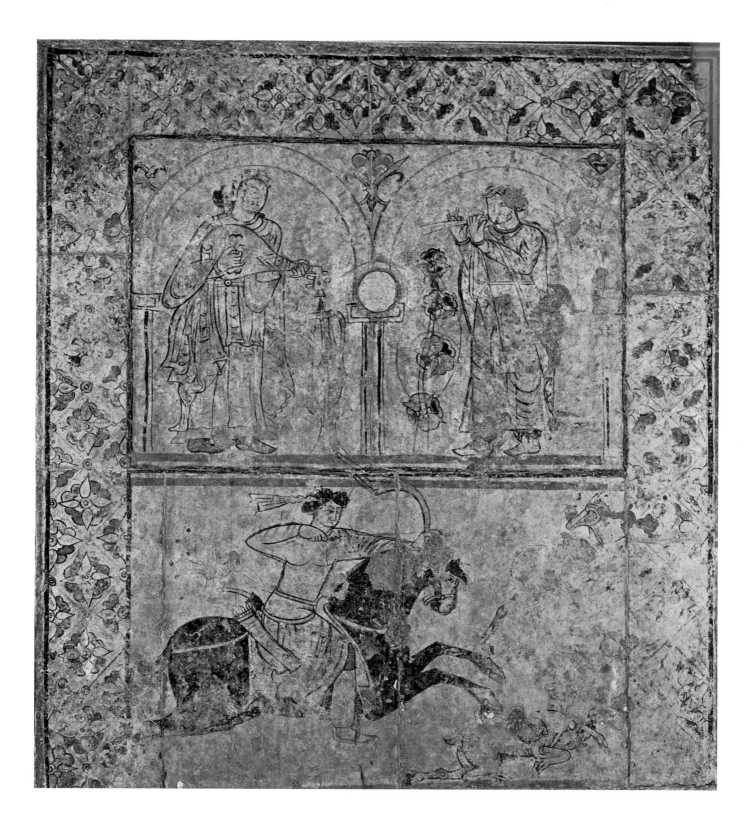

Musicians and Hunting Cavalier, c. 730. Floor Fresco from Qasr al-Hayr al-Gharbî (Syria).
National Museum, Damascus.

border "so like the selvage of certain kinds of rugs." This effect may, however, be incidental since the "tassel" also appears elsewhere as a floral pattern; but inasmuch as the geometric mosaic in the chamber also has a carpet-like appearance, the whole might nevertheless represent a mosaic imitation of a textile, in this case probably a tapestry.

Illustration page 39

The main design consists of a large apple or quince tree with a few leafy plants to the right and left. Among these on the left are two gazelles seen eating leaves; in doing so they move slightly forward towards the middle and front of the scene. On the right a ferocious-looking lion has just jumped onto the back of a third gazelle which frantically but unsuccessfully tries to escape. The tree, though perhaps not as sinuous and detailed

Illustration page 25

as those in Jerusalem and Damascus, nevertheless has realistic features, for instance the uneven growth of the main branches or the twisting of one of these branches around its straighter and sturdier neighbor. Both trunk and foliage are composed in such a way that the central part of each unit is given in pale yellow, which is followed by green and this in turn by a blue green; the whole is set against a dark edge which appears as a silhouette around the tree and as an interstitial color between the leaves. Against this dark background the red fruits with their white highlights stand out in marked contrast. Since the black edge is heavier on the right side of the trunk this color is apparently an effort to represent shadows. In the foliage appears one departure from the general pattern: on the left a branch is shown in two tones of gray instead of the usual green and blue green. This is another realistic feature seeming to indicate the result of a blight that has affected this part of the tree.

Again we have to ask ourselves whether there is any particular significance to this theme. Scenes with peaceful animals and ferocious beasts attacking other creatures were, of course, a common feature of Roman and Byzantine mosaics. They occur, for instance, in the mosaics of the Great Palace in Constantinople now attributed to the third quarter of the sixth century and in the mosaics of Antioch. The motif originates, however, in the Ancient East; in particular the lion killing a weaker animal was a theme current there for millennia. There the theme of the attacking lion has apparently a royal connotation. This is evident, for instance, when it appears on the embroidered tunic of Ashurnasirpal, on the shield of Sargon II, or among the reliefs at Persepolis. It continued to be used with such associations for many more centuries for it occurs in the form of a lion killing a camel on the formal robe made for King Roger II by Arab artisans in Palermo in 1133-1134 and even as late as 1578 on the seal of the Ottoman Grand Vizier Qara Oweis Pasha. This poses the question of whether the representation should here be regarded as a genre subject or as one with symbolic meaning. Since this is the only figural mosaic found in the audience chamber and is furthermore on the raised dais where the lord of the mansion would have been seated, it seems more than likely that the design had a special significance. This becomes all the more evident when we remember that the sculptured stucco figure of the so-called caliph, conspicuously placed within the ceremonial gateway to this very bath, is standing on a base guarded by two lions. This indicates that the lion was in this milieu closely associated with the concept of imperial power. It seems reasonable to state that the apse mosaic, over and above its mere decorative quality, had also

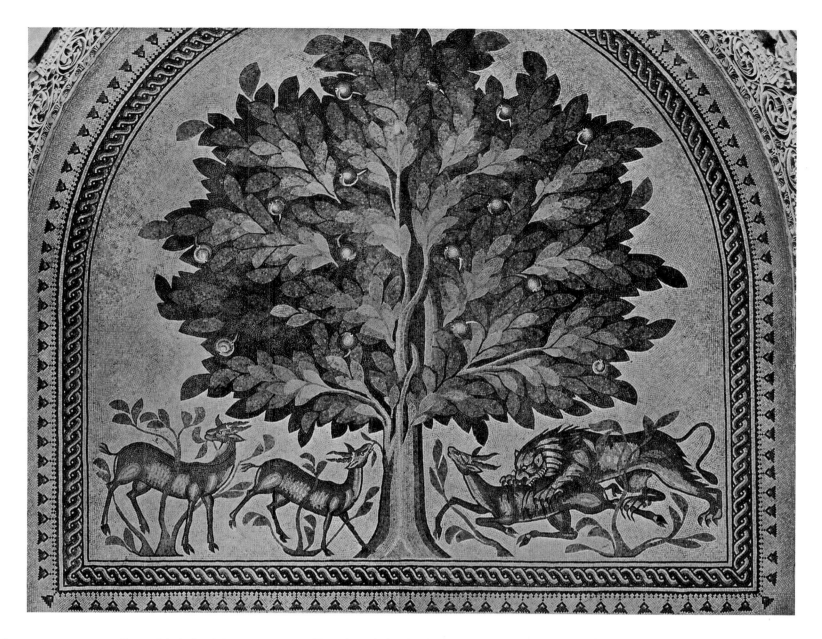

Tree with Animal Scenes, 724-743. Floor Mosaic in the Audience Chamber of the Bathhouse of Khirbat al-Mafjar (Jordan).

the special function of symbolically demonstrating the irresistible power of the caliphate. The Oriental theme is, however, expressed in the artistic language of the West in which, at that time, the symbolic association of "tree" and "world" was also current. Altogether, there is here again a blending of styles and concepts that is typical of the Umayyad period.

The assertion of universal power by the Umayyad dynasty is a major theme with many variations, employed for both sacred and secular buildings. Since it is not only proclaimed in places of public gathering such as mosques, but also in palaces located

in or near the desert, the constant—indeed one might almost say, compulsive—use of this leitmotif must have had yet another intent. If one thinks of the magic power with which the pagan and Christian Near East imbued images, it seems quite likely that these Umayyad paintings were meant in a similar way. Their aims, perhaps only unconsciously projected, would have been to perpetuate the power of the regime by sympathetic magic. But alas, changed political and intellectual conditions, and particularly the hostility toward the Umayyads in the succeeding age, caused the true meaning of these paintings to be soon forgotten.

THE PLEASURES OF THE COURT
(THE EARLY 'ABBÂSID PERIOD: 9th TO MID-12th CENTURY)

Toward the end of the Umayyad period there developed a mounting pressure on the dynasty by dissatisfied elements. New non-Arab converts from many countries who felt themselves to be disfranchised Muslims, frustrated Arab groups, religious dissidents, and extremists combined under the leadership of a descendant of 'Abbâs, an uncle of the Prophet. This opposition centered in Eastern Iran. In 750 it succeeded in defeating the last Umayyad caliph, whose family was almost exterminated. One of the early moves of the new 'Abbâsid dynasty was the transfer of the capital to the East. In 762 Madînat as-Salâm ("the City of Peace"), better known as Baghdad after an earlier Persian village on the same site, was founded on the Tigris. The main support of the dynasty came from the east, especially Iran; the first important viziers were also from there. In view of this orientation the caliphs followed Persian ideas and fashions; in particular they imitated the court ceremonial and other practices of the Sasanian kings whose residence had been close to Baghdad.

In this period the cohesion of the caliphate suffered severely. Already by 756 Spain had seceded from the central government; then one region after another—Morocco, Tunisia, Eastern Iran—became semi-independent, the caliph being recognized only as the nominal head. The most far-reaching defection was that of Egypt, where from 969 to 1171 a dissident dynasty from Tunisia ruled as counter-caliphs. The 'Abbâsids fell increasingly under the influence of their viziers; later the actual power was exercised by the commanders of the Turkish palace guard. By the middle of the tenth century the caliph was nothing more than a figurehead who did not even have full control over Iraq. Externally, too, the tide was turning, and certain outlying regions, such as parts of Spain and Sicily, were reconquered by Christian rulers.

In spite of the political break-up of the caliphate, literature and the arts flourished in this period. From this time we also have the first extensive records of paintings, which now are spoken of as something accepted, rather than objectionable. Some sources speak of themes familiar to us through surviving monuments. In other cases these references are the only indications of the existence of a particular type of painting. For instance, it is stated that in one of the caliphal palaces of the ephemeral ninth century capital Samarra, there was a picture of a church with monks and the leader of their vigils. An account by the tenth century poet Mutanabbî speaks of the decoration of a tent, either a painted cloth or, more probably, a tapestry. He describes a landscape with peaceful and fighting animal groups and a scene showing a Byzantine king and his generals prostrating themselves before a ruler, the Hamdânid Sayf ad-Dawla. Finally, to mention yet another type of painting, an eleventh century pharmaceutical treatise contains the story of how a seemingly barren Turkish slave girl in Baghdad, following the custom of her people, asked her master to have a handsome child portrayed by an artist, so that she might look at the painting during the marital union and bear an

infant like him. No paintings of these various categories have been preserved. Other references to pictures are of a more general nature. For instance, painters of murals are mentioned in the Geniza documents referring to conditions in Fâtimid Egypt. Finally, accounts that speak of the destruction of paintings either willfully by man or by decay indicate a still wider use of this art than is established by literary references or latter-day finds.

This being a period of peace, in spite of despotic rule and intermittent social unrest, the themes of the paintings made at the courts during this first period of the 'Abbâsid dynasty are, of course, generally different from those of the Umayyads. The small number of extant monuments, their fragmentary condition, and the literary references to otherwise unknown themes make any generalization rather tentative. Yet it seems that among the main topics of this politically-satiated period, and possibly the most important of all, were the pastimes of the courts.

SAMARRA No scientific excavation has been undertaken in Baghdad. Since the old city lies under a modern capital, it seems unlikely that much can be recovered except for chance finds resulting from the removal of earth for new constructions. However, archeological campaigns between 1911 and 1913 resulted in the recovery of paintings at Samarra. This city was founded by a son of Hârûn ar-Rashîd as a new capital and was used as such only from 838 until 883, when it became a provincial town of religious significance only. Unfortunately, most of the paintings recovered at this site were lost in the aftermath of World War I. They are in the main known to us through the publication of their discoverer, Ernst Herzfeld.

Some of the paintings were found in private houses and bath establishments, but the most important ones were discovered in the Jawsaq Palace, especially in the harîm. One, of an elaborate acanthus scroll inhabited by animals and human figures, is a late version of a favorite Roman motif. The greater number of the paintings, however, exhibit an entirely different East Hellenistic style, obviously that of Sasanian Iran. The Persian character of these pictures calls to mind a story in the *Arabian Nights* according to which the paintings in a garden pavilion were executed in the Persian manner by several Persian painters whom the caliph had called in for this purpose.

Illustration page 191 A typical example of the Samarra style is the picture of two fully clothed female dancers who, while moving toward each other with bowls in crossed hands, ceremoniously pour wine into the containers from behind their heads. The golden vessels, diadems, and belts, the pearls in their hair and earrings, as well as the heavy costumes and long braids, make it clear that these entertainers belong to the caliphal court. The motif of dancers is ultimately a classical one, but in this painting there is little to betray such an origin. The heavy-cheeked, broad-chinned, long-nosed faces are Oriental. Such fashionable details as the arched curls, shaved corners of the coiffure, the long braids and wide collars, have Eastern parallels in the Sasanian minor arts and the Turfan frescoes. The folds no longer fall in a natural manner but, above the abdomen and knees, have been turned into rhythmic patterns with no semblance of reality. More important still is the treatment of

the subject as a whole. It is an action picture; but its movement is so slow that it looks as if it were arrested. The whole scene is devoid of transient expressions and individual features, let alone of physical abandon or feminine grace, all so natural to the dance. The stress is on bodily volume and structural solidity of the figures in a symmetrically balanced composition. As a matter of fact, the only non-figural element is so ambiguous that it is not certain whether it represents a bowl of fruit or pastries; perhaps it might even stand for "mountains." The end result is a monumentally rendered symbol of the royal dance rather than a portrayal of living dancers—a timeless ceremony rather than a dramatic incident.

The hunt, as another royal pastime, is portrayed in a scene which shows the killing of an antelope by a huntress. This painting presents the same heavily clothed female figure, the same physical type, and similar adornments. But even this dramatic subject, so full of tension and movement, is accorded only the barest suggestion of action. It is again a symbol rather than the representation of an actual event.

Another royal pastime, the imbibing of intoxicating drinks, is not represented by drinking scenes but indirectly conjured up by about a dozen tall pottery vessels with painted decoration on one side. D. S. Rice has shown that the jars originally contained naturally or artificially fermented wines, indicated by "labels" which also gave the names of the wine grower, the merchant, or the cellarer. The paintings on these vessels render themes which have a close connection with the court. They consist of female entertainers, hunt-ers, military officers and bearded figures in dark clothes who were probably monks, since Illustration page 191 the monasteries had vineyards of their own or much patronized taverns. In spite of the gay scenes that these vessels must have witnessed, the subjects are treated with gravity. Most of the figures are shown frontally, staring out at the viewer in absolute immobility. This pose is particularly significant in the case of a heavily clad hunter carrying a gazelle on his shoulders, since it forms the greatest possible contrast to the classical treatments of the same motif such as the easily striding, lightly dressed figure on the mosaic floor of the Great Palace in Constantinople.

Representations of royal pastimes existed already in Umayyad times. However, the development from the hunting scene at Qusayr 'Amra to the musicians of Qasr al-Hayr and finally to the paintings of Samarra clearly indicates a change of emphasis. In the frescoes of Qusayr 'Amra the events in their stress on movement were, so to speak, taking place in time and space. In Samarra the figures have become all but immobilized as they gaze icon-like at the viewer and on into the infinite; by shifting from a dramatic incident to a symbolic representation the pictures have gained, however, an impressive monu-mentality, which perfectly fits the royal association. It is also significant that in this change to abstraction the figures have not only become less sensuous, but even more ambiguous sexually; for several of the Samarra fragments there is still disagreement among scholars as to whether girls or young men are represented. Yet this timeless grandeur of the royal subjects exercised a great appeal and established an international style that was copied by the contemporary minor courts and continued to influence the royal arts of the following centuries.

In view of the Persian character of the Samarra painting it is not surprising that the excavations at Nishapur in Eastern Iran have yielded fragments of paintings in the same style dating from the late eighth or early ninth century. Even the curls on the foreheads of the plump women are the same. Another local type of painting with formal floral themes covered little niches, which, in serried rows, filled vaults or squinches near the ceilings.

Unfortunately, only a few fragments of monumental paintings of the Samarra and following periods are preserved from Egypt, but to judge from them and the designs on pottery there seems no doubt that in the late ninth, tenth and part of the eleventh century the style current was close to that developed in Iraq, especially since the founder of the Tûlûnid dynasty had come to the Nile valley from Samarra.

THE CAPPELLA
PALATINA
IN PALERMO

We are fortunate in having preserved, in an unexpected place, one very extensive series of paintings derived from the art of Samarra. It is the ceiling of the palace church of Palermo, built for the Norman rulers of Sicily. This island, after having been ruled from 827 to 1061 by Muslim governors dependent first on Tunisia and then on Egypt, became Christian again when the Norman count Roger I conquered it completely. The Norman court, however, adopted many Muslim ways. The wide use of Arabic is attested by inscriptions both on the ceiling of the palace church and on the formal robe of Roger II. Such inscriptions are not only in the Arabic tongue, but are also Muslim in spirit. For example, the palace sundial invokes Allah's help for the ruler's long life and the support of his standards, and the date is given according to the Muslim era. An even more striking proof of this Arab-Muslim acculturation can be seen in the occurrence of "Allah" and the "Hijra" year in a context where one would expect a pronounced Christian orientation: on the Arabic tombstone erected in 1149 by the sovereign's priest, Grisante, for his deceased mother in a specially built church. Of King William II the Muslim traveler Ibn Jubayr says that he not only had great confidence in Muslims in all his affairs, but also that he was proficient in Arabic, which he could both read and write. The Christian women of Palermo, too, followed the fashion of the Muslim women in going about veiled and in staining their fingers with henna; they, too, spoke Arabic fluently. One other report of Ibn Jubayr is of interest, namely that "no Christian king was more given to the delights of the realm, or more fond of comfort and luxury" than William II, whom he also said to be "engrossed in the pleasures of his land and the display of his pomp in a manner that resembles the Muslim kings."

The Cappella Palatina, the chapel of the Royal Palace of Palermo, was built in 1140, and its decorations were added in the following years. It is a hybrid structure consisting of a Byzantine-type sanctuary with Christological mosaics, combined with a Western nave having scenes from the Old Testament as wall decorations and a wooden ceiling in the Muslim manner. This ceiling is flat over the two aisles, but over the nave it consists of two rows of stars with interstitial crosslike figures in a complex, three-dimensional arrangement, the whole apparently meant to look like a starry sky. The setting is particularly varied along the edges, which descend tier upon tier in a combination of little projecting niches. As in the case of the earlier stucco niches of Nishapur, the various

Feasting Ruler with Attendants, middle of the twelfth century.
Painted Ceiling Panel. Cappella Palatina, Palermo.

Ascension Scene, middle of the twelfth century.
Painted Ceiling Panel. Cappella Palatina, Palermo.

46

units, especially those of the elaborate cornice, carry painted decorations, although none is large enough to allow space for more than four figures. This small size together with ever-varying positions and the great distance of the panels from the floor makes them difficult to see. Originally they—and especially those in the eastern section—were viewed to better advantage by the king's party, for there was a royal box high up on the northern wall, near the northeast corner. We may therefore assume that the areas best visible from this vantage-point also contain the most significant themes, iconographically speaking.

A careful analysis by Ernst Kitzinger of the mosaic decoration of the sanctuary has shown that there is special stress on those scenes that depict Christ in the role of triumphant ruler or on panels with warrior saints. This emphasis on royal or military themes reflects in turn on the ruler, who was regarded as the earthly representative of the Heavenly King, and who faced just these leitmotifs from a second royal box. When the Muslim painters were asked to do their share of decorating the Church, in the ceiling area outside the sanctuary proper, they, too, used the royal theme. However, in contrast to the mosaic-workers of the sanctuary, the Arab-Muslim artists could treat their subject only in a secular fashion as they had probably also done in the living quarters of the Palace. Their main subject matter consists of what the Arabic inscription on Roger's formal robe declares to be "the pleasures of days and nights without surcease and change." The king himself is introduced and one sees him enthroned, cup in hand, and attended Illustration page 45 by his pages or slave girls, while on nearby panels we find his boon companions or musicians playing various instruments, along with dancers and other entertainers. Some of the individual figures have the strict frontality and monumentality of the Samarra pictures. In the case of the king this seems particularly appropriate for it stresses the representational character of court art; it also reflects the king's preoccupation with his unrelenting enemy, time, the same concern which is apparent in the formula used after the name of every ruler: "May his life be everlasting." The dependence on the Irano-Iraqi style is apparent even in details of fashion: the curls on the foreheads of the women and their side locks are still the same as in Samarra. However, in the nearly three hundred years that had elapsed, certain motifs had lost their immobility for reasons that will be discussed in the next chapter. Thus, for instance, the bodily movements of the female dancers are much more pronounced and the rhythm faster.

One of the most elaborate treatments of the "royal entertainment" theme shows two male flutists standing at the sides of a wall fountain, the water of which spouts from Illustration page 48 a lion head; forming an artificial cascade, this water flows over a series of steps into a small basin out of which rises a water jet. Above this scene two ladies look out from windows into what must have been a royal reception room of the type still preserved in the Zisa, an Arab-Norman palace in Palermo. Here the pleasurable association of music and women, of the tinkling noise and coolness of running water, and, in general, the luxurious court life are all rendered as an ensemble. It is still a rather static, symbolic picture and presents its content symmetrically and in an additive fashion, but in its greater complexity and in its descriptive presentation of a locality, it goes well beyond the rather cryptic indications in the Samarra paintings.

Scene at a Wall Fountain in a Palace, middle of the twelfth century.
Painted Ceiling Panel. Cappella Palatina, Palermo.

48

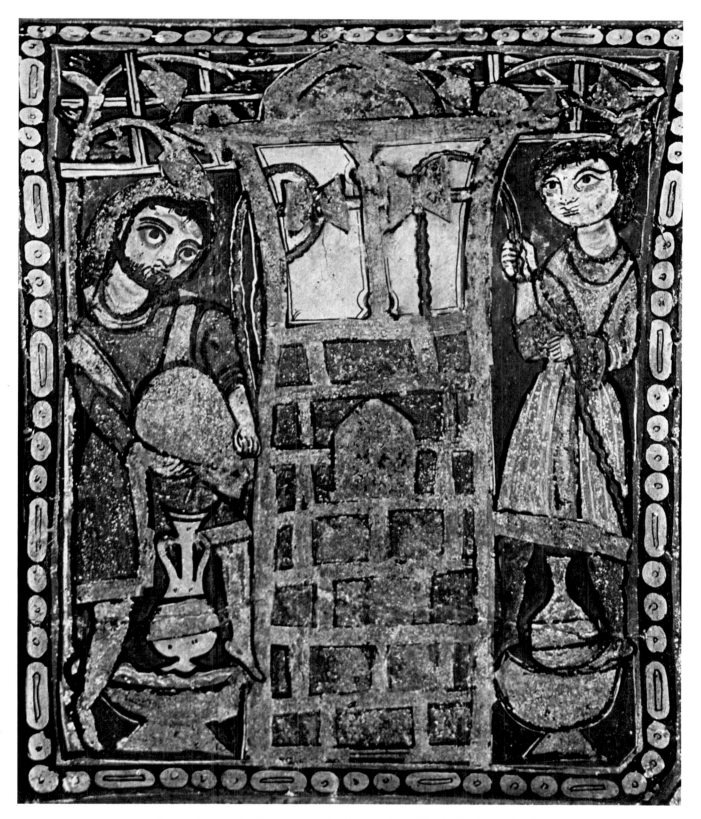

Scene at a Well, middle of the twelfth century. Painted Ceiling Panel.
Cappella Palatina, Palermo.

The theme of royal power appears as a secondary motif. The key here is again King Roger's Arabic robe with its representation of two powerful lions, each crushing a camel. Related motifs of a lion fighting a snake coiled around its body, or of an eagle clutching an antelope, rabbit, or smaller bird in its claws, occur in many places. While there are also representations of animals which are merely decorative, these larger, "royal" compositions, probably derived from designs on Muslim textiles, metalwork, or pottery, should be regarded as symbolical in the context of the whole church. Therefore, though these animals are involved in a crucial action, they have a static, monumentalized aspect, as if the awe-inspiring royal animal were perpetually to defeat its opponent by magic power. To this category belongs another, more complex picture in the same

Illustration page 46

style, which combines the theme of the victorious king with that of the ascension. Here an enormous eagle clutching two antelopes in its talons carries on its body a small figure whose royal bearing indicates that it is that of a ruler. This king is carried aloft to higher regions, which are indicated by two female figures apparently of angelic nature. It is a royal apotheosis, the highest form of glorification of a king, who like another Alexander is carried to heaven. The theme has both Western and Eastern associations, but since similar ascension motifs occur in this period in various Islamic media, its Muslim background, in spite of the king's classical garb, is as incontestable as its close relationship to the other paintings of the ceiling.

It is not possible now to say for certain who the artists were who painted these pictures. André Grabar has deduced from the painting of a church in the same ensemble that this particular picture could have been painted only by an artist who was neither Christian nor Sicilian. Ugo Monneret de Villard assumed in his large book about this ceiling that the style, which derives ultimately from Iraq, was at least in part due to immigrant artists who came from Mesopotamia. The solid-colored background used for the compositions supports this assumption since this feature is still to be found in Mosul paintings during the next century. It is also possible that Fâtimid Egypt provided artists, although Fâtimid style in the twelfth century was probably more advanced. A third and very real possibility is that the influence came from Tunisia because the old Iraqi style may have lingered there longer. Tunisia was also the country from which Sicily had originally been conquered and on which it had long been dependent, both politically and economically. Moreover, the Normans had established their sovereignty over that region; and Roger II even issued gold coins there in his name.

AS-SÛFÎ'S "TREATISE ON THE FIXED STARS"

Representations of the pastimes of the court should be regarded as displays of royal prerogatives, not as the flaunting of libertinism. Some rulers, in fact, were even concerned with scientific matters. Such an interest was of course not always academically detached, but sometimes aimed at the king's well-being, as is easily understood in the cases of medicine, pharmacology, and astrology. A dome with the constellations of the stars had already occurred in Qusayr 'Amra. The fixed stars interested also the powerful Buwayhid Sultân, 'Adud ad-Dawla, who about 960 charged one of his teachers, 'Abd ar-Rahmân as-Sûfî from Rayy in Iran, to compose a book on the subject. That such a royal concern

Treatise on the Fixed Stars (Kitâb Suwar al-Kawâkib ath-Thâbita) of as-Sûfî: Virgo, 1009 (400 A.H.). (223×147 mm.) Marsh 144, page 223, Bodleian Library, Oxford.

with astronomical matters was not unusual is shown by the attitude of the already-mentioned William II of Sicily, the same ruler who made such an effort to imitate Muslim kings. According to Ibn Jubayr he paid the greatest attention to astrologers and tried to entice every passing Muslim member of that profession to remain at his court.

As-Sûfî's treatise is a critical evaluation of earlier ninth century Arabic treatises, all of which go back to Ptolemy's classical work known as the *Almagest*. Like the classical models the texts of as-Sûfî (and of his Muslim forerunners) were illustrated with pictures of constellations. They continue the iconography represented by the *Atlas Farnese* and the illuminated manuscripts of Ptolemy and of the *Phainomena* by Aratos. The Bodleian Library's copy of as-Sûfî's treatise was written by his son after his father's holograph in 1009. This book represents, therefore, an earlier manuscript of c. 965; the general type probably existed already in the ninth century. Unlike the three-dimensional and more illusionistic classical prototypes, the Oxford manuscript uses a *linear* design around the red dots indicating the stars of the constellation because—as we know from a literary source—the author had traced his illustrations from the pictures on a celestial globe where they had been chased into the metal surface. These pictures represent a Muslim transformation of the classical originals, just as the text has been critically brought up to date. Since the human figures were often no longer clearly identified with the legendary Greek originals, the iconographic themes were reinterpreted and the constellations re-named. The stress is on the basic figures and the approach, being less mythological, is therefore more scientific. The physical types are Oriental, as is particularly marked in the figures of females. Even their styles of coiffure are the same as those found in Samarra and Palermo. Another revealing stylistic feature is the treatment of the garment folds, which is closely related to that of Samarra. Altogether, as has been aptly shown by Emmy Wellesz, this is another version of the Irano-Iraqi style, though definitely later than the Samarra paintings and, owing to its function and technique, of a more delicate nature.

Even more obvious is the Muslim character of the changes in iconography. Now most of the men wear turbans or, in one case, the tall *qalansuwa* cap. The most characteristic change in female figures is that they no longer display large areas of their nude bodies, but are fully clothed. Also, the constellation of *Canis* is turned into a Near Eastern *Saluqi* hunting dog and *Equus* receives wings borrowed from a Persian monster. Many figures lose their connection with Greek mythology altogether. *Virgo* traditionally had been shown as a winged figure, often holding ears of grain; sometimes she appeared as a half-nude Nike-like figure. In the Arab version she has none of these classical features.

Illustration page 51 If one were to characterize her attitude, one would think of her as dancing. Indeed, most of the figures, male or female, are represented as if they were involved in some specific step of a performance. *Hercules* is now actually called "the dancer." The most illuminating case in this respect is *Andromeda*. In late classical representations she had been shown as a nearly nude female figure with both hands fastened by chains to rocks at her right and left. In the Bodleian version the chains and rocks have disappeared and the figure is fully clothed, even having a second frilled skirt over the pantaloons. The richly bejewelled girl with her expressive hand lifted high and her fluttering garments might be the image

of an entertainer dancing before a royal audience. This transformation and the treatment of the various subjects indicates clearly how even a long-established scientific iconography was influenced by court art and its predilection for the royal pastimes.

Another Samarra feature, a bisexual attitude that had led to the near disappearance of sex differences, is even more strikingly found in the figures of this manuscript. Thus *Hercules*, like many of the female figures, wears a rich diadem in his full hair and while swinging a fanciful sickle-like sword he seems to be involved in an intricate dance.

Some of the animal constellations are more plastically rendered and are therefore closer to their classical prototypes. The majority of the illustrations are, however, executed in the linear style that distinguishes these text illustrations. By aptly merging and reinterpreting classical iconography and Iranian stylistic features in the skillful drawings, the artist was able to create a very specific style, which, like that of the paintings of Samarra and the Cappella Palatina, must be regarded as characteristic of this age.

THE EMERGENT AWARENESS OF THE EVERYDAY WORLD
(EGYPT AND IRAQ, 11th CENTURY)

From the middle of the eighth century on there took place in the caliphate a great internal change that reached its zenith in the second half of the tenth and the eleventh century. The Arab warriors rapidly lost their place as the leading members of a society that was increasingly directed toward peaceful pursuits. A new class of signal importance appeared: the merchants and artisans who now formed the middle class in the many urban centers throughout the Muslim world. Many industries flourished, producing especially textiles, but metal and ceramic objects as well. There was an enormous amount of trading within the Islamic world without regard to internal frontiers and this activity extended as far as India and China in the east and Europe in the west and north. There was a constant movement by caravan or sailing ship over distances that hardly seemed to matter. It was not only merchants who traveled, but also scholars, *littérateurs*, judges, and at times, even artisans. Muslim society became truly international; and during this process of constant cross-fertilization a relatively high degree of tolerance extended by Islam toward other religions opened up still other human resources.

The rise of an influential merchant class made itself noticeable in many quarters. New financial affluence resulted in political power; the caliph who founded Samarra had, for instance, two viziers who had been a miller and an oil merchant respectively. Literature abounds in statements about the high social and religious standing of the merchant class. It was also pointed out that the prophet Muhammad had come from a trading town and that the first caliph, Abû Bakr, had been a cloth merchant, and the third, 'Uthmân, an importer of cereals. The early prophets, too, had followed a trade: Noah had been a carpenter, Abraham a cloth merchant, and David an armorer. All this expressed the new status of the bourgeois class.

It was natural that the approach to the art of painting of this newly risen group would be different from that of the court. Instead of symbols of power and the prerogatives of the rulers, we now find an avid concern with the reality of everyday life; instead of a penchant for timelessness, a predilection for movement and action describing the singular event of the moment.

Two stories in the contemporary literature throw an illuminating light on this new attitude. The celebrated blind poet Bashshâr ibn Burd (c. 714-784) chided a glass blower of Basra for having applied an unsatisfactory design to a beaker and threatened to punish him by means of a satiric poem. This the glass blower knew he could prevent by in turn intimidating the poet with the prospect of painting his ugly face on the door of his house. Here is an early example of painting used for the personal objectives of a humble artisan living in an Iraqi metropolis. The painting itself would have been of individual character and based on observation; actually being a caricature, it exaggerated reality.

The second story refers to an artistic competition between an Egyptian and an Iraqi painter, arranged in the middle of the eleventh century by the Fâtimid vizier and collector

Wrestling Scene (fragmentary) on a Luster Painted Pottery Bowl. Egypt, Fâtimid Period,
eleventh or twelfth century. (Diameter 383 mm.) No. 9689, Museum of Islamic Art, Cairo.

of paintings, Yâzûrî. The Iraqi artist tried to outdo his competitor by announcing that
he would paint the figure of a dancing girl as if she were coming out of a wall. This
challenge was accepted by the Egyptian who proposed to show the same subject as if the
figure were going into the wall, which was thought to be the more difficult problem.
We learn that both achieved the illusion of movement by coloristic means, possibly also
by foreshortening. Here we have literary proof not only of how close the style and icono-
graphy of Iraqi and Egyptian paintings in the eleventh century must have been, but
also that the use of movement and observation was no longer restricted to the middle
class, but had affected the art of the court as well. This is precisely the reason for the
greater freedom of many of the post-Samarra paintings and the more pronounced concern
for the *mise en scène*. The story gives the names of the two artists as Ibn 'Azîz and Qasîr;

this is paralleled by the fact that it is also from this period that we have the earliest extant signed drawing, by one Abû Tamîm Haydara, who made it in tenth century Egypt. This presupposes that a new sense of self-importance imbued the painters, a phenomenon that is again corroborated by our story which tells us that Qasîr "had an exaggerated opinion of his work" and "demanded extravagant wages."

Illustration page 55

The new type of realistic painting is known to us mainly from figure designs painted on pottery or carved in wood or ivory from eleventh and twelfth century Egypt; more monumental examples either have been lost or remain to be discovered. A typical example is on a fragmentary bowl in the Museum of Islamic Art in Cairo. It shows a wrestling match between two bearded wrestlers of individual mien who are clad only in trunks. The exhibition of their art is witnessed by several turbaned people sitting or standing around; one of them to the left might even be the umpire. These spectators show their excitement by raising their arms in vivid gestures. Such a lively tableau must have been on view many times in the squares of the large and small cities of Egypt; but it was only in this period (eleventh century) that it was considered interesting enough to become the subject of a painting, and then it was placed on an object of potential use.

Illustration page 49

An example of how the new realism affected courtly painting is a scene in the Cappella Palatina that shows two men at a well. The young man on the right is operating a pulley to hoist a bucket of water, while the bearded figure on the left, standing further in the foreground, is handling a larger water container. In front of both of them stand various vessels indicating further activities. Since the whole scene is placed in a trellised arbor, the artist's interest goes beyond the mere action and takes in the whole *mise en scène*. This is only one of several genre-like scenes in the Palermo church, while others show buildings near which such genre actions might have taken place. All this forms part of the discovery of reality; or its rediscovery, as just such subjects had already been the themes of Pharaonic and Hellenistic Egypt.

The Flowering of the Art of the Book

2

Book of Songs (Kitâb al-Aghânî), volume 17: Enthroned Ruler with Attendants, detail.
Probably Northern Iraq (Mosul), c. 1218-1219. Feyzullah Efendi 1566, folio 1 recto, Millet Kütüphanesi, Istanbul.

GENERAL REMARKS ON THE MANUSCRIPTS
OF THE LATE 12th TO THE MIDDLE OF THE 13th CENTURY

IN any survey of pictorial representations extending from the early eleventh to the mid-twelfth century, one is struck by the fact that after the early auspicious experiments with realism no immediate further development seems to have taken place. It is not until the seventh decade of the twelfth century that a new burgeoning of picture-making takes place and then it is found in many media: metalwork, ceramic vessels, tiles, and stucco. At the end of the century this development gains further momentum, and at that time it is suddenly traceable also in manuscripts, the finest miniatures of which date mainly from the first half of the thirteenth century.

We can assume, however, that this flowering of book illumination began even earlier than 1200. There is, for instance, a Coptic Gospel painted in 1180 in Damietta in the Delta of the Nile (Bibliothèque Nationale, Copte 13), which is quite different from any other illustrated Coptic manuscript. Certain of its iconographic and stylistic features can only be explained as due to the influence of contemporary illuminated Arab paintings.

Although the surviving material is much more extensive and diverse than that of earlier periods, one is still very much aware of the great losses which must have occurred. No mosaics, frescoes, or other large-scale paintings that are later than the paintings on the ceiling of the Cappella Palatina of Palermo have survived in the Near East, with the sole exception of a large frieze with some rather poor variations in glass mosaic of the architectural and vegetal themes of the Great Mosque in Damascus. These decorate the Madrasa Zâhiriya in the same city and were executed in 1277. As to books, while there are certain works of which several illuminated manuscripts exist, others have come down to us in only one copy, even this sometimes in a fragmentary condition. Occasionally also we learn by chance of an illuminated text of which no other trace has been preserved. Thus Bishr Farès found a reference to an illuminated manuscript of ash-Shâbushtî's *Book of the Monasteries*, which a sixteenth century jurist-historian had seen in Damascus. This is a literary work of the tenth century dealing particularly with viticulture and the enjoyment of wine in taverns attached to monasteries. No copy containing miniatures has as yet been discovered. Sometimes no immediate clue can be found to the choice of certain books for illustration in the thirteenth century, such as, for instance, an Arabic text that shows figural designs representing chemical elements (*Muzhaf as-Suwar*, dated

1270; Istanbul, Library of the Archeological Museum, no. 1574). This makes the tracing of new material very difficult and discoveries are often made only by chance or after a tedious search.

In dealing with these miniatures, it becomes obvious that the methods of approach normally available to the historian of art are of little help with this limited, sporadic, and often undocumented material. We cannot establish groups according to regional schools because in many instances we have no idea where certain important manuscripts originated; nor do we have a single Muslim manuscript written before 1300 which can safely be attributed to such an important country as Egypt. Also, at the middle of the century a large-scale migration began to take place of artists and artisans seeking escape from the horrors of the Mongol invasion; these refugees continued to work for new patrons further to the west. This brought about a mixing of styles.

Manuscripts as a class present certain peculiar difficulties. When a text was copied older colophons or other inscriptions with dates might be taken over verbatim, and it is sometimes impossible to fix the date of a given manuscript, since too few securely dated volumes have survived to make possible the setting up of definite standards. Moreover, the copyist could for one reason or another use several manuscripts to establish a new text, and then introduce miniatures of different styles in a single volume. Even a division into two major subject groups—illuminations of scientific works and *belles-lettres*—cannot be carried through successfully, since the first group is at times influenced by the second. It seems, therefore, more instructive to present this material from the few surviving manuscripts according to certain formative principles, quite without reference to the place of origin. Even so a clear-cut division is not always possible, but we at least gain a better understanding of the creative forces which influenced Arab-Muslim painting in the High Middle Ages.

THE PRINCELY STYLE IN THE PERSIAN MANNER

Early Arab poets were fully aware of animals as literary subject matter, and their descriptions, particularly of horses and camels, reveal acute observation. The paintings of Qusayr 'Amra have shown us many realistically rendered animals: scenes of the hunt, others of a more decorative nature, and even one curious picture of a bear imitating human behavior by sitting on a stool and playing what seems to be a musical instrument. It is not surprising, therefore, that one of the earliest literary works in Arabic of a secular nature should have dealt with animals: a book of fables called *Kalîla and Dimna* after its main characters, two jackals. This book was the Arabic version of a much older Indian collection of animal stories attributed to a wise Brahman called Bidpai. The translator, Ibn al-Muqaffa' (died 759), did not work directly from the Sanscrit original, but from an intermediary sixth century Persian version. In the foreword the translator stated that he used animals to attract the interest not only of young people and common folk, but more specifically of kings, as the Indian book of fables had indeed been a "mirror for princes." Illustrations in various colors were said to have been used to increase the pleasure of the reader and to make the morals of the stories more effective. The hope was also expressed that the book might continually be sought after and repeatedly copied and illustrated.

Illustration page 190

Here then we have the case of a text specifically addressed to kings, illustrated from early Muslim times on, and based on an earlier Persian version which in all probability had contained miniatures in what must have been the usual courtly manner of the Sasanians. Unfortunately, no early medieval illustrated copies have come down to us. However, the animal illustrations in our most ancient *Kalîla and Dimna* manuscript, written probably in Syria about 1200 to 1220 (Bibliothèque Nationale, Arabe 3465), still preserve some of the formal hieratic aspects associated with a courtly style. Many of its miniatures are arranged in simple, balanced compositions, usually with an animal on either side of an axis which is sometimes imaginary and at other times established by a tree—altogether a definitely heraldic manner of presentation. There are also miniatures which represent animals in action, but these too are rather formal, and the anecdotal, transitory character is reduced to a minimum. However, in spite of their solemnity the animals have a natural and lifelike look. The gift of speech has, to be sure, been added, but even this is convincingly rendered as in the picture of the "King of the Crows in Council with his Advisors." The one example of a purely static treatment is the frontispiece. This shows a seated prince with a page standing on either side. The scene is placed on a red background, with the upper parts filled by stylized plants and a bird.

Illustration page 63

Illustration page 62

Since this miniature is not well preserved, the iconographic type is here presented by an analogous example from the twenty-volume set of *The Book of Songs (Kitâb al-Aghânî)* by Abu'l-Faraj al-Isfahânî finished after about four years' labor in 1219; of this work six volumes with such frontispieces have survived (volumes II, IV and XI,

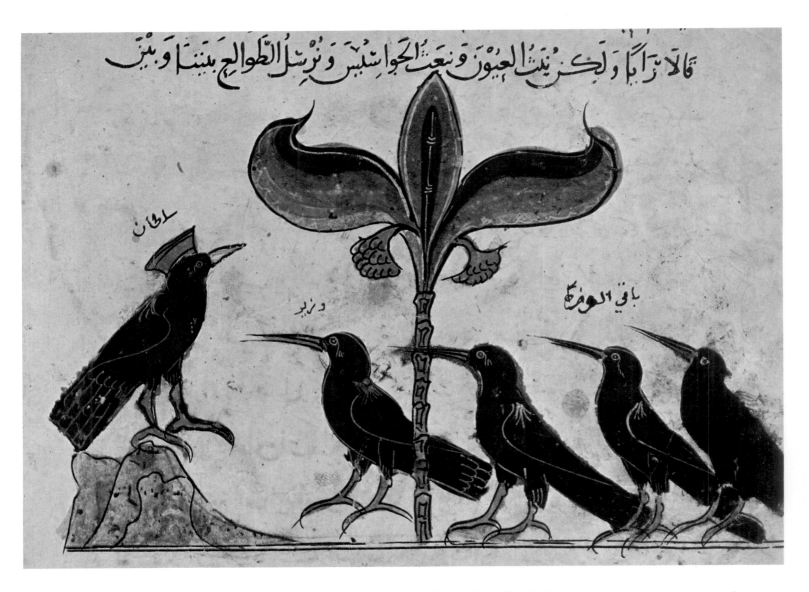

Kalîla and Dimna: The Council of the King of the Crows. Probably Syria, c. 1200 to 1220. (131×202 mm.)
MS. arabe 3465, folio 95 verso, Bibliothèque Nationale, Paris.

the latter dated 1217, National Library of Cairo, Adab 579; volumes XVII and XIX, Millet Kütüphanesi, Istanbul, Feyzullah 1565 and 1566; volume XX, Royal Library, Copenhagen, NO. 168). In five of these volumes a ruler is represented in one of his characteristic poses or pursuits: receiving dignitaries, drinking in the company of his courtiers, testing a bow and arrow, or setting out on horseback, alone in a formal landscape hunting with his falcon. Finally, the most unusual, but still appropriate frontispiece shows female members of the court dancing, playing musical instruments, and bathing. These paintings are formal in composition and manner of representation, even when the figures dance or make music, and this ceremonial character is emphasized by a wide, elaborate border (of which only the inner frame is shown here).

The frontispiece of the seated prince holding a bow and arrow in the company of Illustration page 65 eight pages is typical of this courtly style in the composition, which is symmetrical down to the three flower vases in the foreground; in the strict frontality of the ruler; in the rejection of all individual sound, expression, or gesture; and finally in the motionless attitude of the figures, typified in the arrested gesture of the ruler, who has stopped using his weapon and gazes out into the infinite. The importance of the central figure, shown in a rich blue coat with folds indicated in gold, is further stressed by his size, his royal bearing, and particularly by the two genii who float above him holding a scarf over his head. From the manner of presentation it seems clear that this picture and the others of the series are symbolic, and that they do not illustrate the texts which they precede. Apparently, however, the specific aspect of the ruler chosen for a particular frontispiece has in certain cases been suggested by the story that follows.

Kalîla and Dimna: The Lion and the Jackal Dimna. Probably Syria, c. 1200 to 1220. (125×191 mm.)
MS. arabe 3465, folio 49 verso, Bibliothèque Nationale, Paris.

Illustration page 65
Illustration page 45

A frontispiece showing the ruler drinking in a formal attitude and setting, occurred at least as early as the tenth century in a paper manuscript found in Egypt (Vienna, Nationalbibliothek, Chart. ar. 25751). A link is here evident between the Sasanian proto- types and the thirteenth century examples.

The treatment of the royal figure and his attendants naturally calls to mind the picture of the seated ruler in the Cappella Palatina made about seventy years earlier. The frontispieces are richer in detail and color; the figures are more numerous and they reveal a different ethnic stock, apparently Turkish—not too surprising a fact in view of the many Turkish rulers found throughout the Near East at this time. Since the prince is a non-Arab, his weapon is not the sword, the usual Arab symbol of lordly power, but the bow and arrow which are the symbols of such power in the regions further east. In any case, this picture of a Turkish ruler in a style which goes back to Sasanian art, but is now used to decorate a classical Arabic text, seems characteristic of the international and complex character of medieval Arabic civilization. However, the usual anonymity of medieval Muslim painting has been overcome; the corners of the inner frame contain a name: "Badr ad-Dîn ibn 'Abd Allâh," apparently the signature of the artist who created this particular illumination and perhaps also others of the set.

The precise meaning of these frontispieces has long been a subject of scholarly dis- cussion. Owing to their subject matter, one might be inclined to think of this as a royal manuscript and of the painting as representations of the historical figure who commis- sioned it. There is, however, no clear internal indication to support such a belief; nor is proof of a direct royal connection found in the Paris *Kalîla and Dimna*, or other manu- scripts containing courtly frontispieces. On the other hand, royal manuscripts are clearly designated as such. The conclusion to be drawn is that although a royal connection is not impossible, it is unlikely. However, literary works were usually commissioned by royal patrons (as for instance this very *Book of Songs*) and splendid copies continued to be made for other royal connoisseurs or members of the court. What we find then in this and related cases are probably copies after some royal archetype made for a well-to-do member of the middle classes living in one of the big cities. Such books are thus parallels to the pieces of metalwork with royal and feudal scenes which rich merchants had copied for themselves in obvious imitation of vessels made for the ruling class. Where this set of twenty volumes was made in the four years apparently needed for its completion is still a moot question. The close relationship with inlaid bronzes made in Mosul or in the Mosul manner and the use of a peculiar method of indicating garment folds found in Christian manuscripts of the Mosul region point to that important center in Northern Mesopotamia. At this period the Mosul region was under the sway of an Armenian who, having started his remarkable career as a slave, became a more and more dominant figure, and was finally recognized as king. It may therefore very well be that we have here an echo of pic- tures in which Badr ad-Dîn Lu'lu' himself was shown; at least the inscriptions on the sleeve bands indicate that this identification was made soon after the completion of the paintings.

The courtly type of frontispiece is not restricted to works of *belles-lettres*. Occasionally it is also to be found in scientific books. It occurs, for example, in two manuscripts

Book of Songs (Kitâb al-Aghânî), volume 17: Enthroned Ruler with Attendants.
Probably Northern Iraq (Mosul), c. 1218-1219. (Page: 306×220 mm., painting: 170×128 mm.)
Feyzullah Efendi 1566, folio 1 recto (frontispiece), Millet Kütüphanesi, Istanbul.

containing an Arabic translation of the *De Materia Medica*, the herbal of Dioscorides, which, though poorly preserved, still portray the Roman botanist enthroned with two other ancient savants flanking him at either side (Istanbul, Ayasofya, NO. 3704, thirteenth century; Bologna, Biblioteca Universitaria, cod. ar. 2954, dated 1244). Unlike the frontispieces in books of entertainment, which go back ultimately to Persian models and represent the continuation of the Irano-Iraqi style known to us from Samarra and Palermo, these portrayals and other representations found in scientific books are, like the texts they illustrate, based on Byzantine models.

BYZANTINE ART IN ISLAMIC GARB

It will be recalled that during the Umayyad period the two major elements of Arab painting were classical and Iranian; these elements existed side by side and, apart from a deliberate choice of subject matter, showed no Islamic slant. In the subsequent 'Abbâsid period the Iranian element became prevalent. During the new flowering of Arab painting which had its inception toward the end of the twelfth century, the classical element again predominates, this time by way of Byzantine inspiration. After a development of six centuries, the Arab world was able to integrate classical-Byzantine influences into its own scheme of things. This it achieved by keeping Byzantine iconographic types and many aspects of Byzantine style, at the same time adapting them to the Arab-Muslim way of life. This process is particularly apparent in the case of Greek texts translated into Arabic, for which illuminated Byzantine manuscripts with figural designs were available.

An analysis of the Dioscorides manuscript dated 1229 in the Topkapu Sarayı Müzesi in Istanbul (Ahmet III, 2127) illustrates this process. According to an entry in a decorative frame this manuscript was written for Shams ad-Dîn Abu'l-Fadâ'il Muhammad, who apparently ruled over Northern Mesopotamia and parts of Anatolia and Syria, but who has not otherwise been identified. The scribe, whose name indicates that he or his family came from Mosul, not only gives the date of execution according to the usual Muslim era but adds that of the Seleucid era as well, and even more unexpectedly, closes the colophon with a blessing in Syriac, hereby betraying his "Western" orientation. Everything indicates that the volume originated in Northern Mesopotamia or possibly Syria.

The first pictorial composition is a splendid double frontispiece, each part showing Illustrations pages 68-69 figures on gold ground within an arched frame (folios 1v, 2r). In the painting at the right a seated figure, apparently Dioscorides, is seen addressing the two figures on the opposite page who approach him from the left. Both of these standing figures carry books. The sage wears a classical garment, here combined with a turban, while his disciples appear in Muslim attire, though their physical appearance is not Oriental. That this dichotomy goes even deeper becomes apparent when one realizes that this is an Islamic interpretation of an author picture like that in the famous Byzantine Dioscorides manuscript written before 512 for the Princess Juliana Anicia (Vienna, Nationalbibliothek, Cod. Med. graec. 1). The botanist of the earlier manuscript sits in a similar chair with his foot on a stool, as here, but he is bareheaded and stretches his hand toward a young woman in classical garb, designated as *Heuresis*. This personification of Discovery is shown holding one of the most efficacious medicinal herbs, the human-shaped mandrake, to which a dog is tied; according to ancient beliefs this animal was used to extract the root and thus break the deadly effect of the plant. In the Islamic version allegory and superstition have been discarded. Undoubtedly one of the reasons for their deletion was that they were represented by such objectionable figures as a barefaced woman and a dog, the latter considered unclean by Muslims, the former to be improperly attired and also inappropriate

De Materia Medica of Dioscorides: Two Students. Northern Iraq or Syria, 1229 (626 A.H.). (195×140 mm.)
Ahmet III, 2127, folio 2 recto (left side of frontispiece), Library of the Topkapu Sarayı Müzesi, Istanbul.

De Materia Medica of Dioscorides: Dioscorides Teaching. Northern Iraq or Syria, 1229 (626 A.H.). (192×140 mm.) Ahmet III, 2127, folio 1 verso (right side of frontispiece), Library of the Topkapu Sarayı Müzesi, Istanbul.

as a source of inspiration. Replacing them are the dedicators of a Byzantine dedication picture, who appear in the frontispieces as Evangelists offering their Gospels to Christ or monks submitting their works to an emperor. This motif was, however, reinterpreted in a Muslim context. The relationship has now been changed into that of master and disciples, and the scene represents both the act of instruction and of certifying copies of the teacher's work that had been written by his students. This is apparent from Dioscorides' gesture of speech, and from the respectful manner in which the students approach him, holding a copy of the master's book; they hope to be allowed to submit it to him and to receive his statement of approval, so that they in turn can teach it. In other words, the scene symbolizes the chain of tradition stretching from classical to Islamic times.

One should not assume, however, that the double frontispiece is based directly on the Juliana Anicia Codex. The bulging garment folds across the body of the seated herbalist and the more elaborate form of the chair are not to be found there, and are known to us only from a later and different type of author picture, the Evangelist portraits at the beginning of eleventh century Byzantine Gospels. Small as these formal changes are, they provide sufficient proof that the frontispiece of the Istanbul manuscript is based on a later Byzantine prototype which had in turn reinterpreted the early sixth century version.

Illustration page 71 The next folio of the Arabic manuscript shows another treatment of the subject of Dioscorides and student, an indication that more than one model was available to the thirteenth century artist. In this single-page representation, the Roman Dioscorides has been transformed into a Muslim, and the un-Islamic chair replaced by the low stool found in later Byzantine paintings. On the other hand, the mandrake has reappeared as the object under discussion. This picture is less formal than the preceding one, but also lacks its coloristic splendor and fine facial drawing. Neither of the two compositions has any princely connotation, and the quality of the paintings is the sole indication of their aristocratic origin.

Of the other miniatures in this manuscript two more deserve to be discussed here. Both of them accompany the usual discussions of plants of medicinal value, but they Illustration page 72 represent opposing points of view. The "Grapevine" (fol. 252 verso) reproduces the organic growth of the plant from the roots to the last tendril. The color gradations of the individual leaves are carefully differentiated, and the veins in many are distinctly drawn. Every part moves freely in space, and in its very irregularity the whole is treated with illusionistic naturalism. It is a faithful copy of a classical type of illustration, so faithful indeed that if it were not painted on paper one would be inclined to regard it as a Greek "original" inserted into the Arabic volume. What is not clear at first is whether the model was early Byzantine (sixth century, if not earlier) or of the Macedonian renaissance (tenth or eleventh century). The naturalism and delicacy of the design and its full-page size support the attribution to the earlier date—all the more important from an historical point of view as this plant is missing in the Vienna codex.

Illustration page 73 The "Lentil Plant" (fol. 80 recto) stands in the fullest possible contrast to the classical "Grapevine." Here the whole painting is symmetrically composed. All corresponding

De Materia Medica of Dioscorides: Dioscorides and Student. Northern Iraq or Syria, 1229 (626 A.H.) (192×140 mm.)
Ahmet III, 2127, folio 2 verso, Library of the Topkapu Sarayı Müzesi, Istanbul.

De Materia Medica of Dioscorides: Grapevine. Northern Iraq or Syria, 1229 (626 A.H.). (235×195 mm.)
Ahmet III, 2127, folio 252 verso, Library of the Topkapu Sarayı Müzesi, Istanbul.

parts are identical and are shown with hardly any gradation of color; when given at all, the indication of the veins is purely schematic. Altogether the plant has the appearance of a decorative design whose precisely drawn elements might have been made with a stencil. The unorganic character is also demonstrated by the lack of a root (which would not have been consistent with the stylized design), and by the horizontal placing of the plant on the page in defiance of its natural direction of growth. Although Byzantine miniatures in Dioscorides manuscripts from the seventh century on reveal a trend toward simplification and stylization, this tendency is much more pronounced in the Arab version. One might even say that in its abstract quality the painting of the "Lentil" represents the Islamic form of the plant. That this process of

De Materia Medica of Dioscorides: Lentil Plant. Northern Iraq or Syria, 1229 (626 A.H.). (145×180 mm.) Ahmet III, 2127, folio 80 recto, Library of the Topkapu Sarayı Müzesi, Istanbul.

73

transformation proved to be so much more radical than the Islamization of the Dioscorides figures on folios 1 verso and 2 verso is natural because the Arab-Muslim artists were much more accustomed to design plants, and especially stylized vegetal forms, than to the drawing of human figures. The manuscript contains other examples of the same diametrically opposed renditions, and there are also, of course, plants which show transitional stages. Happily, several paintings are rendered in a pure Byzantine style (i.e. folios 6 verso, with a human figure; 67 recto, with animals; 96 verso and 97 recto, with plants). At least two of the plant pictures (and possibly many others) are the work of an Arab-Muslim artist as is indicated by the signature ʻAbd al-Jabbâr ibn ʻAlî as-S... on folios 29 recto and verso.

One may ask how it was possible for a manuscript of royal status such as this one not to achieve greater integration—to use, as it does, two different versions of the author picture, one directly following the other, and to present the plant illustrations in totally different styles. Copying from various sources, however, is a typical feature of manuscript production throughout the medieval world, East and West. Furthermore, to one familiar with Arabic literature the juxtaposition of source material is a familiar phenomenon. The texts of even the best known and most admired authorities, in the fields of history or natural science, for example, abound in passages where various mutually exclusive versions of an event or descriptions of a natural feature follow each other. Usually no effort is made by the author to select the best version; he simply closes the list with the statement "Allah knows best," whereby he divests himself of the responsibility of a critical selection and throws the final evaluation into the lap of God. It can thus be assumed that this dichotomous condition of the manuscript would not have disturbed the Arabic prince for whom the manuscript was made, even in the unlikely event that he should have had the critical eye of a connoisseur.

Finally, it may be stated with some assurance that if the pages of the Dioscorides of 1229 had become detached and brought to the art market at different times, most scholars would have attributed them to different manuscripts. The diversified aspect of this copy, therefore, teaches us two important lessons. First, that it is vital to understand the totality of a work of art. Secondly, that often the decisive factor of a manuscript is its prototype rather than the region of production; for the prototype can be imported or the artist can be an immigrant and will, therefore, be working in a different style.

The Choicest Maxims and Best Sayings (Mukhtâr al-Hikam wa-Mahâsin al-Kalim) by al-Mubashshir, an eleventh century writer on philosophical, historical, and medical subjects, presents other Byzantine themes in Arabic-Muslim transformation. This work was not directly translated from the Greek as was the Herbal of Dioscorides, but being based on the lives and sayings of such Greek sages as Homer, Solon, Hippocrates, Socrates, Aristotle, Pythagoras, Galen, and others, it relied almost exclusively on translations from Greek texts and dealt with classical subject matter. At least one illustrated manuscript is preserved (Topkapu Sarayı Müzesi, Ahmet III, 3206), though its discoverer, Franz Rosenthal, has pointed out the loss of some pages which apparently contained miniatures. This volume is not dated, but an inscription in gold on the title

The Choicest Maxims and Best Sayings (Mukhtâr al-Hikam wa-Mahâsin al-Kalim) of al-Mubashshir: Authors in an Ornamental Setting. Probably Syria, first half of the thirteenth century. (250×142 mm.) Ahmet III, 3206, folio 173 verso, Library of the Topkapu Sarayı Müzesi, Istanbul.

The Choicest Maxims and Best Sayings (Mukhtâr al-Hikam wa-Mahâsin al-Kalim) of al-Mubashshir:
Socrates and Two Students. Probably Syria, first half of the thirteenth century. (146×164 mm.)
Ahmet III, 3206, folio 48 recto, Library of the Topkapu Sarayı Müzesi, Istanbul.

page gives an historical clue, stating that it was written for a certain secretary of Atâbek
Ylmây who has, however, not as yet been identified. On the basis of the miniature
style, the manuscript should be attributed to the first half of the thirteenth century
and possibly to Syria.

The volume opens with a badly preserved double frontispiece that presents on each
page the half figures of seven sages, placed within a series of octagons and quatrefoils

created by an allover geometric pattern. While the sages are all shown in Arab-Muslim dress and within a Muslim configuration, their use as quasi-author pictures within a geometric frame at the beginning of a book is, like their number, a distinctly classical feature. Units of seven wise men form a standard iconographic group in the art of classical antiquity.

The double finispiece is better preserved. Here each page shows six full-length Illustration page 75 figures in a decorative framework which, though different from that used in the frontispiece, is of a type found elsewhere in Islamic art. The figures wear a wrap-like cloth over the head, much in the manner of Christian monks, but Muslim preachers, also, were in the habit of using a scarf of similar type to cover the turban. In contrast to the figures of the frontispiece, who are shown engaged in a number of different activities, those of the finispiece are all speaking. As their fervent expressions, powerful gestures and tense postures indicate, they are fully absorbed by the all-pervading power of the word. The upper and central figures seem to be facing upward and speaking with zeal. The significance of their upward look and passionate speech becomes clear, however— as does their total number, twelve—when we realize that these figures are based upon

The Choicest Maxims and Best Sayings (Mukhtâr al-Hikam wa-Mahâsin al-Kalim) of al-Mubashshir: Solon and Students. Probably Syria, first half of the thirteenth century. (102×178 mm.) Ahmet III, 3206, folio 24 recto, Library of the Topkapu Sarayı Müzesi, Istanbul.

representations of Old Testament prophets (or possibly of Apostles). Furthermore, as K. Weitzmann has pointed out, the Muslim artist would of course find the author pictures of a Byzantine manuscript (such as the two frontispiece pages, each with six Old Testament prophets, in a Turin manuscript) placed at what was for him the end of the book. This may have resulted in his placing his own groups of author pictures at both ends of the manuscript, one appropriate to Muslim usage, the other according to the Byzantine arrangement.

The al-Mubashshir finispieces are also remarkable as works of art. The figures are skillfully placed within the geometric framework, which in no way impedes their violent gestures or the inner drama which seems to be taking place. More unusual, in view of the Islamic predilection for two-dimensional design, is the concern shown for plastic quality in the artist's treatment of the figures. Still more remarkable, perhaps, is his power to imbue them with life, even with vibrant energy which finds expression in the motions of body, hands, and eyes. In this respect, these sages recall Romanesque book illuminations, especially the figures of the "Master of the Berthold Missal" from the Abbey of Weingarten, dating from the early years of the same century. Very rarely has an Arab-Muslim artist been able to impart such vitality and spiritual quality to a fully mastered figural design and to present so powerful a crescendo as the grand finale of his book.

The typical miniature within the manuscript shows a Greek sage facing a group of men to whom he is giving instruction. In some instances the master seems to be glancing at a book where pseudo-Greek writing appears, consulting an astrolabe, or holding a tool; but more often he is merely engaged in lively discussion with his students. All are shown in Arab garb, though a few of the sages wear the special head cloth already noted on the figures of the finispiece. There is no doubt that we are again confronted with an Arab transformation, this time of a Byzantine author picture in which an ecclesiastical teacher is shown with monks or other disciples. Although the inner tension of the al-Mubashshir text illustrations cannot match the spiritual quality of the finispiece, the characterization of the different personalities is ably done, while the vivid gestures of speech and the various, sometimes slightly exaggerated postures produce the impression of an intense discussion. All these features appear in the picture of Solon. In the miniature of Socrates we have a different iconographical situation. While the sage is still represented as speaking, he now assumes the dual role of speaker and thinker, and it is the characteristic pose of "thinker" that predominates. This figure type, again, has a long line of antecedents—the classical philosopher to start with, eventually, as Weitzmann has shown, transformed into an Old Testament prophet. That the process of Islamization is not quite complete is evident from the ill-fitting turban. Concern for emphasizing a foreign origin, on the other hand, is responsible for the reddish blond beard given to Solon by the artist, in vivid contrast to the hair and beards of the auditors.

The same postures and gestures recur frequently throughout the manuscript, and might therefore seem to offer a somewhat stereotyped repertoire. But they are so ably combined that each picture, seen by itself, creates the impression of a unique event, presented in a natural manner. At the same time, the boldness of color and the omission

Illustration page 77
Illustration page 76

Assemblies (Maqâmât) of al-Harîrî: Abû Zayd addresses an Assembly in Najrân (Forty-second Maqâma). Probably Syria, 1222 (619 A.H.). (157×205 mm.) MS. arabe 6094, folio 147 recto, Bibliothèque Nationale, Paris.

of all unnecessary detail within an interior or landscape adds to the distinct impression of a certain monumentality which these paintings, small as they are, succeed in conveying. Indeed it is by bridging the contrast between a lively transitory event of human interest and a grand manner of presentation that the artist has created the special quality of these Arab-Byzantine paintings.

In view of the powerful influence of Byzantine art on the book illustrations of the early thirteenth century it is not surprising to find that the same source affected also a piece of Arab literature which owed nothing to classical tradition. This was the eminently popular *Assemblies* or *Maqâmât* by al-Harîrî (1054-1122), the fifty chapters of which take

Illustration page 79 place in various Arab or other Muslim milieus. Thus, if we look at a characteristic minia-
ture from an al-Harîrî manuscript dated 1222 (Paris, Bibliothèque Nationale, Arabe
6094), we are at once struck by what H. Buchthal has called its "Hellenistic" aspect.
There is the rather grave mood which distinguishes so much of Byzantine painting. The
face of the bearded figure on the left who represents the main character, Abû Zayd, is
rather Byzantine, and this aspect is all the more obvious in that he appears in the head
scarf used by Christian monks. The treatment of the folds, particularly in the garments
of the two figures on the left, is still to some extent classical in spite of the fact that the
soft gradation from light to shade has disappeared and the rendition has become rather
harsh. For the architecture, the tripartite background scheme so frequently encountered
in Byzantine painting and mosaics is used, and also the characteristic central arch.
Finally, taking the scene as a whole, one could easily assume that its iconographic proto-
type was, as K. Weitzmann has pointed out, the New Testament event of the "Washing of
the Feet": Abû Zayd assumes the role and posture of Christ and approaches the figure
represented in the characteristic pose of Peter, while the figures behind him could well
have been Apostles.

Illustration page 77 By introducing an architectural background, the painter has stressed the locality of
the action. In this respect the scene differs from the al-Mubashshir miniature of "Solon,"
which takes place in an interior, though in other ways the two are iconographically and
stylistically related. However, this background is still symbolic rather than specific. The
figures lack any relationship to the architecture, which is purely two-dimensional and
indeed so untectonic in character that it might have been constructed out of pieces
of cardboard. There is only the barest indication of ground, and as yet no frame to
contain all the figures.

Unfortunately, this is again one of the manuscripts concerning the origin of which
we have no specific information. Nor do the closely related figural scenes in the *Kalîla
and Dimna* manuscript in Paris, referred to earlier, provide any clue. H. Buchthal has
made out a strong case for a studio in Northern Syria, a hypothesis which has been
generally accepted.

THE ARAB-MUSLIM CONTRIBUTION

The preceding pages have traced the significant contribution made by certain extraneous elements, Iranian and Byzantine, to the newly flourishing art of Islamic miniature painting. But before foreign models could be accepted to such a degree there had to exist an intellectual attitude within the Arab mind that allowed for a much broader use of miniature painting. The question is: What could have brought about this new readiness for figural illustrations?

There is probably no simple answer to this question. Seen from a wider perspective, certain general conditioning factors must have existed. To these might have belonged the long and effective rule of some outstanding personalities who directly or indirectly prepared the ground for this new efflorescence. The able 'Abbâsid caliph an-Nâsir (1180-1225) might have been one, or the regent and later king of Mosul, Badr ad-Dîn Lu'lu' (1218-1259). Outside the courts, the wealthy merchants must have been large-scale buyers of artistic products. This is proven by the many non-royal objects known to us. It is also indicated by the continued emphasis given in the Arabic literature just prior to this period to the importance of the merchants and other groups within the bourgeoisie, an attention that reflects their acceptance as a class of vital significance. This sentiment is paralleled by persistent praise of the great cities in the Arab world. They had passed their greatest prosperity, but as in other civilizations, this period of initial decline was also one of increased artistic prosperity. The figural art created in these urban centers continued the realistic manner in use in Egypt as early as the eleventh century.

Two additional factors seem to have served as catalysts. First, as we know from brief references in contemporary literature, there was a sudden surge of the popular dramatic arts—Shi'ite passion plays, puppet theater, and shadow plays, the last perhaps the most significant in this context. Indeed, when one hears of performances of shadow plays showing scenes of camels marching through the desert, ships plowing through the seas, land battles with foot soldiers and horsemen, ships with sailors climbing up the masts, fortresses attacked with siege machines, fishermen with nets, and bird catchers with slings, we come very close to the action shown in the miniatures. These plays, like the manuscripts, also included, of course, more ordinary scenes between two or more figures. Such a relationship seems all the more significant when we realize that the shadow figures were made of multicolored hide, held against a white screen, and thus were in their physical appearance not too different from the miniatures. Finally, there is from more recent times at least one piece of evidence showing the effect of shadow figures on book illustrations; a *Kalîla and Dimna* manuscript in Istanbul of the eighteenth century (Istanbul, Library of the Archeological Museum, NO. 344) that definitely betrays the influence of the Turkish *karagöz* figures.

The second factor was the great popularity of the *Assemblies (Maqâmât)* by al-Harîrî. This work was widely appreciated by the educated because of its linguistic ingenuity. It also provided a hero with a popular appeal: the erudite and wily rogue,

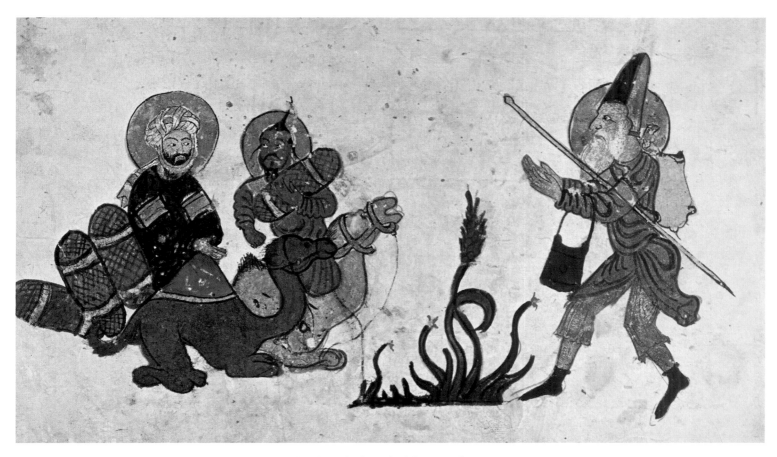

Assemblies (Maqâmât) of al-Harîrî: Abû Zayd leaves al-Hârith
during the Pilgrimage (Thirty-first Maqâma). Second quarter of the thirteenth century. (92×188 mm.)
MS. arabe 3929, folio 69 recto, Bibliothèque Nationale, Paris.

Abû Zayd, who lived by his wits, and in clever defiance of the official moral code managed to overcome the insecurity of urban life. In some respects he seems to be the literary equivalent of the somewhat later "robbers" *('ayyârûn)*, who in the great cities of the Muslim world, especially Baghdad, in the middle of the twelfth century, tried to exercise a leveling form of social justice by equalizing property and counteracting the efforts of the authorities to maintain order. Although in literary make-up the *Assemblies* have been thought to represent an approach to the dramatic style, we do not know of any popular theatrical versions based on the experience of an unscrupulous vagabond such as Abû Zayd in puppet shows or shadow plays of the twelfth century. But if plays using such subjects existed the texts were probably not often written down, because, being created for the entertainment of a rather uneducated audience, they did not require high literary exactitude. Unfortunately, neither the texts nor shadow figures of the twelfth century have survived. However, the three shadow plays from the second half of the thirteenth century which did survive, have led orientalists to see in them an apparent dependence on al-Harîrî's work. All this leads to the assumption that when, in the latter part of the twelfth century, a flowering of the popular arts, especially of the shadow

plays, took place, these may very well have treated subjects related to the *Assemblies* of al-Harîrî; in turn, these productions served as inspiration for a large body of manuscript illuminations, especially for the famous *Maqâmât*.

When, with this hypothesis in mind, we now look at one of the miniatures of a *Maqâmât* manuscript of the second quarter of the thirteenth century (Bibliothèque Nationale, Arabe 3929) it is not hard to visualize as its models the groups of figures and dramatic gestures peculiar to shadow figures or puppets. Even the little plant in the center looks like a piece of stage property used to mark a locality; it therefore does not form part of a general ground line, nor has it any connection with the adjoining figures. In any event, this painting with its vivid characterization of Abû Zayd has nothing of the derivative Byzantine aspect of the *Maqâmât* miniature of the manuscript dated 1222 in the same library. Unfortunately, this is again one of the many Arabic manuscripts of this period that contains no information as to place of origin or date. Its style betrays a connection with the art of Mosul in Upper Mesopotamia, although it is not yet possible to give it a precise location. Its date is the second quarter of the thirteenth century and possibly the later part of this period. Illustration page 82

Illustration page 79

When we consider the new realism of the late twelfth and thirteenth century, it becomes at once obvious that the greater intimacy provided by a book page allowed refinements that a small and distant ceiling panel, or a round, concave dish, could not easily furnish. Given these better conditions, and in particular the new cultural impetus, the earlier realistic approach developed quickly into genre painting. This tendency becomes clear when we examine a miniature in the manuscript of the *Book of Antidotes* (*Kitâb ad-Diryâq*) written in 1199 by an unknown late classical author referred to as Pseudo-Galen or Pseudo-Joannes Grammatikos (Bibliothèque Nationale, Arabe 2964). The picture illustrates a story of the physician Andromakhos who used to come to the fields to supervise his peasants while his servant brought them food. One day a decomposed snake was found in the sealed jug containing a beverage which afterward served as a cure for a leper. The illustration depicts a scene in the fields, in which, however, the main figures of the story, the physician and the servant carrying the all-important food, jug and tray, occur only in the background, in the upper left corner, while the tillers, also referred to in the text, occupy the corresponding section on the right. The larger part of the painting is thus devoted to various agricultural activities not mentioned by the author. They appear in the natural progression of farm work: after the tillers comes the harvester, who cuts a plant with a sickle, then a man with a threshing device pulled by two bullocks, after him two peasants, who winnow and sift grain, and finally, a small donkey which brings or takes away another load. All these scenes are based on acute observation, and careful attention has been given to such details as the movements characteristic of various types of work, the tools used, and the different garments. Only the round discs behind the heads, which in this period are often used to stress the significance of this part of the body (even of birds), are a direct continuation of a Byzantine iconographic feature, although the connotation of saintliness has not been taken over. But even this motif has changed: around some of the haloes are colored and Illustration page 84

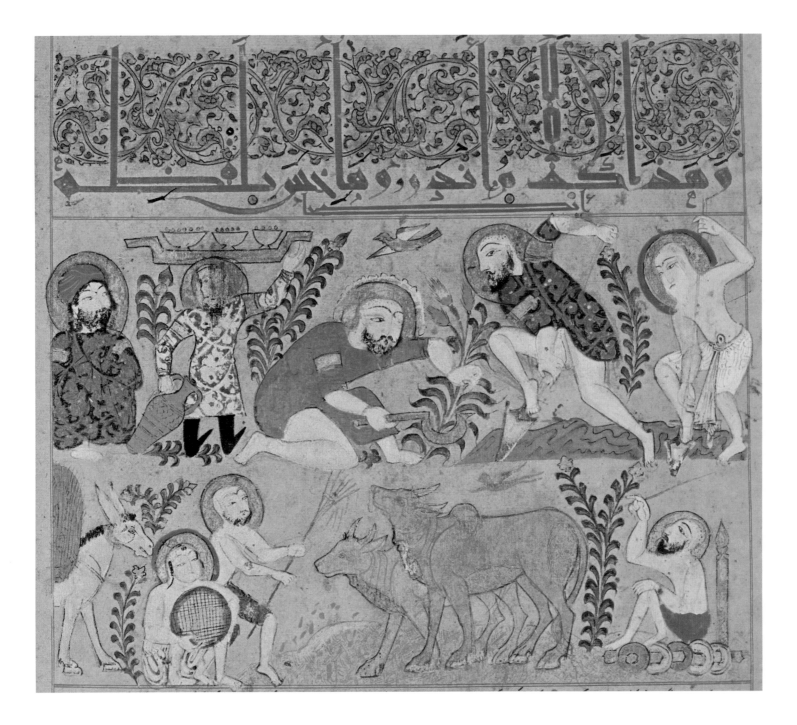

Book of Antidotes (Kitâb ad-Diryâq) of Pseudo-Galen: The Physician Andromakhos watches Agricultural Activities.
Probably Northern Iraq, 1199 (595 A.H.). (140×210 mm.) MS. arabe 2964, old page 22,
Bibliothèque Nationale, Paris.

84

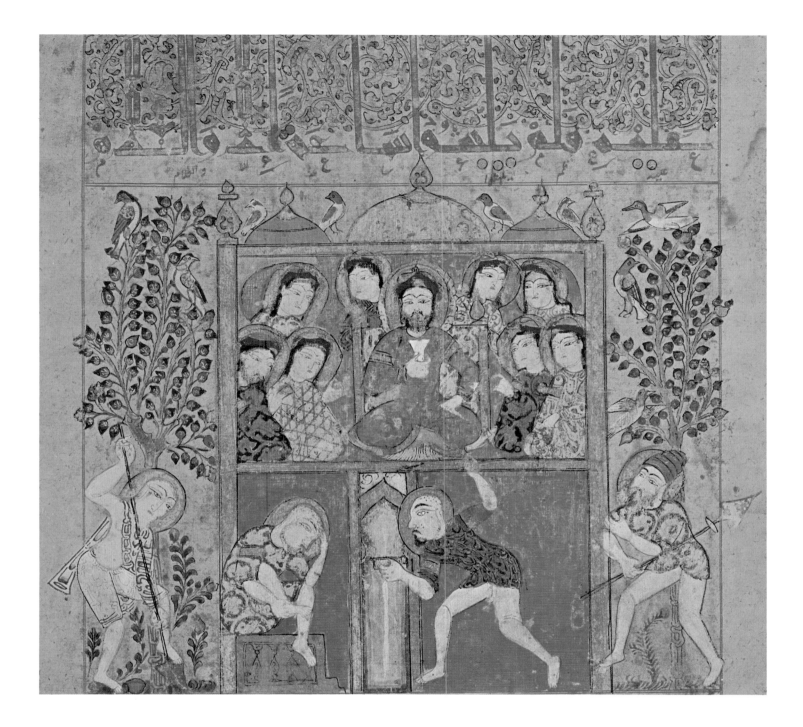

Book of Antidotes (Kitâb ad-Diryâq) of Pseudo-Galen: The Poisoned Favorite at the King's Pavilion,
revived by a Snakebite. Probably Northern Iraq, 1199 (595 A.H.). (165×210 mm.)
MS. arabe 2964, old page 27, Bibliothèque Nationale, Paris.

floriated edges, an indication that a further development has taken place. Only in two aspects does the miniature show decided limitations, at least from the modern point of view. There is little understanding of space. Some realization of it is apparent in the threshing scene, and the winnower stands behind the sifter; otherwise each figure is placed by itself in the picture plane. Moreover, as Bishr Farès, the discoverer of the manuscript, has pointed out, the spatial relationship of the two superimposed registers is still the same as in Assyrian reliefs. Secondly, the figures are merely given in an additive fashion, one action taking place next to the other without any connection between them. Apart from the dovetailing of the figures in the composition and the progression in the work and its common rhythm, there is no interrelationship between the figures. This inclination of stringing together isolated elements (a tendency sometimes called "atomistic") is, moreover, stressed by placing a plant or other dividing motifs to separate the groups. The colors also, with their somewhat spotty handling, contribute to the impression of discontinuity. These stylistic features make the miniature look rather like a figural sampler of agrarian themes. But far more important than these compositional limitations is the extension of the iconography. We must assume that the artist worked in an urban center; still he reveals a marked interest in agrarian activities, indeed, so much that he went beyond the illustrative necessities. This novel concern with peasant work is, however, to be found also elsewhere in contemporary Iraqi art, as it occurs in the inlaid scenes of metalwork and pottery.

Apart from its pronounced genre aspect, the miniature has claims to consideration as a cultural object. Many of its inscriptions, some of them in beautifully executed *Kûfic* script, make it clear that the book was written and apparently also illustrated by a Shiʿite scribe for his nephew. Both men belonged to a family of high religious standing, as is indicated by the frequent occurrence of the title "imâm" in their lineage. Proof is thus given that members of the middle class, even of theological distinction, owned and appreciated illuminated books and apparently no longer had religious compunctions against their use. Unfortunately, we do not know the town or the region where the manuscript was executed; it seems, however, reasonable to assume that it was made in Iraq, most probably in the northern part.

Several manuscripts of this period combine Persian, Byzantine, and Arab features. Sometimes these elements appear separately in different miniatures, but there are also single paintings where two or more strains are skillfully blended.

As early as the ninth century Byzantine illuminators of Dioscorides manuscripts had occasionally added human figures to the usual paintings of medicinal herbs, in order to point to an affliction against which the particular plant was efficacious or to show how it was best collected and prepared as a drug. The first appearance of such "explanatory figures" in an Arabic Dioscorides manuscript is in a volume written in 1083,

De Materia Medica of Dioscorides: The Pharmacy. Baghdad (Iraq), 1224 (621 A.H.). (135×174 mm.)
No. 57.51.21, Metropolitan Museum of Art (Bequest: Cora Timken Burnett), New York.

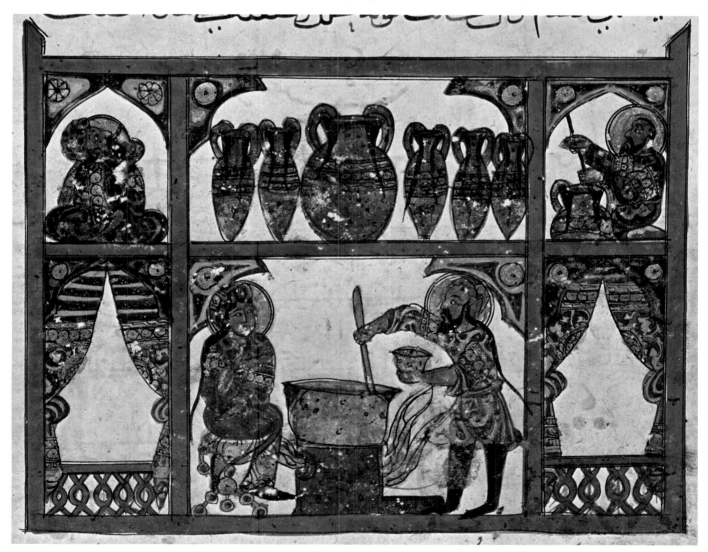

which was based on a version of 990 (Leiden, University Library, Or. 289, Warn.).
In these early Byzantine and Arab volumes the human figures are still awkwardly
placed and too small in relation to the plants. However, a series of miniatures in a
manuscript of 1224 (Istanbul, Ayasofya, NO. 3703) shows a further stage in the develop-
ment of these illustrative accretions. While some are still fairly close to the Byzantine
prototypes, others have become true, well-balanced genre scenes. This applies parti-

Illustration page 87

cularly to the many paintings showing the production of medicinal concoctions. In
addition there are scenes, such as the treatment of patients or a gathering of physicians,
which might be based on illustrations in other Byzantine manuscripts; but these, too,
are rendered with much greater realism. A third group is entirely "Arab" in conception,
such as landscape settings in which a certain plant is growing, or the weighing of a drug
is taking place in a well-equipped pharmacy in the bazaar. It is quite unlikely that all
of these new iconographic subjects were invented for this or a similar manuscript; some
could easily have been derived from various other illustrated Arab manuscripts such
as the *Maqâmât*. Owing to a felonious act these paintings were among the first Arab
miniatures to come to the attention of the West. This happened because, sometime
before 1910, about thirty-one leaves were cut out of the manuscript in the Istanbul
Library and then sold to public and private collections throughout the world.

Illustration page 87

A typical example of such a genre scene added to a text which did not call for it,
is the picture of a "Pharmacy" now in the Metropolitan Museum of Art. In the lower
story of the shop a pharmacist is at work heating a concoction made with honey; he is
watched by a seated youth. The major part of the upper floor is used for the storing of
large jars, one of which is being tested by an attendant. The figure on the left is singled
out by his meditative attitude as a physician, the master-mind of the whole workshop.
In spite of well-observed détails of human behavior and obvious interest in the *mise
en scène*, the painting still lacks any understanding of space as such. Actually in its
flatness and in the organization of the architectural framework and even in the character
of its figures, it recalls the stage setting of a shadow play.

Illustration page 89

While the prototype of the "Pharmacy" might very well have been a tavern scene
such as we find in *Maqâmât* manuscripts, the illustration accompanying the chapter
on the plant "Atrâghâlus" (from the Greek *astragalos*) reveals a different type of trans-
formation, which is due to the influence of another source. The plant itself is rendered
in the usual manner: root, stems, and leaves. But instead of being placed in abstract
space, as was done in Byzantine manuscripts and in Arab volumes following the
Byzantine tradition, the plant is now combined with a hunting scene in which a fierce
dog emerges from behind a range of hills to pursue a fleeing gazelle. There is no obvious
reason why such a subject should have been introduced in conjunction with the plant.
On the other hand one notes that several miniatures in the same manuscript combine
a plant with a bird or two, or with a grasshopper, butterfly, and rabbit, while one other
illustration shows a bird being pursued by an eagle. Without resorting to the more
extreme forms of humanization found in the "Pharmacy" the artist nevertheless reveals
in all these miniatures a manifest wish to enliven the plant illustrations.

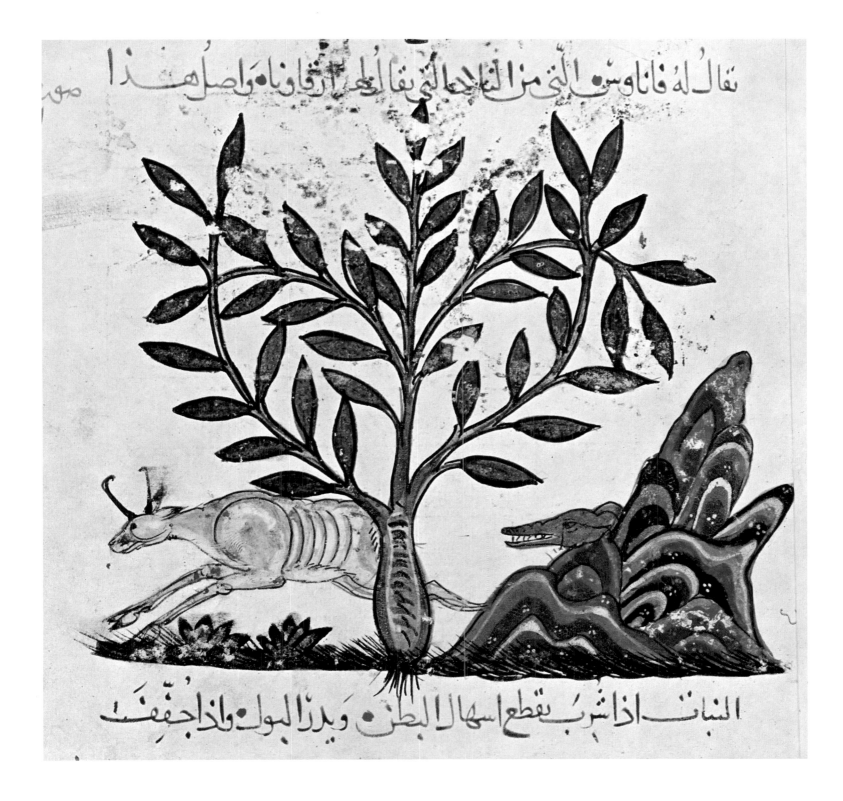

De Materia Medica of Dioscorides: The Plant Atrâghâlus combined with a Hunting Scene.
Baghdad (Iraq), 1224 (621 A.H.). (160×193 mm.) MS. 3703, folio 29 recto, Ayasofya, Istanbul.

Animal accretions without any textual basis had occasionally occurred in mid-Byzantine Dioscorides manuscripts, but in the Ayasofya volume the Islamic artist benefits from a surer sense of composition and achieves a more pleasing decorative effect. Animals pursuing each other also occur elsewhere on Islamic objects of this period. Whole friezes of them, for example, are commonly found on Islamic metalwork, a fact that demonstrates the continued popularity of an age-old motif. In these cases the animals occur without landscape elements, and their corporeality is less pronounced. Illustration page 89 In the Dioscorides miniature, however, the rendering of the gazelle's body and the position of its legs reveal a full awareness of the three-dimensional quality of the subject. Furthermore, the low plants as well as the piles of roughly triangular hill forms with their folded layers—abstract though they are—present an important element in the composition. They have the added function of helping one visualize an earlier stage in the action: the dog fiercely rousing its prey and the gazelle bounding out into level country where it can hope to escape in unimpeded flight. The verisimilitude of the action and the stress on the setting make it quite likely that the iconography of the hunting scene derives from a painting in a manuscript. As we are dealing with a classical work, the elements from a foreign source that at one point in the development intruded into the scene might very well have been contained in an illuminated Byzantine text on hunting. A likely source would have been Pseudo-Oppian's treatise on *The Chase with Dogs*. A well-illustrated eleventh century copy of this work in the Biblioteca Marciana of Venice (Cod. gr. 479) does indeed contain realistic and lively scenes similar to the Arabic painting, which is, however, on a grander scale.

The combination of plant and hunting scene results in a happy fusion of two disparate elements which supplement each other. Although the *atrâghâlus* (a ground shrub with a radish-like root) is actually too large for the context, the tree-like character imparted to it provides the composition with a central axis; it also fills the otherwise empty space above the hunting scene and thereby establishes the near vertical format of the Baghdad school which differs from the broader compositions of the contemporary Persian and Mosul schools. Moreover, the plant—no longer floating in space, but rooted in the ground of the supplementary scene—actually seems to have become an integral part of the landscape with its spirited action, because the painter has put the *atrâghâlus* into a spatial relationship with the running gazelle. A static plant illustration has thus become part of a dramatic event; and through this combination of pure science with an ever-popular Arab sport, the painting undoubtedly gained in human appeal.

The Dioscorides manuscript of 1224 is unique among scientific manuscripts owing to its decorative charm, the freshness of the artist's perception, and the genre character of its paintings. This makes its place of origin a matter of special interest. Although the colophon gives no indication of where this may have been, H. Buchthal's researches leave little doubt that it was in Baghdad that the volume was written by the scribe, one 'Abd Allâh ibn al-Fadl, and illustrated by the unknown artist.

A skillful combination of the courtly Iranian style and of Arab genre painting is found in the Paris manuscript already referred to dealing with *Antidotes* by Pseudo-

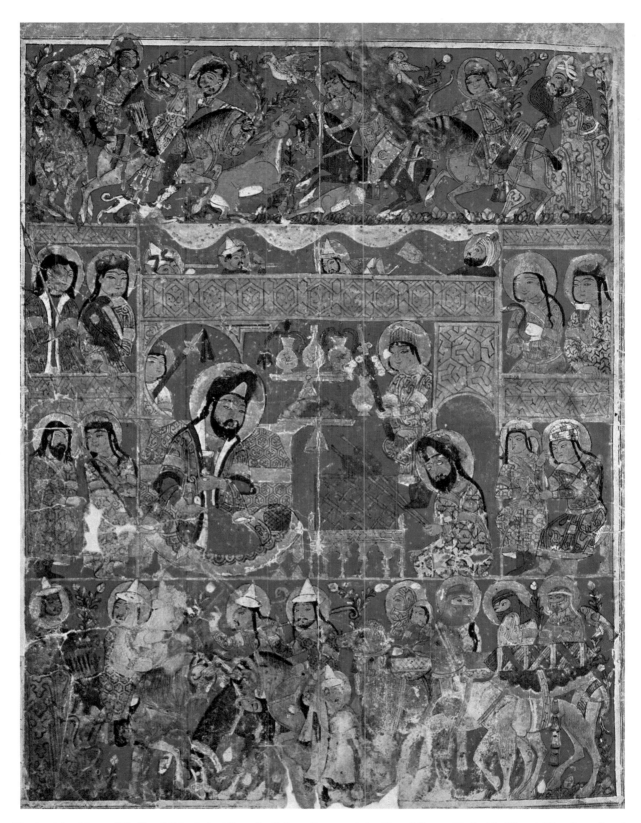

Book of Antidotes (Kitâb ad-Diryâq) of Pseudo-Galen: Scenes of the Royal Court. Probably Mosul (Northern Iraq), middle of the thirteenth century. (320×255 mm.) A.F. 10, folio 1 recto, Nationalbibliothek, Vienna.

Illustration page 85 Galen, written in 1199. One of its miniatures illustrates the story of how the favorite of a king had been poisoned by his enemies and then shut up in a garden pavilion. There he was bitten by a snake whose venom acted as antidote, so that he revived and was rescued. In the painting the victim is seen rubbing his bitten foot, but his posture indicates that he is still under the influence of the poison. He is rescued by two gardeners who rush in from the right, one of them still holding his spade. Both wear the scant clothing usual for their occupation. A third gardener behind the pavilion is unaware of these happenings and continues his work. In the upper story the king is seen drinking in the company of his courtiers. This being a courtly subject, it is executed in the appropriate Iranian Illustration page 65 style used also for the frontispiece of the *Book of Songs* manuscript in Istanbul. There is a vivid contrast between the strict symmetry of this composition with its frontally seen king and motionless figures and the commotion, vivid gestures, and realistic details in the genre scene below. The two strains are well blended, however, and are held together by the framing trees at the sides. Actually in the process of harmonizing the two basic manners the miniature has achieved greater inner cohesion than is evident in the "purer" Illustrations pages 84, 87 agricultural scene of the same volume; but like the "Pharmacy" of the Dioscorides manuscript of 1224 it makes no attempt toward a representation of spatial depth.

Illustration page 91 The frontispiece in another manuscript of the *Book of Antidotes* presents a royal scene as the subject of its central portion (Vienna, Nationalbibliothek, A.F. 10). Here, too, the king is drinking and surrounded by serried rows of courtiers. But certain definite changes are to be noted. The innovation is not that the king is now seated on the left to make room for another figure, since this is the scheme for audience scenes already known to us from inlaid metalwork. It is rather that the seated man in front of the king is preparing some roasted meat over a grill, a pleasant subject, but hardly a formal one. One of the attendant figures in the lower left has also dared to turn his head as if to whisper a word to his neighbor. Furthermore, we can observe the figures of four workmen behind the palace, all of whom are engaged in some ordinary labor. Realistic details of daily life have therefore entered this scene, and the formal spell is broken. To underline this further two scenes have been added, a hunting scene above and a group of horsemen and of women mounted on camels below. These, it might seem, are projections of the courtly life; but in their unrestrained attitudes they are again at variance with the rigid protocol which had governed the frontispieces of strictly Iranian style derived from Sasanian rock reliefs or silver plates. The two scenes in the top and bottom registers differ in style and format from the usual representations in Arab manuscripts. They may be strongly influenced by contemporary Seljuk Persian paintings like those of a similar horizontal format in the recently discovered *Varqeh and Gulshâh* manuscript in Istanbul (Topkapu Sarayı Müzesi, Hazine 841). Unfortunately, this second *Book of Antidotes* is not dated. It may be assumed to be from the middle of the thirteenth century and is generally thought to have been executed in Mosul. Such an attribution would also explain the inclusion of contemporary Persian elements. We know, for instance, from signed objects that Mosul had attracted Iranian metalworkers who had been dislodged by the Mongol invasion.

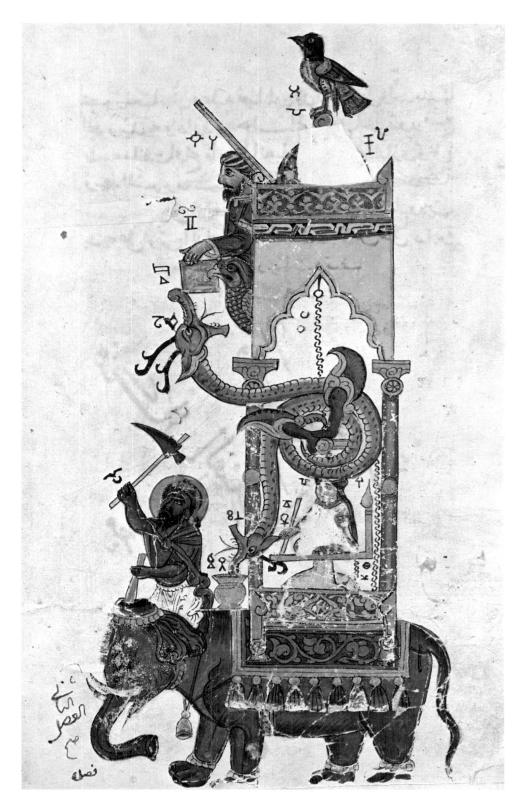

Book of the Knowledge of Mechanical Devices (Kitâb fî Ma'rifat al-Hiyal al-Handasiya) of al-Jazarî:
The Elephant Clock. Probably Syria, 1315 (715 A.H.). (310×219 mm.)
No. 57.51.23, Metropolitan Museum of Art (Bequest: Cora Timken Burnett), New York.

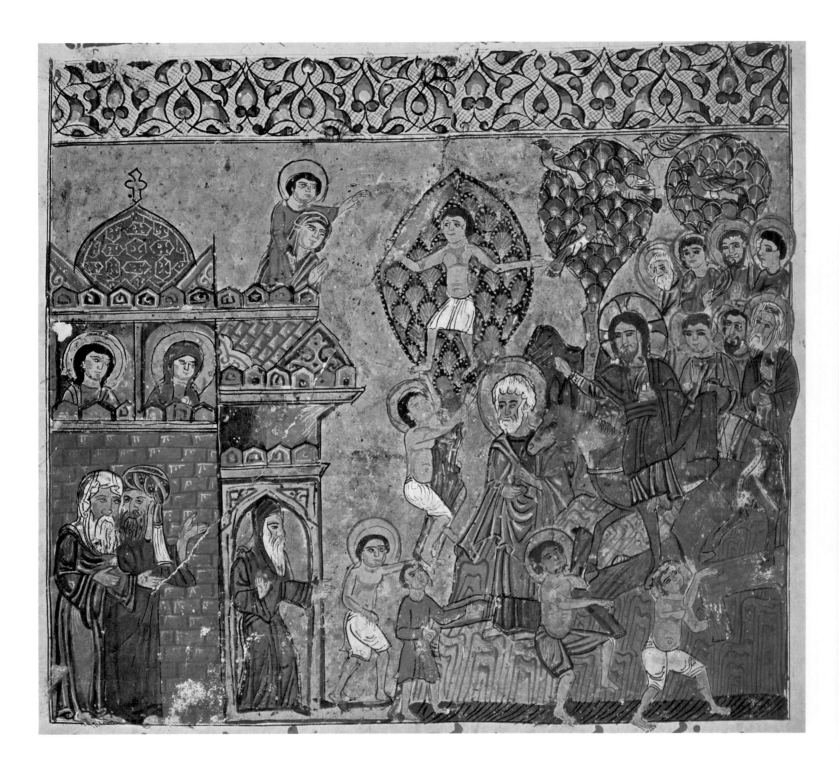

Jacobite-Syrian Lectionary of the Gospels:
Christ's Entry into Jerusalem. Monastery of Mar Mattaï near Mosul (Northern Iraq), 1220 (1531 Seleucid Era).
(220×250 mm.) MS. siriaco 559, folio 105 recto, Biblioteca Apostolica, Vatican.

The interplay of various cultural strains is more complex in the illustrations of a technical treatise which, to judge from its many copies, proved to be very popular. The Artuqid Sultân, Nâsir ad-Dîn Mahmûd (1200-1222), who resided in Âmid in northern Mesopotamia, had admired the various mechanical contrivances built by his court engineer, and so asked him in 1206 to write a book about them. The result was al-Jazarî's *Book of the Knowledge of Mechanical Devices (Kitâb fî Ma'rifat al-Hiyal al-Handasiya)*. The scientific knowledge necessary for these automatic machines was based on the mathematical and mechanical discoveries of Archimedes and other Greek scientists, which were later made popular by such Greek compilations as those of Heron of Alexandria and Philon of Byzantium. Since the classical texts had illustrations to explain the nature and function of the various contrivances, these were taken over in the Arab translation. The idea of using illustrations for al-Jazarî's book thus came from classical prototypes, though only the basic engineering features and certain details remained the same as in the Greek forerunners. The general character is Oriental.

A typical example is the miniature in the Metropolitan Museum of Art of an Illustration page 93 "Elephant Clock," coming from a now broken-up manuscript dated 1315 of unknown provenance, but possibly from Syria. Although more than one hundred years later than the original illustrations and, therefore, revealing some stylistic changes in the treatment of the figures, this example has nevertheless been chosen because the essential technical details are better preserved than in the version of 1254 (Topkapu Sarayı Müzesi, Ahmet III, 3472), which on the whole it carefully follows.

The clock indicates the passage of hours in three different ways. Functionally, the time can be read first from a scale to which the little rotating figure above the elephant is pointing; or secondly, from a large dial (not indicated in the painting) on top of the castle-like structure on the elephant, where one after the other of a series of black openings turns white after each hour. The purpose of the third method lies in its entertainment value, and this was obviously the *raison d'être* of the whole contraption. Every half-hour the bird on top of the cupola whistles and turns while the mahout hits the elephant with his pick-axe and sounds a tattoo with his drumstick. In addition, the little man who seems to be looking out of a window on the upper left moves his arms and legs to induce the falcon below to release a pellet. This moving downward, makes the dragon turn until it is finally ejected into the little vase on the elephant's back. From there it drops into the animal, hits a gong, and finally comes to rest in a little bowl where the observer can establish the half-hours passed by counting the number of little balls collected there. This automaton is reminiscent of the elaborate clocks found on medieval town halls and churches, in all of which the passage of time is made more palatable by the amusing performance of moving figures.

The whole concept of an elephant carrying an elaborate towerlike howdah is Oriental and came originally from India. It was therefore not far-fetched for the artist to make the mahout a dark-skinned Indian wearing only trousers and a narrow scarf. However, his goad, a stone pick, though given according to al-Jazarî's specification, is quite un-Indian. This change was occasioned by the fact that in the Arab world the most widely

Illustration page 93 used figure of an Indian was the symbol of Saturn, who is usually portrayed with this particular tool as his emblem. Another Oriental belief, but one which preceded Islam by thousands of years, is revealed in the threatening symbolic battle between the bird, signifying the sky and light, and the snake, standing for darkness and the underworld. But in spite of this display of Oriental figures and ideas, a few Greek concepts have nevertheless crept into the design. The elephant is shown without any articulation in its legs; in this respect it follows the classical belief that this beast is jointless. Also following Byzantine prototypes, the artist made the trunk too long and gave it a wide tip.

From the examples cited so far, it should be clear that in spite of restrictive religious mandates, the Muslim painters were able not only to achieve characteristic forms of expression, but to hold their own when, in illuminating Arabic manuscripts, they had to compete with well-established Iranian and Byzantine pictorial patterns. The vitality of their style becomes even more apparent when it is realized that they left their imprint on Christian manuscripts written within the Muslim world. We have already referred to a Coptic Gospel manuscript of 1180 in the Bibliothèque Nationale which betrays this influence in Egypt. To this can be added some illuminated manuscripts executed in Mesopotamia for the members of the Jacobite Syrian Church. The miniature of "Christ's Illustration page 94 Entry into Jerusalem" in a Syriac *Lectionary of the Gospels* written in 1220 in the Monastery of Mar Mattaï near Mosul (Vatican Library, Siriaco 559) reveals the manifold nature of the influence exercised by Mesopotamian Arab-Muslim painters, especially those of the Mosul region. Many of the figures resemble those of Arab manuscripts in the garments and turbans worn, the more Oriental cast of the faces, the large, curved noses, and the vivid gestures. This applies in particular to the inhabitants of Jerusalem seen on the left and in front. Even in their behavior these figures recall details in Arab miniatures; for instance, one of the men in front of the building is seen turning to his companion in the Illustration page 91 manner of the two court attendants on the left in the frontispiece miniature of the *Book of Antidotes* in Vienna. Another revealing feature is the use of the halo for nearly all the figures, not only for Christ and the Saints as one would expect in a Christian manuscript of Byzantine derivation. The presence of haloes even on some of the soldiers in the "Massacre of the Innocents" indicates clearly that the painter has adopted the indiscriminate application common in Arab miniatures. The stylization and coloring of the trees and mountains are purely in the Arab manner, as are a few of the architectural elements. The purest Islamic element in this ensemble is the arabesque border on top, which occurs in this position also in some Arab miniatures. These relationships, along with others, are so striking in this manuscript and in a closely related one of the same date in the British Museum (Add. 7170) that it was formerly thought that, owing to its older pictorial tradition, the Jacobite Syrian school represented one of the prime sources of Arab-Muslim painting. H. Buchthal was the first to point out that these points of resemblance are, however, foreign elements in an otherwise Byzantine style, while they are usual in Arab-Muslim paintings. The priority must therefore go to the latter.

FULFILLMENT IN BAGHDAD

Although it is an intriguing task to dissect a manuscript for the various cultural styles it incorporates, the art historian is well aware that the prize belongs to the mature and fully integrated style, in which, even when the artist is inspired by some earlier concepts, he has reshaped them in such a way that they have become something new and original. So far as we know, Arab painting reached its full integrating power shortly after 1200 in the capital of the 'Abbâsid caliphate, and attained its full glory there in the second quarter of the century.

·By a whim of history the first piece of evidence for this development is a text on veterinary medicine pertaining to horses, *The Book of Farriery* or *Kitâb al-Baytara* by Ahmad ibn al-Husayn ibn al-Ahnaf. According to the colophon of a manuscript in the

Book of Farriery (Kitâb al-Baytara) of Ahmad ibn al-Husayn ibn al-Ahnaf: Two Horsemen. Baghdad (Iraq), 1210 (606 A.H.). (c. 120×c. 170 mm.) Ahmet III, 2115, folio 57 recto, Library of the Topkapu Sarayı Müzesi, Istanbul.

The Epistles of the Sincere Brethren (Rasâ'il Ikhwân as-Safâ): Authors and Attendants.
Baghdad (Iraq), 1287 (686 A.H.). (200×174 mm.) Esad Efendi 3638, folio 4 recto, left frontispiece,
Library of the Süleymaniye Mosque, Istanbul.

The Epistles of the Sincere Brethren (Rasâ'il Ikhwân as-Safá): Authors, Scribe and Attendants. Baghdad (Iraq), 1287 (685 A.H.). (202×173 mm.) Esad Efendi 3638, folio 3 verso, right frontispiece, Library of the Süleymaniye Mosque, Istanbul.

National Library in Cairo (No. 8f, Khalîl Aghâ) this volume was written in Baghdad in 1209. Unfortunately, the miniatures in it are not well preserved, but there is a manuscript of the same text written by the same scribe one year later, which contains illustrations in exactly the same style (Topkapu Sarayı Müzesi, Ahmet III, 2115). Although there are no pre-fifteenth century Greek manuscripts of hippiatric texts still extant, we may assume with assurance that these two Arab manuscripts and their miniatures are ultimately based on Byzantine prototypes. There is even another such manuscript in Istanbul with illustrations showing plastically rendered faces with red cheeks and sunken eyes and garment folds in the Byzantine manner, an indication that these paintings represent a stage still closer to the now lost Greek model (Süleymaniye, Fatih, 3609). However, what we find in the two manuscripts of 1209 and 1210 gives us *prima facie* no clue to these antecedents.

Illustration page 97

The specific character of the text demanded no elaborate miniatures. Usually one or two persons are attending an ailing horse, all of them placed on a ground line with grass and a few plants. One exceptional miniature in the genre manner shows two galloping riders. Because of the natural movement of horses and riders, the drawing of the faces, and the costumes, we are no longer conscious of a prototype from another civilization. They seem typical products of an Arab milieu. In a limited way the miniature even achieves an effect which had escaped other artists. Though the ground is simply rendered as in all the other miniatures, the overlapping of the two figures creates a feeling of space. This impression is further strengthened by the fact that the more distant horseman is placed on a slightly higher level. This sense of depth supports our impression of unencumbered movement and makes us admire the artist's facility in handling his medium. Apart from their innate qualities these two closely related manuscripts (and the one presently to be discussed) are also most important as the key documents with the help of which it is possible to establish the characteristic features of the Baghdad style.

Illustrations pages 98-99

The stage of full maturity is represented by a double frontispiece miniature in a manuscript of *The Epistles of the Sincere Brethren (Rasâ'il Ikhwân as-Safâ)*, a tenth century encyclopedic text with ultra-Shi'ite tendencies. These two miniatures came from a volume the colophon of which indicates that it was written in Baghdad in 1287. They are therefore documents which are later than the cataclysmic Mongol conquest of the 'Abbâsid capital in 1258. They do not yet show any of the newly imported Far Eastern elements that were to become so evident later on. Though painted relatively late in the thirteenth century these two pages represent the pure Baghdad style at its height and in its most dynamic aspect.

While the heading of the left side gives us the title of the book, that on the right indicates that we are here in the presence of five authors: Abû Sulaymân Muhammad ibn Mis'ar al-Bustî called al-Maqdisî, Abu'l-Hasan 'Alî ibn Zahrân az-Zinjânî, Abû Ahmad an-Nahrajûrî, al-'Awfî, and Zayd ibn Rifâ'a. The "author picture" is an invention of classical antiquity already extensively used in the papyrus scrolls. After the codex was invented at the end of the first century A.D. it continued to be commonly inserted at the

The Epistles of the Sincere Brethren (Rasâ'il Ikhwân as-Safâ): The Scribe, detail in the right frontispiece. Baghdad (Iraq), 1287 (686 A.H.). Esad Efendi 3638, folio 3 verso, Library of the Süleymaniye Mosque, Istanbul.

beginning of texts. Indeed, it has been stated by a most competent art historian that "in medieval manuscripts author portraits outrank numerically any other type of miniature." Yet it can be maintained that there is no other medieval treatment of the subject quite like this, and that in this double composition the original idea has been so well assimilated to the concepts of Arab-Muslim civilization that it can be regarded as a characteristic production, epitomizing the happy union of Arab learning and Arab painting at its best.

Illustrations pages 98-99

What strikes one first in this miniature is its coloristic difference from the other paintings so far discussed. In these the dominant color combinations were of red, blues, and greens. Here we have instead blue, two browns, gold, and black. Our second impression is that now at last we have a true concern for the setting, with the complex arches, the various decorative motifs, and the tied-up curtains all carefully rendered. The arrangement of the sides of the polygonal structure at an angle gives a certain degree of depth to the composition. This impression is further strengthened by the dark brown background behind the two figures in the upper stories, which distinctly implies the shadows in the recesses of an open portico. What is most striking, however, is the artist's ability to characterize the individual personalities and to interrelate them. This brings up the question of the subject of these two paintings. Since the same setting is used in both pages and the scene is said to portray five scholars, as Farès was the first to point out, it is natural to assume, as has been done, that they are shown twice, with three sages

Illustration page 99

seated in each lower story and two in each upper. The right scene would then represent a more contemplative mood in which the philosophers meditate, read, and write, while

Illustration page 98

the assembly at the left would depict a lively discussion between the three sages in the lower story. The figures on the right and left are, however, different enough to preclude this interpretation, especially as only on the right side do we find a beardless youth, who could hardly portray a sheikh. Moreover, it seems rather unlikely that the same set of figures would be shown in two stages. Such variations never seem to occur in the many later double frontispieces painted in various countries of the Near East. A more convincing explanation is that the miniature on the right shows only two of the three masters, who are joined by a scribe. The three other sages are on the left page. In both instances the figures on the balcony represent students or men of lower grades of initiation—hence their smaller size. In addition servants are seen standing in the wings, all of them characterized as persons of foreign origin and limited mental capacity. Because of their lowly station they are by far the smallest in size with the single exception of the fan-wielding attendant in the left miniature, who seems to have rushed to the fore and, leaning on a supporting column, creates a breeze with his fan. Being thus actively associated with the main figures, he is shown in larger size than would otherwise be his due. This is true

Illustration page 101

also of the scribe on the right page, who has temporarily stopped in his work and seems now lost in his own thoughts while he awaits further dictation. A scene of intense intellectual activity is portrayed, the creative nature of which is further brought out by its contrast to the passive mood of the figures in the upper stories and the mental inertia of the lowly servants, all of whom are quiet bystanders in a spiritual drama.

From a formal and compositional point of view, too, the two pages betray the hand of the master. The symmetrical arrangement, which in both pages groups all units around a central axis, could have led to an immobile aggregate of figures, as it did in the frontis- Illustration page 65 piece of *The Book of Songs* in Istanbul. The various gestures of the figures and the inner tension pervading the scenes, however, counteract a propensity toward rigidity. The two opposing tendencies shown by the architectural setting on the one hand and the main actors on the other complement each other and strike a happy balance. The handling of secondary features is also very revealing. The linear patterns in gold and white in the folds and designs of the garments and curtains enrich the surface; they help to produce a sense of vibrant activity which underscores the main theme, and also offer relief from the straight lines of the lower brick wall and of other structures.

LIFE ENCOMPASSED. I. THE EXTERNAL WORLD
(THE GREAT MAQÂMÂT MANUSCRIPTS OF LENINGRAD AND PARIS)

In the immensely varied and sustained effort of the *Maqâmât* illustrations executed in Baghdad, Arab painting reaches its apogee. This is in spite of the fact that the al-Harîrî text seems in itself to offer little to an illustrator. Its main point is the verbal ingenuity of the hero Abû Zayd who, by clever improvisations and unscrupulous pretences, knows how to move an assembled crowd or an important figure so that he is offered many gifts. For centuries Arab readers have admired the many allusions, ingenious metaphors, plays on words, riddles, and other *tours de force* that give these picaresque adventures their literary merit. The illustrator as an artist is oblivious to such philological attractions; he can use only the situations created for the delivery of these verbal conceits. However, since the fifty chapters take place in many localities, these paintings in their deliberate effort to be as explicit as possible give us an unparalleled insight into the life of the Arab world: they are especially informative about Iraq because it was there that they were executed. We witness one episode taking place in a mosque, others in a

Illustration page 112
Illustrations pages 106, 122

library, in a bazaar, or caravanserai, in a cemetery, desert encampment, or on a verdant island in eastern waters; again we see the court of a governor, a palace with attendant slaves, a schoolroom at the moment when the bastinado is given to a pupil, a campfire

Illustration page 108

near which an animal is being slaughtered, or we observe a ship as it is setting sail, lone

Illustration page 117

riders in the desert, a camel herder with her charges, mounted musicians and so on. It is a parade of rich men and poor, sad and gay, excited and relaxed, curious and bored. In their realism these paintings reveal many features of medieval life otherwise unknown. Thus we learn about urban domestic architecture long since lost in actuality; even such details as the movable roof parts which could be rolled to one side for proper ventilation

Illustration page 108

can be easily understood. We can study the manner in which the planks of boats were sewn together as they still are in Mukalla in Southern Arabia. Or we can get a close glimpse into the instrument chest of a barber-surgeon. More remarkable still, we manage to penetrate into quarters inaccessible even at the time, such as the women's chambers. Indeed, this incomparable mirror of medieval Arab civilization reproduces practically all phases of human existence from birth to tomb.

Of the two manuscripts, the one in the Bibliothèque Nationale (Arabe 5847), often referred to as the "Schefer Harîrî" after its former owner, is the better known, since many of its paintings have been published and most of its miniatures were detached and shown in an exhibition in 1938. This manuscript with its ninety-nine pictures, a few of them two-page compositions, was written and illustrated in 1237 by Yahyâ ibn Mahmûd al-Wâsitî, known for short simply as al-Wâsitî, after the town Wâsit in Southern Iraq where the artist or his family originated. The other manuscript is in the Institute of Oriental Studies of the Academy of Sciences in Leningrad (MS. S 23). It is not too well preserved in parts and has lost its first eleven pages; it is not dated; and only a few miniatures have been published. For these reasons it has so far not found the recognition it deserves. Yet

its illustrations have great expressive power. Also, as D. S. Rice has quite rightly stated, it should be regarded as the earlier of the two manuscripts. In contrast to the Paris manuscript, certain of its miniatures are found in their proper place within the text or they present an iconography which exactly matches the episode described.

There must have been other outstanding *Maqâmât* manuscripts now lost. This is indicated by a third, recently discovered illuminated example (Istanbul, Süleymaniye, Esad Efendi 2916), which has the same elaborate repertory and genre quality as the two other volumes. Although it differs from the two other manuscripts in the treatment of the major scenes, the Istanbul al-Harîrî is iconographically and stylistically related to them, possibly more closely related to the Leningrad volume than to the one in Paris. It is the latest of the three manuscripts, as according to an architectural inscription in one of its miniatures, it was copied while the last 'Abbâsid Caliph al-Musta'sim billâh (1242-1258) was still alive. Unfortunately the third manuscript has suffered irreparable damage through the rubbing out of all the heads and torsos by an iconoclast. The same impulse of desecration is visible in the Leningrad volume, but there the bigot was satisfied with drawing a line across the neck of each figure. By this means the paintings were made theologically permissible because each person represented was no longer alive, having so to speak "had his throat cut." We have spoken earlier, in the Introduction, of the negative attitude of Islam toward figural painting. To witness this point of view in action makes us realize again the difficulties under which the painter worked, and how much mankind must have lost in consequence.

A characteristic miniature of the Leningrad manuscript is that showing Abû Zayd Illustration page 106 appealing to the generosity of the Governor of Merv (Thirty-eighth Maqâma). In the manuscript of 1222 this scene does not depict Abû Zayd as one of the two central actors and no proper interrelationship between the few figures shown has been established. By contrast the same subject is here turned into a dramatic spectacle. Abû Zayd is eagerly pleading his case and gives emphasis to his speech not only by vivid gestures, but by pressing his whole body into the act. Yet in spite of the eloquent appeal, the face of the Governor expresses disdain. He is still undecided whether or not he should act. The contrast between the two is also physically underlined: here the small cringing figure of the poor hoary vagabond; there the imposing figure of the rich governor, whose pomposity is conveyed in the billowing expanse of his garments, drawn in large elliptical units and edged with a golden trimming which moves upward in a stepwise diagonal. Four figures at the right form part of the assembly, all of them attentively witnessing the proceedings. Among them is al-Hârith, the narrator, probably the figure directly behind the Governor. This group of motionless figures is juxtaposed to the Governor's two pages, who, with total disregard for the proceedings, pass the time in talking to one another. The architecture is on the whole conceived in two dimensions with a flatness unrelieved even by the small domes over the side wings. Thus it still looks like a stage prop for a shadow play, more elaborate than that used for the "Pharmacy" in the Illustration page 87 Dioscorides manuscript of 1224, but essentially of the same type. This scenery serves, therefore, only as a framework for the various figures: the Governor fits into one of the

Assemblies (Maqâmât) of al-Harîrî: Abû Zayd before the Governor of Merv (Thirty-eighth Maqâma). Baghdad (Iraq), c. 1225-1235. (175×191 mm.) MS. S 23, page 256, Oriental Institute, Academy of Sciences, Leningrad.

Assemblies (Maqâmât) of al-Harîrî: Abû Zayd before the Cadi of Sa'da in the Yemen (Thirty-seventh Maqâma).
Baghdad (Iraq), c. 1225-1235. (177×179 mm.) MS. S 23, page 250, Oriental Institute, Academy of Sciences, Leningrad.

Illustration page 106 high arches, the onlooker behind him into a niche, and the two pages into a lower arch at the left, probably close to the entrance into the audience chamber. Only the gesture of one of the pages who idly embraces a column with his arms and one leg, or the placing of three of the seated figures in front of the Governor's high chair, betray a budding interest in space. That this is not an accidental feature is indicated by the artist's frequent concern with spatial relationships in other contexts. Open staircases with turns in interior settings, for example, are typical of his manner of exploring such problems.

Assemblies (Maqâmât) of al-Harîrî: Abû Zayd asks to be taken aboard a Ship (Thirty-ninth Maqâma). Baghdad (Iraq), c. 1225-1235. (154×204 mm.) MS. S 23, page 260, Oriental Institute, Academy of Sciences, Leningrad.

The same general setting is also found in an illustration of the "Thirty-seventh Illustration page 107 Maqâma," showing many figures in the same positions within the tripartite architecture. The mood has changed, however. Instead of the fervent speech to an overbearing, though silent governor, Abû Zayd is addressing a cadi who is immediately sympathetic to his complaint. Also the attending figures reveal a greater interest in the procedure; hence, unlike his counterpart in the painting we have just analyzed, the bystander leaning against the column on the left follows the discussion with rapt attention, while one of the seated figures in front is seen busily writing, possibly recording the proceedings. The scene is again startling in its realism in comparison with earlier works. Yet in the volume it is almost a repetition, as it is actually a close variation of an illustration to a previous chapter.

A more specific concern for local color is apparent in the boat scene illustrating the Illustration page 108 beginning of the "Thirty-ninth Maqâma." This is again as flat and explicit as the first two miniatures here discussed, but richer in unusual details. Abû Zayd has hailed a ship setting out for Omân and begs to be taken aboard. Holding the basket with his provisions and making an imploring gesture, he stands on the left, a marginal figure in the composition, but disproportionately large in relation to the boat. The uncommon sight of a seagoing craft inspired all three great *Maqâmât* painters; in the case of the Paris manuscript even to such an extent that the artist dispensed with the initial episode involving Abû Zayd to show only the genre theme of a boat at sea. Here we observe the ship with all the details of its construction and equipment and on it the crew and passengers: the captain seated in his cabin; the mate talking to the would-be passenger; the sailors busy with mast and sail; and the galley slaves bailing water into the sea. The crew are Indians whose features and dress are in vivid contrast to the fair-skinned turbaned passengers from the Near East seen looking out of the portholes. All the commotion and bustle of the start of a long voyage is to be found here. But the skillful use of the limited range of colors—brown, blue, and white—ties the whole together.

Another painting solves the illustrative problem in a different manner. It deals with Illustration page 111 a typical incident of the *Maqâmât*: during the search for a lost camel, Abû Zayd has come to a tribal encampment and finds a person calling for someone who has lost a "mount" which he carefully describes. Thinking that this applies to his animal, Abû Zayd claims it. When the stranger refuses to accept his identification and hand the "mount" over to him they appeal to a sheikh. There the defendant explains his original speech which was in the nature of a *double-entendre* (so typical for the *Maqâmât*) and presents to the judge his "mount"—which turns out to be a sandal.

This episode of the "Forty-third Maqâma" is represented against the bright yellow interior of a black Bedouin tent, which makes the figures stand out effectively. As telling as the main scene is, the artist is here not so explicit with regard to the setting as he was in the three other miniatures just discussed. Instead he hints at the aspect of a busy encampment and at the same time tries an experiment in suggesting real space. To achieve this aim he shows us the heads and shoulders of human figures and animals emerging from behind the first of the two broadly curving tents and groups of tall pointed spears projecting in the background. The artist thus contrives to suggest that there were more

tribespeople than the two men talking to each other and the one veiled woman; and more animals than the two camels, one rearing up its head, the other greedily stretching out its neck to crop some grass. Not only is the main scene enlivened by an appropriate setting, but an effort has been made to overcome the flatness of the other miniatures.

Illustration page 111 An analysis of some of the formal aspects of the same painting reveals the artist's ingenuity. The black Bedouin tents form a perfect frame around the central theme and set it off from the secondary features. While these semicircular shapes with their jagged upper edges seem to hug the ground, the straight lines of the spears in the background introduce a counter movement at complementary angles. Instead of being spottily used as in *The Book of Antidotes* of 1199, the colors here tie the painting together. For instance, the red of the figure on the left is found again in the judge's carpet and the garment of the righthand figure in the middle ground. It will also be noted that the artist almost entirely dispenses with the "halo" and has used it only once: to distinguish the head of the black-veiled woman from the black background.

The sage seated on a low bench against an upright bolster, discussing a case with persons who stand in front of him, is the same motif found in the scenes of a doctor talking to his assistant in the Dioscorides manuscript of 1224. In the new tent setting the process of assimilation has advanced to a point where the classical origin of the iconographic theme is all but forgotten. Since the Dioscorides manuscript of 1224 has been generally accepted as having been painted in Baghdad, this very close parallel in the Leningrad manuscript points to the same origin.

Illustration page 112 Another picture in the "Fourth Maqâma" of an encampment offers a completely different composition. Here the artist uses the perspective derived from an imaginary high viewpoint for the basic scene in which a traveler listens to the talk of two strangers. This allows him to present not only the main figures seen in the background, but also some other members of the caravan, such as the camp cook at his stove, the rich merchant resting in his tent, and the groom attending the camels. As in some miniatures of the Dioscorides of 1224 the main subject is overshadowed by the genre aspect with all its intriguing details. Actually the cumulative effect of all the figures, tents, and animals produces a richer impression than the number of individual components would seem to warrant; but the end result is a vivid picture of a camp site.

The master of the Leningrad *Maqâmât* has occasionally used another compositional scheme that constitutes a special achievement. In this he reaches the opposite pole from the style common in ancient Assyrian reliefs, in which every figure and detail was unequivocally indicated. The new feature, a typical phenomenon of the urban world, is the crowd composed of many overlapping figures, arranged not only in rows, but also in a Illustration page 113 circle or ellipse. We see it around a pool, or shop, a banquet setting or wherever something unusual is happening. Its anonymity is made even more evident by having only a few figures stand out, whether by a remarkable face or because the person is involved in an unusual action. This otherwise faceless mass of people is juxtaposed to the main actors or surrounds a scene, watching with spellbound attention. This creates the effect of a spectacle within a spectacle.

Assemblies (Maqâmât) of al-Harîrî: The Case of the Lost Mount (Forty-third Maqâma). Baghdad (Iraq), c. 1225-1235. (141×205 mm.) MS. S 23, page 288, Oriental Institute, Academy of Sciences, Leningrad.

The wide variety of compositional schemes is one of the telling characteristics of this master: some paintings are quite simple, others complex; some disregard spatial depth, others try to explore it. The work is also appealing in its genre character and richness of detail. It reveals great psychological insight. While color plays a significant role, it does not overshadow the draftsmanship apparent in the underlying design. Indeed this linear quality and a greater spontaneity, as well as an interest in scenes of large crowds and the rather small scale of most of the figures, distinguish the work of this master from that of al-Wâsitî, the painter-calligrapher of the Paris manuscript.

The illustrative part of this famous manuscript opens with a double frontispiece showing, on the right, an enthroned Turkish official or prince, while on the left an Arab

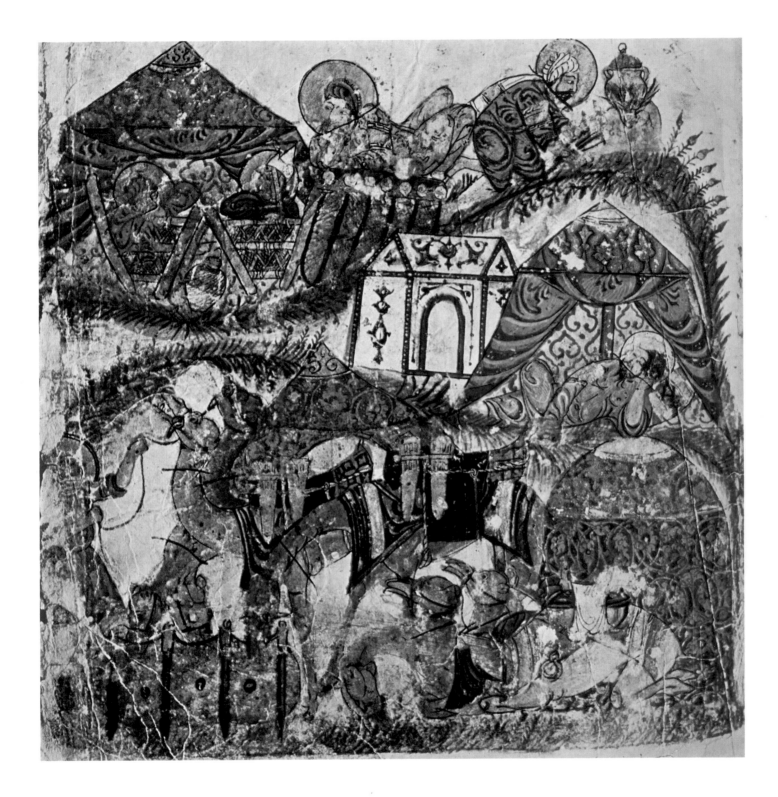

Assemblies (Maqâmât) of al-Harîrî: The Encampment (Fourth Maqâma). Baghdad (Iraq), c. 1225-1235. (192×199 mm.) MS. S 23, page 22, Oriental Institute, Academy of Sciences, Leningrad. (Enlarged)

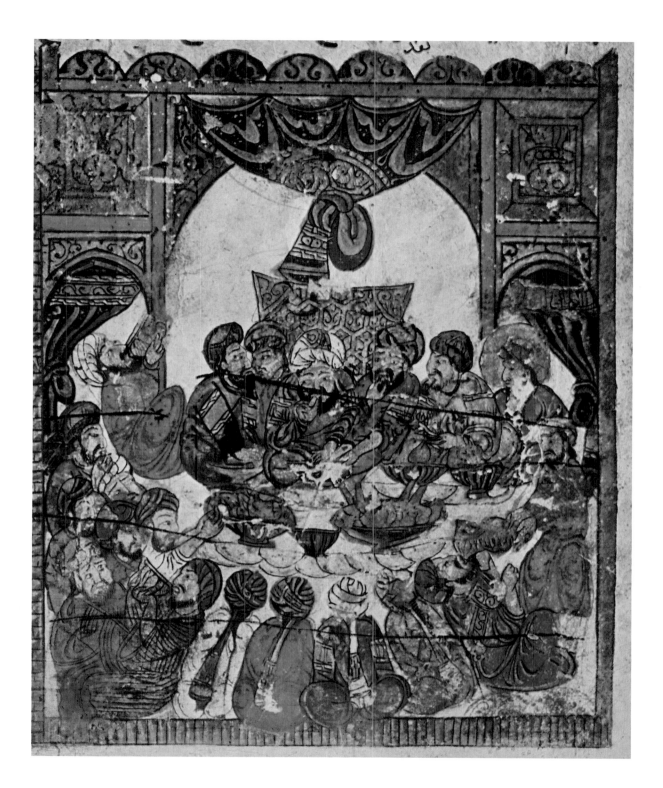

Assemblies (Maqâmât) of al-Harîrî: The Wedding Banquet (Thirtieth Maqâma). Baghdad (Iraq), c. 1225-1235. (168×185 mm.) MS. S 23, page 205, Oriental Institute, Academy of Sciences, Leningrad. (Cropped on the left).

dignitary, also enthroned, appears in a nearly identical, elaborate framework. There is a subtle distinction between the two pages which goes well beyond the different facial characteristics, headgear, and clothing. The Turk, representing the worldly power, is still given in strict frontality and the frozen attitude usual for such throne scenes; the Arab, on the other hand, has turned slightly to the right and seems to be delivering a speech, to which the gesture of his right hand gives further emphasis. There is, therefore, a closer

Assemblies (Maqâmât) of al-Harîrî: Abû Zayd before the Governor of Rahba (Tenth Maqâma).
Baghdad (Iraq), 1237 (634 A.H.). Painted by Yahyâ al-Wâsitî. (194×220 mm.)
MS. arabe 5847 (Schefer Harîrî), folio 26 recto, Bibliothèque Nationale, Paris.

relationship between him and his surroundings, a familiarity deepened by the mutual bond of the Arabic language. This difference between the two main figures has even affected the animals which move in the arabesques of the surrounding frame. Above the Turk's head is an inert spreadeagle (or falcon), like a coat of arms; a similar bird of prey above the Arab has lost its heraldic stylization. It is shown in profile, ready to fly off, and is thus imbued with potential movement. Another significant development is to be noted in the concept of the scene as a whole. The composition no longer consists of an enthroned figure with attendants right and left, the lineal descendants of an idol representing a god with minor celestial beings at his sides, all facing the onlooker, who, magically hypnotized, has to pay homage to the deity. Now there are also figures in front of the throne, separating the main figure from the onlooker. This new element transforms the scene into a separate event which we can witness as detached outsiders not involved with the spectacle. By showing the central figures in the first row from the back and those on the sides in three-quarter view (though turned to the front, owing to an inability to give the proper foreshortening from the rear), the artist has added another realistic element which further helps to change these pages, especially that on the left, into genre scenes.

An illuminating example of the art of this second great *Maqâmât* painter is the scene Illustration page 114 from the "Tenth Maqâma" in which Abû Zayd falsely accuses his son before the Governor of Rahba, stressing the boy's physical beauty in order to make the judge covet the handsome youth. Al-Wâsitî dispenses with any setting or trappings other than the essential governor's throne, since anything else would have distracted from the human drama. For the sake of this drama all the figures are broadly and effectively characterized: the stupid official, looking vain and lecherous and given a foreign appearance by his red beard; the hypocritical, yet highly persuasive old scoundrel, and the well-dressed youth with his deceptive look of bashful innocence. The little page looking on curiously through an opening of the Governor's throne is al-Wâsitî's only concession to description of the milieu, but he does this with a human touch, not with columns, arches, and domes. The painting is more than an illustration of an amusing episode. Sharpened by psychological means, it approaches social satire. One is led to regret that al-Harîrî's collection of unrelated incidents did not allow al-Wâsitî to present a complete "Rake's Progress" cycle. But this additive sequence of events of equal significance, presented without progress in time and dramatic climax, reflects the Arab mental attitude, which, in this respect, is totally different from the Western approach.

Al-Wâsitî could, however, work also in the opposite manner, which might be termed the "panoramic." In the "Forty-third Maqâma" the travelers Abû Zayd and al-Hârith Illustration page 116 meet a man near a village and a discussion ensues. This is the scene shown in the foreground of our painting. But intriguing as we may find the different faces or the expressions of the camels, the real effect of the painting is achieved by the panoramic view of a village in the background. All the main buildings are shown: the mosque with its minaret, the domed bazaar in the doors of which people are seen bargaining or waiting for customers, and finally, on the right, the fortified wall with a gate. The animals of

Assemblies (Maqâmât) of al-Harîrî: Discussion near a Village (Forty-third Maqâma). Baghdad (Iraq), 1237 (634 A.H.).
Painted by Yahyâ ibn Mahmûd al-Wâsitî. (348×260 mm.)
MS. arabe 5847 (Schefer Harîrî), folio 138 recto, Bibliothèque Nationale, Paris.

the Oriental streets appear—a cow, troops of goats, some of them drinking from a pool Illustration page 116 further to the front, and on the roofs a hen and rooster. The whole is framed between the vignette-like picture of a woman handling a spindle on the right and a palm tree on the left. This is no longer a static ready-made architectural setting derived from classical stage scenery or a shadow play; it is the image of a living village, of its physical and social aspects as well as of its economy.

The text of the "Seventh Maqâma" speaks only in the most general terms of the horsemen who were getting ready for one of the major Muslim feasts. But this was enough to provide us with a vivid genre picture of mounted musicians and flag bearers, all aligned Illustration page 118 for the great occasion. Al-Wâsitî knows how to avoid monotony: the flags and trumpets project upright and at various angles and thus form a counter movement to the horizontal lines of animals and riders; the drummer sits higher than all the others and so breaks the row of faces, and the mule with his long ears forms an amusing contrast to the horses, the last three of which being ill-matched, bring up a lame rear. The scene is basically static but full of color and latent excitement: the trumpeters are already blowing their instruments and some of the animals stamp impatiently on the ground.

Assemblies (Maqâmât) of al-Harîrî: A Drove of Camels (Thirty-second Maqâma). Baghdad (Iraq), 1237 (634 A.H.).
Painted by Yahyâ ibn Mahmûd al-Wâsitî. (138×260 mm.)
MS. arabe 5847 (Schefer Harîrî), folio 101 recto, Bibliothèque Nationale, Paris.

Assemblies (Maqâmât) of al-Harîrî: Horsemen waiting to participate in a Parade (Seventh Maqâma).
Baghdad (Iraq), 1237 (634 A.H.). Painted by Yahyâ ibn Mahmûd al-Wâsitî. (243×261 mm.)
MS. arabe 5847 (Schefer Harîrî), folio 19 recto, Bibliothèque Nationale, Paris.

118

Assemblies (Maqâmât) of al-Harîrî: Pilgrim Caravan (Thirty-first Maqâma). Baghdad (Iraq), 1237 (634 A.H.).
Painted by Yahyâ ibn Mahmûd al-Wâsitî. (253×267 mm.)
MS. arabe 5847 (Schefer Harîrî, folio 94 verso, Bibliothèque Nationale, Paris.

It is worthy of note that the illustration just discussed is not found at the appropriate place in the text but in a later passage, although al-Wâsitî, the calligrapher who was also the painter, could have placed it easily in the correct context. It seems most likely, therefore, that it was not created for this particular volume, but copied from another manuscript in which case the same inference may doubtless be made for the other miniatures in this copy.

Illustration page 119 A related scene but on a much higher pitch is the one showing a caravan of pilgrims on the way to Mecca, an illustration to the "Thirty-first Maqâma." Full of religious rapture, the party is seen heading for the sacred city to the accompaniment of stirring music. We seem to feel the dynamic force of this cavalcade from the unimpeded movement in one direction and the forward thrust of flags and trumpets. As in the village scene, a grassy line curving toward the rear indicates the receding space and the horizon on its further edge; but here all the figures are in front or in the middle ground; this reinforces the impression of a crowded mass of men and animals, all animated by the same excitement.

In this painting which is all swirling movement, the camels are scarcely noticed.
Illustration page 117 One of the illustrations of the following *maqâma*, on the other hand, presents with the utmost directness the quintessence of the animal's look and nature. The text speaks of a drove of camels which had been presented to Abû Zayd for a brilliant legal discourse. Driven by a female herder they stand as if offering a salute—that is, all but two which try greedily to crop the grass. Again monotony has been successfully avoided. The painter renders the animals in many shades of tan and brown and makes the most of the peculiar structure of the bodies—at once balanced and unwieldy—in contrast to which the figure of the herder appears shapeless and out of harmony. One relishes in particular the rhythm of the sinuous curves of the many necks rising over a bewildering number of legs. The two camels of darker color serve as internal accents, while the necks of the two foraging animals, which frame the group, introduce a counter movement and at the same time stress the leftward motion. Men have often spoken of the camel's odd shape and strange behavior, but probably in only a few instances has its character been so tellingly rendered. One has to search as far as the Japan of the late seventeenth century to find in Kōrin's screens of "Walking Cranes" an artistic parallel of kindred spirit.

Much as we admire the *Maqâmât* paintings thus far discussed, their subject repertory of governors and sheikhs, horses and camels, tents and villages has not gone beyond what might be expected from an Arab painter bent on depicting the milieu in which the various "assemblies" take place. What is unusual and evokes our surprise is above all the free and brilliant execution. The case is different, however, with regard to a totally unexpected
Illustration page 121 illustration of the "Thirty-ninth Maqâma" which presents the interior of a mansion at the moment when the lord's wife is in the throes of a difficult child-birth. Although the
Illustration page 87 setting is a usual one—the tripartite, two-story scheme also employed for the "Pharmacy" in the Dioscorides of 1224—the main theme is rendered with an unmitigated realism that induces awe rather than surprise at its unwonted frankness. The central figure of the woman in travail appears colossal, a true symbol of fertility; she is assisted by the midwife

Assemblies (Maqâmât) of al-Harîrî: The Hour of Birth (Thirty-ninth Maqâma). Baghdad (Iraq), 1237 (634 A.H.).
Painted by Yahyâ ibn Mahmûd al-Wâsitî. (262×213 mm.)
MS. arabe 5847 (Schefer Harîrî), folio 122 verso, Bibliothèque Nationale, Paris.

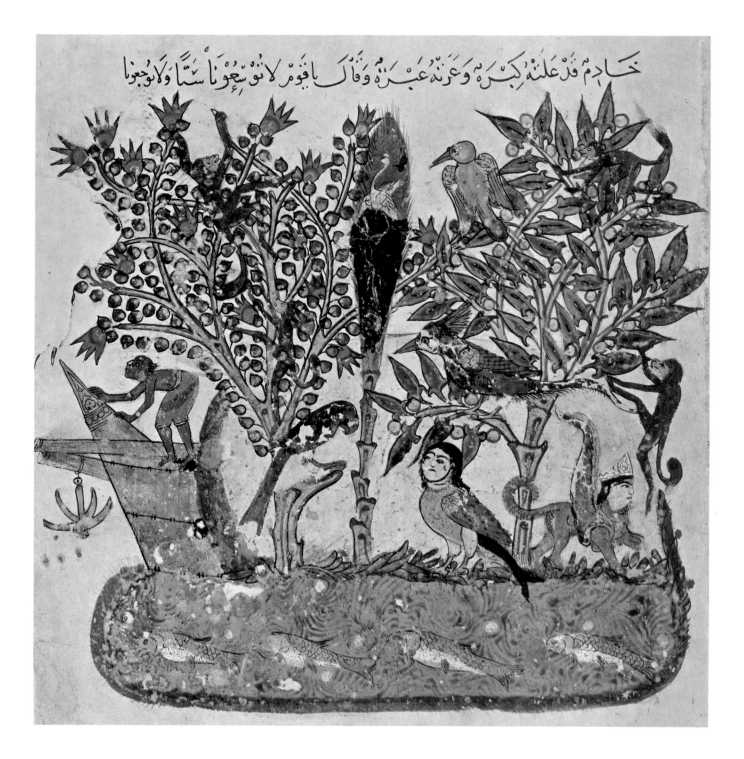

Assemblies (Maqâmât) of al-Harîrî: The Eastern Isle (Thirty-ninth Maqâma). Baghdad (Iraq), 1237 (634 A.H.).
Painted by Yahyâ ibn Mahmûd al-Wâsitî. (259×280 mm.)
MS. arabe 5847 (Schefer Harîrî), folio 121 recto, Bibliothèque Nationale, Paris.

122

and an attendant who supports her while in the wings two other servants stand by, one Illustration page 121 with a large incense burner. Above the women's quarters is the public part of the mansion, in the center of which the master and two of his retainers are shown. The symmetrical arrangement of this scene, in the strict frontality of the central figure and the motionless attitude of the participants, is characteristic of the princely style in the Persian manner. As the event recounted in the text takes place on an eastern island, the enthroned figure and his attendants are rendered as Indians; the lord appears, however, in the pose of a holy man and not that of a ruler. By contrast the two side figures are Arabs: on the left is Abû Zayd writing an amulet to bring about a speedy and successful delivery, while the figure on the right is possibly al-Hârith, who is seen holding an astrolabe to prepare a horoscope. Although there are classical iconographic prototypes for the woman in labor resting her arms on supporting servants and Indian ones for the figure of the sadhu-like lord, the whole concept of the miniature and its overall composition are highly original. There are not even parallels to it in the *Maqâmât* manuscripts of Leningrad and Istanbul.

All the miniatures so far discussed have been based on experience and familiarity with scenes of the kind depicted. The sole exception is the picture of an "Eastern Island" Illustration page 122 on which Abû Zayd and al-Harîth's ship has landed. This subject is largely created by the painter's imagination, which was nurtured by hearsay or the fantastic stories of sailors. It is also possible, however, that it was not al-Wâsitî who originally devised this ensemble, but that it was wholly or in part founded on illustrations of slightly earlier books dealing with voyages to strange lands. Only the bow of the sewn boat with its Indian sailor and the four monkeys in the trees reveal a direct acquaintance with the subject, which in the case of the monkeys is not surprising as they together with their trainers formed a special attraction at Arab fairs. By contrast the trees betray here, as in all the other miniatures of the three *Maqâmât* manuscripts, that the artist was less personally involved in this aspect of the external world and so was satisfied with highly stylized types. They are purely conceptual images, deployed in a decorative fashion. The birds are rendered in the same manner, possibly with the exception of the parrot which could be more easily observed. To give the island its proper aura of exoticism and mystery, the painter not only included the strange bird with a golden crest seen on a low branch to the right, but also added two imaginary human-headed creatures, a harpy and a sphinx.

The concept of this island was almost Rousseauesque for its time—a vision of an untarnished country of the mind. But even here al-Wâsitî was concerned with spatial depth. In the foreground is the expanse of water with its four fishes; in the middle ground the shore line with trees and a cove in which the partly visible boat has found shelter; and finally in the background the more distant parts of the island displayed vertically, as it were, to coincide with the picture plane. This is indicated by the grassy edge at the left and the light brown area behind the trees. By his colorful mixture of the familiar and the fantastic al-Wâsitî (or his model) has succeeded in creating the picture of a lush, distant island.

If we disregard small pictures of plants in their habitat in some thirteenth century
Illustration page 122 Dioscorides manuscripts, this is the earliest known extensive landscape in Islamic
painting, and it nearly dispenses with the human element. It will be recalled in this
connection that European art reaches the stage of "pure" landscape painting only about
two and a half centuries later in the "Creation" painted on the outer side of the wings
of Bosch's triptych depicting the "Garden of Earthly Delights" (Prado, Madrid), and
even here the question has been raised of a possible influence from Chinese scrolls.
Al-Wâsitî's representation of an "Eastern Island" may strike us as primitive and naïve;
but we may at all events be sure that it derives uniquely from creative processes belonging
to the Near Eastern mind.

While the occasional discovery of a classical, Byzantine, or Persian prototype is to
be expected in this period of Arab painting, the appearance of Indian elements is more
unusual. However, it clearly fits into the picture, since we know from contemporary
literature that there was in that period and in the preceding centuries an extensive trade
between the Near East and India, especially with the western Indian ports. Lately the
Geniza fragments, deciphered by S. D. Goitein, have even shown that these commercial
transactions sometimes involved artifacts and the ruins of Fustât near Cairo have indeed
yielded many pieces of printed cotton imported from Gujarat.

The Indian elements in the *Maqâmât* illustrations are not only of an iconographic
Illustration page 121 nature, as in the case of the sadhu-like lord or in details based on observation of eastern
Illustration page 108 ships and sailors in Iraqi ports; they also include a stylistic influence. In this connection
it may be recalled that one of the most characteristic conventions of Western Indian
painting from the eleventh or twelfth century on is the "protruding further eye" which
Dr Moti Chandra has explained as the result of the gradual replacement of the three
quarter view by the profile. Beginning with the left frontispiece miniature there are many
instances in al-Wâsitî's paintings of this curious Indian feature, which can also be
detected among the few remaining faces of the Istanbul manuscript. It appears, for
Illustration page 114 instance, in the faces of the Governor of Rahba and of the accused youth; or in the face of
Illustration page 119 the left pedestrian in the "Cavalcade on the Way to Mecca"; there is even an indication
Illustration page 122 of it in a monkey on a tree at the left and the large bird on the branch at the right in the
"Eastern Island." In all instances this feature is so well blended into the overall picture
that it has possibly not been noted before this. Indeed in their power to assimilate foreign
material the *Maqâmât* illustrations resemble the *Arabian Nights*. G. E. von Grunebaum
has remarked with regard to these that "the spirit of Islam has come to permeate tales
of Jewish, Buddhist, or Hellenistic invention; and Muslim institutions, Muslim mores
and Muslim lore have quietly replaced the cultural conventions of the source material
and lent to the corpus that unity of atmosphere which is so eminently characteristic of
Islamic civilization and which will prevent the observer from noticing at first sight the
motley array of heterogeneous elements of which it is composed." The *Maqâmât* paintings
may or may not have a higher degree of originality than the *Nights*, but in their power
to assimilate and integrate foreign elements and to shape the whole into a mirror of Arab
civilization, the two works are alike.

LIFE ENCOMPASSED. II. THE AGONIES OF LOVE
(THE BAYÂD AND RIYÂD MANUSCRIPT IN THE VATICAN)

Old Abû Zayd tells us in the "Forty-eighth Maqâma" that he is a refugee from the town of Sarûj which in 1101 had been taken by French crusaders. The subjects of the miniatures by the great *Maqâmât* painters are, therefore, the many situations in which Abû Zayd fights the battle for existence. The arena of this struggle is the domain of public life, which, as always in the Near East, is the world of the male. The scenes that show women are few, and on the whole the female sex plays only a minor role. In this panorama of the external world there is, therefore, no place for the tender relations between men and women. For this we have to look elsewhere.

Although the love theme is a major one in Arab literature, so far only two illuminated manuscripts which deal with that subject have come to light. The first (Vienna, National-bibliothek, Chart. ar. 25612) is a small paper fragment with a few lines of text and a simple colored drawing of two tombs with a tree growing between them. This enabled D. S. Rice to identify these pages as part of an illustrated manuscript of the literary genre treating the stories of famous lovers; he placed it in the latter half of the ninth or the early years of the tenth century in the Eastern Mediterranean world, most probably in Egypt. The second manuscript, discovered by G. Levi Della Vida, is artisti-cally much more important (Vatican Library, Arab. 368). Unfortunately, it, too, is very fragmentary, with pages missing at the beginning and end and throughout the manuscript; not all of the remaining pages are even in proper order. Therefore, the exact nature of its story escapes us, especially since no other copy has been found, although the title *The Account of Bayâd and Riyâd* occurs in an Istanbul manuscript containing stories on the order of the *Arabian Nights*.

The narrative takes place in Northern Mesopotamia, as we learn from references to the small river Tharthâr. The hero Bayâd is a poetically inclined merchant from Damascus who has journeyed abroad with his father. One day he is espied by Riyâd, a handmaiden of a noble lady, who is the daughter of a chamberlain. He is brought into the company of this lady and her girl attendants, and there Bayâd falls in love with Riyâd. There are many complications—the separation of the lovers, an estrange-ment between Riyâd and her mistress and fear of the chamberlain, who seems once to have pursued Riyâd for himself; but there is also much activity on the part of the go-between in the form of messages, letters, or advice for the tormented lovers. The kind of love presented in this story was first described by Plato in the *Symposium*: "... In the pursuit of his love custom... allows him to do many strange things, which philosophy would bitterly censure if they were done for any motive of interest... He may pray, and entreat, and supplicate, and swear, and be a servant of servants, and lie on a mat at the door (of his beloved)..." This behavior pattern was later developed in an exaggerated form in the Greek novel, and then taken over by Arab poets and writers, who called it "'Udhrite love" after some famous lovers among the 'Udhra, a South

Story of Bayâd and Riyâd (Hadîth Bayâd u Riyâd): Shamûl delivers a Letter from Riyâd to Bayâd.
Maghrib (Spain or Morocco), thirteenth century. (190×205 mm.)
MS. ar. 368, folio 17 recto, Biblioteca Apostolica, Vatican.

Story of Bayâd and Riyâd (Hadîth Bayâd u Riyâd): Bayâd lying unconscious at the River.
Maghrib (Spain or Morocco), thirteenth century. (198×210 mm.)
MS. ar. 368, folio 19 recto, Biblioteca Apostolica, Vatican.

Arabian Bedouin tribe. Some examples are found in the *Arabian Nights* and it is apparently this type of love which is treated in the Vienna fragment. Bayâd and Riyâd, too, express their love in the approved manner; they sing of their love, they feel tormented, they often sigh and moan, they look thin, ill and wasted, and at times they faint and fall unconscious to the ground.

While this story of "Platonic love" originated in the Eastern Mediterranean or even further east, the manuscript itself is from the lands of Western Islam, that is Northwest Africa or Spain. This fact is evident from the character of the writing and certain details in the architecture such as the double windows. The miniatures, like the rest of the manuscript, have suffered a great deal, but several of them are well enough preserved Illustration page 126 to give a good insight into their style. In one scene we see Shamûl, one of the handmaidens and a friend of Riyâd, deliver a letter from her to the distraught Bayâd. The meeting takes place by the river outside the city, near one of the palaces with an Illustration page 127 enclosed garden. In another scene a friend of the elderly go-between, who has been sent to watch the poor lover, sees him near the river as he falls to the ground in a faint after finishing a woeful song about his longing. The miniature shows not only the palace with its enclosed garden, but also one of the big water wheels called *nâ'ûra*, a type once widely used in Mesopotamia, Syria, and elsewhere in the Near East, which can still be seen today in Hama on the Orontes. The third miniature is in a happier mood. Here Illustration page 129 Bayâd is in a garden enclosure and sings of his love, accompanying himself on the *'ûd*, the Arab ancestor of the Western lute. He faces the noble lady with her handmaidens, all of whom have in turn presented songs in a similar vein. As a result of the young Damascene's poetical rendition, three of the young girls interrupt their drinking to listen spellbound to the poet's love song, while others turn to their mistress to observe her feelings.

The illustrations succeed very well in reproducing the lachrymose mood of the story and give dramatic rendering to some of its tense moments. Much attention is paid to the locality of the various scenes. In many ways the settings parallel those of the *Maqâmât* scenes, though the architectural elements are here always placed at the sides and not in the background as is more usual in the Eastern paintings. There is, however, one specific difference: the action takes place in a more aristocratic and refined atmosphere. In order to love in the proper style of the Arab stories the hero must belong to the well-to-do; only then could he enter the palaces of the nobles. In this respect the *Bayâd and Riyâd* manuscript differs from the more popular milieu represented by the paintings of the great *Maqâmât* masters. Also in those moments when a person was not deeply disturbed by emotions of love, every action and every expression was strictly regulated by convention. The deportment of the figures in *Bayâd and Riyâd* is thus in sharp contrast to the rough, jerky movements of the *Maqâmât* characters. Even the sounds evoked by the two sets of illustrations—the lovers' melancholy songs and the voices in strident dispute or the blaring street noises—seem to come out of different worlds.

There is no indication as to where this manuscript was executed, whether in Morocco or, as one might think in view of the sophistication of the miniatures, in Spain itself.

Story of Bayâd and Riyâd (Hadîth Bayâd u Riyâd): Bayâd singing and playing the 'Ûd before the Lady
and her Handmaidens. Maghrib (Spain or Morocco), thirteenth century. (175×192 mm.)
MS. ar. 368, folio 10 recto, Biblioteca Apostolica, Vatican.

The affinity with thirteenth century paintings in the Eastern Mediterranean points to a similar date. We have only to compare the trees to establish this relationship or consider Illustration page 79 the staring eyes without pupils, which have a close parallel in the *Maqâmât* manuscript dated 1222 in the Bibliothèque Nationale. The iconographic setting with Bayâd playing Illustration page 129 the *'ûd* before a group of ladies is similar to that of "Solon Addressing his Students" in Illustration page 77 the al-Mubashshir manuscript; but the types are here appropriately changed and another distinguished person, the noble lady, is added at the left. Moreover, the composition Illustration page 94 using architecture at one side of the main scene, at least, is a feature found in the Syriac *Lectionary* of 1220 from the Mosul region. Even the motif of a figure embracing a column, Illustrations pages 106-107 known to us from the Leningrad *Maqâmât*, occurs in a miniature with Riyâd (not illustrated here) as does the open staircase. All this supports not only a thirteenth century

Treatise on the Fixed Stars (Kitâb Suwar al-Kawâkib ath-Thâbita) of as-Sûfî: The Dancer (Heracles). Ceuta (Morocco), 1224 (621 A.H.). (136×163 mm.) Ross. 1033, folio 19 verso, Biblioteca Apostolica, Vatican.

date for the manuscript, but indicates also that for this treatment of an Eastern theme in the West the illustrator leaned heavily on Eastern traditions to which he gave local color by introducing Western features.

The Story of Bayâd and Riyâd is, however, not the only illuminated manuscript from Western Islam which treated themes current in the Eastern Mediterranean world. A Dioscorides of the thirteenth century in the Bibliothèque Nationale (Arabe 2850) contains pictures of plants that are very similar in their general character to those in the volumes executed in Baghdad or Northern Mesopotamia. Occasionally some limited indication of the plant's habitat is provided and in one case snakes are introduced; but otherwise there are no human or animal images. More important is the *Book on the Fixed Stars* by as-Sûfî, executed in Ceuta (Morocco) in 1224, the only Western Islamic manuscript so far found which has information about both place of origin and date (Vatican Library, Ross. 1033). This manuscript follows the iconographic tradition of this famous text, but with some definite changes. The constellation of "Hercules," for instance, still shows him Illustration page 130 as the "dancer," but he has lost the sickle-like scimitar that he held in the manuscript of 1009 in the Bodleian Library (Marsh 144). He has also been turned from a youth into a mature, bearded man who, unlike other figures, does not wear a turban. The linear aspect traditional in the Eastern as-Sûfî manuscripts is preserved at least in the delicately drawn face; but the "Hercules" is now dressed in a garment the red and blue stripes of which seem also to be the stylization of the fold patterns. Unfortunately we cannot yet say how much of this figure represents a common Western version; nor do we know from the small amount of material available whether there was a marked difference between Moroccan and Spanish examples. The as-Sûfî drawings do, however, indicate that various forms of artistic expression were used in Western Islam, during the thirteenth century, for the stylistic differences between this manuscript and *The Story of Bayâd and Riyâd* are very marked.

Spain is also the only Muslim country from which an example of late medieval wall decoration has survived. However, even in this case the small size of the figures in the superimposed bands (the horsemen being hardly 20 cm. high) suggests a possible connection with miniature painting. These figural decorations were found on the portico walls of a ruined house, now called Torre de las Damas, in the Alhambra Palace in Granada and according to Leopoldo Torres Balbás should be attributed to the first half of the fourteenth century. In spite of their fragmentary state many different subjects executed in more than a dozen colors and gold can be recognized: mounted figures, domestic scenes with Moors of both sexes grouped as for a feast, hunters pursuing various animals including a lion and a monster, mounted troops returning to an encampment, the cavalcade including women and chained captives, also camels, loaded mules, and sheep. Varied as these subjects are, they are shown with little movement and no interest in space; each figure or scene is placed next to the other in additive fashion against an undecorated background. Although the iconography and the composition recall related features among Iranian painting of about the same period, there are also connections with earlier enameled decorations on Syrian glass and with Christian Spanish miniatures

as well. These East-West connections are all the more important as they demonstrate once again that in spite of local differences a unity of interests and artistic expressions existed throughout the Islamic world, in the early centuries as well as at the end of the Middle Ages.

The virtual disappearance of Spanish-Arab painting—there is not a single illuminated manuscript pertaining to it in any of the Iberian libraries—is all the more to be regretted because it makes it impossible for us accurately to gauge the impact this art has had on Hispano-Christian painting. However, because of this unquestionable influence, Mozarabic and Mudéjar painting can serve us in turn, as sources from which we can get some further glimpses of this lost art. We can reconstruct some aspects of it with the help of quasi-archeological methods. In this work certain manuscripts will be particularly valuable. For instance, the *Biblia Hispalense* (or *Codex Toletanus*) of the first half of the tenth century is an important document for the early period (Madrid, National Library, Vit. 14-1,2), while from the *Books on Chess, Dice, and Draughts* of 1283, written for Alfonso X, the Learned, we can glean some information for the important thirteenth century (Library of the Escorial). Not quite so enlightening, but still very helpful, will be an examination of the decorations in ecclesiastical structures, like the fourteenth century painted panels made for the Cathedral of Teruel, and now in the Archeological Museum of Madrid, or the painted dado in the Monastery of Santo Domingo el Real of Segovia, dating from the same century. Finally, the figural representations in the various media of the decorative arts, such as pottery, tilework, and textiles, will also yield some information. However, the light shed by the few remaining monuments and the data one can gather by historical research can hardly suffice to conjure up a true vision of what was undoubtedly a particularly appealing form of Arab painting.

The Beginning of the End

3

زاید برّیای ایستـاده تاچون بوزمین اُفند اُستخوانش شکسته نشود وبیـل زاشهوت اَنذل باشدچون
آدوو یکشی کند بوزمینهای شرقی لایـخوش رود مرغزادی اندر که کالفـاح نستبیار باشد وبوی می کند دوی

وی خوَند تاشهوَت زیادت کردد وماده باأوباشد واز نجذاشود وچوَن نکش آیذ زبانی زیان بسیار کند

Book on the Usefulness of Animals (in Persian: Manâfi' al-Hayavân) of Abû Sa'îd 'Ubayd Allâh ibn Bakhtîshû':
Two Elephants. Marâgheh (Iran), between 1294 and 1299. (Within inner frame: 182×191 mm; maximum
measurements of painting: 213×235 mm.) M. 500, folio 13 recto, The Pierpont Morgan Library, New York.

THE IMPACT OF THE MONGOL INVASION

THE great turning point in the history of Arab-Muslim painting is the Mongol invasion of the Near East, culminating in the conquest of Baghdad in 1258 and the murder of the last reigning 'Abbâsid caliph. It was a disaster unparalleled in Arab history. Even when cities were not actually reduced to ruins and their inhabitants killed, living conditions were greatly changed. Indeed, this cataclysm seems to have destroyed the social and economic climate that had made the flowering of the art of manuscript painting possible, particularly in the cities of Iraq.

Three major changes took place. First, many artists were physically uprooted. They had to migrate to safer places in the west or northwest. Others, later on, must have gone further east to look for employment in the newly established Mongol capitals. The shift in surroundings brought about the second change: the artists, working under new patrons, had of necessity to adapt themselves to changed times and different tastes. Finally, since the Near East, including Iraq, was part of a large Far Eastern empire, the art of the Near East was now subjected to Far Eastern influences. This infusion of Chinese features went well beyond the frontiers of the Mongol state; they are to be found also in Syria and Egypt, which, thanks to the victory at 'Ayn Jâlût in 1260, had been able to ward off the Mongol invaders.

Iraq seems to have continued the tradition of manuscript illumination in a limited fashion, although for one hundred and fifty years it was ruled by Mongols, who were heathen at first, but later on became Persianized Muslims. The real center was now the Mamlûk kingdom of Egypt and Syria. Here some of the old favorites of Arab book illumination continued to be produced, but in a different spirit. Although painting never again attained the high artistic levels reached in the first half of the thirteenth century, the last third of the thirteenth and the first half of the fourteenth century witnessed a minor revival of the art.

Let us now examine more closely the impact of the Mongol invasion on painting. One of the most significant series of miniatures of this period is a sequence of Illustration page 134 eleven illustrations at the beginning of a manuscript of *The Book on the Usefulness of Animals (Manâfi' al-Hayavân)* by Ibn Bakhtîshû' (New York, Pierpont Morgan Library, M. 500). This text treats man and animals in the same systematic manner that

Dioscorides had applied to plants; it differs only in that, as a medieval treatise, it contains more fantastic folklore and medical superstition than did the classical counterpart. This particular volume was executed in Marâgheh in Northwest Persia between 1294 and 1299 for a private person of obviously discriminating taste, but with no royal or official title. The illustrations of the first chapters, dealing with man and most of the big quadrupeds, continue the Arab pictorial tradition of the pre-Mongol period. In contrast to these the rest of the manuscript contains the work of several painters, who were to varying degrees influenced by different types of Chinese painting. From this juxtaposition of styles we may assume that artists of various origins converged in this Mongol center to produce illuminated manuscripts. To these belonged a painter from Lower Iraq, who continued to paint in the tradition to which he was accustomed. In the

Illustration page 134

"Two Elephants" we have the same grassy baseline for the animals to stand on, close to the front plane, and the same trees and birds in the background that are found in other Arab paintings, especially those from Baghdad; and in several pictures of this first series one can note the same combination of shrewd perception of the animal's special qualities with a natural way of presenting them that had distinguished the

Illustration page 117

"Drove of Camels" in the Paris *Maqâmât* manuscript of 1237. The "Two Elephants" are, however, depicted with more animation than one would expect to find in the illustration of a scientific treatise; indeed, three paintings by this master show animals in scenes of courtship or attending their young. (For another example of this series see the "Two Lions" in Basil Gray's *Persian Painting*, p. 20.) A trend toward an active

Illustrations pages 98-99

interrelationship between figures was already discernible in the two frontispiece miniatures of *The Epistles of the Sincere Brethren*, and there are, of course, many parallels for the inclusion of such genre elements as the little caps and bells of dressed-up court

Illustrations pages 62-63

animals. Compared with the earlier, more formal *Kalîla and Dimna* illustrations, this miniature has, therefore, a greater human appeal. There is one unexpected and novel feature, the transformation of the skin folds into an allover series of stripes. But the tendency to change a natural, haphazard element into an ornamental pattern must have existed in earlier manuscripts now lost; we have already detected it in the stripes of

Illustration page 130

the garment worn by "Hercules" in *The Book of Fixed Stars* written at Ceuta in 1224.

Illustration page 134

While a close tie-up with other Arab paintings is thus assured, it is, nevertheless, legitimate to ask whether the "Two Elephants" and other miniatures of the same series are not possibly rendered in a Persian style as the manuscript was after all painted in Iran. In the light of all that we know of early Persian painting at this time, the answer must be negative. No Persian miniature has so sensitive an understanding of the more unusual animals or reveals such a degree of interrelationship between figures—in this case leading to a physical interlocking of forms. Actually we must assume Persian animal painting to have been formal, even rigidly stylized. This is demonstrated by a bestiary called *Description of Animals (Na't al-Hayawân)*, allegedly the Arab version of an Aristotelian text of which the British Museum owns an undated, though pre-Mongolian manuscript, probably executed in Baghdad (Or. 2784). Here the elephant is a single, purely formalized design, ultimately based on a Seljûk Persian textile pattern; other

miniatures like those of rams or rabbits show the heraldic poses of confronted or addorsed animals, again favored by Persian textile designers. In many instances the Iraqi miniaturist has tried to weaken this ornamental harshness by giving the animals a human touch or by placing them in a landscape setting, but hardly ever has he succeeded in completely breaking the decorative formality innate in the Persian type of animal design. Such evidence assures us that the quite differently treated "Two Elephants" in the Morgan manuscript represents an extension of Arab art into Iran.

In many respects one might regard this miniature as one of the outstanding achievements of pure Arab painting, and if so, it seems to belie the destructive effect imputed to the Mongol invasion; but though the painting has great artistic merit, it also forebodes the end. Transferred to a foreign land and operating under the influence of a strange and highly organized court, this tradition which had formerly expressed itself so freely and naturally came to an end. Though the lines around this miniature appear to be only a minor and insignificant feature, and even an ineffective one as they do not wholly contain the design, they symbolically express the new constraining forces which were to choke the exuberant spirit of this style. The frame presents an element so far used only in the courtly frontispieces and for illustrations of the Mosul school, all of which betrayed a connection with the more formal Persian miniatures. Illustration page 134

Only one manuscript has survived which tried to bring about a fusion of Arab and Chinese features although the effort was not really successful. This is a volume dated 1307 in the University Library of Edinburgh (NO. 161), a work dealing with the chronology of Oriental peoples called *Vestiges of the Past (al-Athâr al-bâqiya 'ani 'l-qurûn al-khâliya)* by the famous Persian scientist and historian, al-Bîrûnî (973-1048). Most of the human figures adhere to the tradition of Arab painting, not only in dress, but also in their arrangement in groups along the ground line at the very front of the picture plane. (For an example, see Basil Gray, *Persian Painting*, p. 27.) However, the faces now have a Mongol cast, and for the delineation of the folds, which are still in the classical tradition, an unusual form of ripply wrinkles is used. The two-dimensional architecture and the interior settings, too, are purely Arab, so much so that a miniature showing Muhammad preaching his farewell sermon might be regarded as very close to the mosque scenes in *Maqâmât* manuscripts. The landscapes are, however, composed of Chinese elements which are also employed for the sky and clouds. Moreover, the receding planes of these outdoor settings reveal a new sense of space which even affected some of the scenes executed in the traditional Arab manner. As most of the paintings in this manuscript differ from the illustrations made in Iran in the early fourteenth century, we can assume that this volume comes from the Iraqi part of the Mongol Persian kingdom, or that it was executed by an Iraqi painter working in a studio in Northwest Iran.

This experiment in adapting a new style did not bring about a new synthesis. While Arab painting persisted in scientific manuscripts, especially in the illustrations of al-Qazwînî's texts, for the illustrations of literary texts this art could not hold its own in competition with Persian painting in the Chinese manner or with the newly developing Persian miniature style.

Ibn Bakhtîshû''s work belongs to a series of illustrated handbooks which deal with specific subjects such as stars, plants, or automata, discussed earlier in this survey; but the group must have been even more extensive, and included, for instance, an illustrated treatise, dated 1188, on medical and pharmaceutical instruments by the Spanish physician az-Zahrawî, known in the West as Abulcasis (Patna, Khudabakhsh Library, NO. 2146). A book of a different type, created in the thirteenth century, succinctly and yet systematically treated every natural phenomenon known in the High Middle Ages. This encyclopedic work was the cosmography of al-Qazwînî (1203-1283) entitled *The Wonders of Creation and their Singularities ('Ajâ'ib al-makhlûqât wa-gharâ'ib al-mawjûdât)*, which dealt with the heavenly bodies and angels, with the minerals, the flora, fauna, and man.

Illustration page 138
Illustrations pages 87, 97, 106-122
Fortunately an early illustrated copy of this text has survived (Munich, Staatsbibliothek, C. arab. 464). It was written in 1280, three years before the author's death, in Wâsit, the city where he had been cadi. The style of the "Angels Recording the Deeds of Men," belonging to this copy, differs from that of *The Book of Farriery*, the *Herbal* of Dioscorides, and the *Maqâmât* of Paris and Leningrad, although these, too, were executed in Lower Iraq. Instead of the extensive and deep-toned color scheme of the earlier manuscripts, the pigments used in this case are more limited in number and are light in hue with darker tones employed only to indicate folds. This produces a much paler

The Wonders of Creation ('Ajâ'ib al-Makhlûqât) of al-Qazwînî: Recording Angels. Wâsit (Iraq), 1280 (678 A.H.). (97×165 mm.) C. arab. 464, folio 36 recto, Bayerische Staatsbibliothek, Munich.

The Wonders of Creation ('Ajâ'ib al-Makhlûqât) of al-Qazwînî: The Miraculous Rescue of the Stranded Voyager.
Wâsit (Iraq), 1280 (678 A.H.). (119×169 mm.)
C. arab. 464, folio 65 verso, Bayerische Staatsbibliothek, Munich.

allover impression and gives the paintings a more linear quality. In this respect the manuscript follows Far Eastern esthetic principles. As the face of the angel at the left indicates, some of the ethnic features also took on a Mongoloid cast. However, the paintings are on the whole still rendered in a Near Eastern idiom.

Though the style of this miniature seems different from that of the nearly contemporary "Two Elephants," both reflect a similar approach: each artist presented his subject on a large scale and then imparted to its surface an allover fold pattern with a life of its own. This mannerism gives to these paintings a powerful, dramatic and tense quality. The "Recording Angels" are important from still another point of view. Their iconography represents a religious concept for the first time in the whole sequence of book illustrations which we have been considering. Angels are included in the treatise because, though supernatural creatures, they are believed to be part of the physical cosmos. Illustration page 138
Illustration page 134

The miniature on folio 65 verso reflects the predilection of the period for the strange and wonderful. It illustrates a well-known sailor's tale that occurs also in the second Illustration page 139

Illustration page 139 voyage of Sindbad in the *Arabian Nights*: a marooned traveler is carried by an enormous white bird which brings him from a deserted island across the sea to human habitations. The drawing of the mountains has again the linear quality not found in earlier Arab miniatures, although other parts of the painting, for instance the bird or Illustration page 138 the voyager, have nothing about them to suggest a Chinese source. As in the "Recording Angels" the artist was able to bring out the monumental and dramatic quality of the scene; by means of the bizarre shapes of the mountains he also gave it the strange desolate look appropriate to the subject.

Illustration page 139 Al-Qazwînî's cosmography became a perennial favorite, not only in the Arabic original, but also in other Islamic tongues, and all these versions have often been illustrated. For the Western connoisseur these paintings have one further attraction, which is clearly brought out by the "Flight of the Giant Bird." Being a rather uncritical compilation, the text contains many fantastic accounts of strange creatures. While those tales have no scientific relevance, some of the miniatures accompanying them do at least provide us with a welcome substitute for an illustrated version of "Sindbad's Voyages." The stories of the *Arabian Nights*, delightful as they are, were not recognized as a higher form of literature, but rather as a popular form of entertainment, and so were in all probability not thought of as worthy subjects for an illustrator. However, there also existed fully accepted works dealing with various scientific and literary genres, which used motifs that occur in the *Arabian Nights*, and episodes of this kind were occasionally illustrated. The Munich manuscript of *The Wonders of Creation* contains probably the earliest examples of such quasi-illustrations of the *Arabian Nights*.

Unlike the case of the miniatures just discussed, the Far Eastern influence did not in most instances extend to the coloring. The blacks, grays, and whites or the rather delicate color-tones of Chinese painting did not appeal to the Near Eastern esthetic sense. Certain other Chinese conventions were, however, taken over. They are strikingly apparent in a miniature from a now dispersed manuscript which seems to have contained another version or possibly an imitation of Bidpai's *Kalîla and Dimna*. In the miniature Illustration page 141 showing a "Bear Talking to Two Monkeys," in the Freer Gallery of Art (NO. 54.2), the Illustration page 117 animals are rendered with the same realism found in the "Drove of Camels" of the Paris *Maqâmât*. The landscape is, however, quite different from anything in that manuscript or in the initial set of illustrations in the Morgan Library's *Book on the Usefulness of Animals*, some of which show animals executed with the same naturalism found in the drawing of the similar creatures in the Freer miniature. Every element of the scenery is now of Far Eastern derivation. Instead of the usual two-dimensional grassy ground Illustration page 134 line which was still found in the "Two Elephants" we can now observe a receding plane on which various plants grow, much as they do in Chinese landscape paintings. The same source is responsible for the gnarled tree with its crooked trunk, the large and smaller plants, and the blue stone with many holes which represents an adaptation of the pumice-stone-like boulders used by the Chinese for decorative purposes. The Chinese influence in this miniature comes, however, only at second hand. It derives from the treatment of Far Eastern elements in Persian manuscripts of around 1300. The miniatures in the later

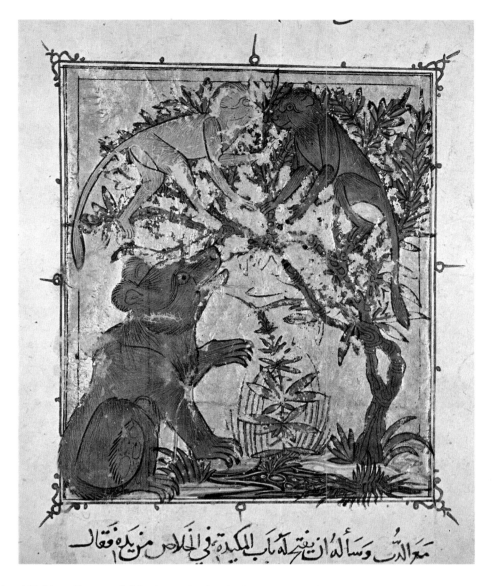

مع الدب وسأله ان يفتح له باب الكيدة في الخلاص من يده فقال

Book of Fables: Bear and Monkeys. Probably Egypt, second quarter of the fourteenth century.
(Painting: 115×97 mm.) 54.2, Freer Gallery of Art, Washington, D.C.

sections of *The Book on the Usefulness of Animals* in the Pierpont Morgan Library
contain many examples where such trees, plants, and rocks occur on a receding plane.

By analogy with other paintings (presently to be discussed) one would have to date
this miniature to the second quarter of the fourteenth century; it was probably executed Illustration page 141
in the Mamlûk kingdom, most likely in Egypt.

Another miniature belonging to the category under discussion is one showing "Two Illustration on title page
Herons" in a second work entitled *The Book on the Usefulness of Animals*, this time
composed by Ibn ad-Durayhim al-Mawsilî who was also the scribe. It occurs in a unique
manuscript, dated 1354, also executed in the Mamlûk kingdom—most probably in Egypt
—and now in the Escorial Library (ar. 898). The calligraphic quality apparent in the

Illustration on title page

execution of the plants, and even more so in that of the two birds, indicates a Far Eastern influence. In this case we know the actual Persian miniature that served as a model. It is now in the Freer Gallery of Art (NO. 27.5) and came from a dispersed manuscript of Ibn Bakhtîshû''s work of the early fourteenth century. The forms have become much heavier and more solid-looking; also some of the original design has been reinterpreted. The waves through which the birds are wading, for instance, have turned into snake-like branches with a few leaves attached. In addition the scene is now set against the gold background typical for a group of Mamlûk manuscripts. But in spite of all the changes the Far Eastern character of the general treatment is quite obvious.

Illustration page 174

Illustration page 152

In other manuscripts the Far Eastern element introduced by the Mongol invasion consists only of a plant, at times even only of a flower forming the pattern of a garment or fitted into some unit within the painting. Though limited in scope, this feature is the most common borrowing and is widely found in the decorative arts. A characteristic example, dated 1337, is to be noted in the scene from the "Twenty-seventh Maqâma" of al-Harîrî in which Abû Zayd helps al-Hârith to regain a lost camel after having first stolen his horse (Bodleian Library, Marsh 458). Instead of a conceptual landscape in the Near Eastern manner, we find one executed in a Far Eastern idiom. In particular, the big, colorful lotus flower in the upper left betrays this origin. Even the irregular ground plane with its indication of overlapping units derives ultimately from a Far Eastern space convention. Since background designs with lotus flowers on their stems also occur in a slightly earlier illustrated Shâh-nâmeh manuscript in a Persian-Mongol style, this form of Chinese influence, too, might very well have been transmitted only indirectly. The human figures are, however, entirely Near Eastern, as is the allover handling, with its gold background and formal frame, which comply with the taste of the Mamlûk kingdom.

The foregoing makes it clear that the impact of the Mongol invasion on Arab painting was quite different from its effect in Persia. There vital features of Chinese painting were grafted onto the Irano-Turkish style, a process which together with certain Arab elements produced a new synthesis—mature Persian miniature painting. This development became possible through the fact that after a few decades the Mongol rulers of Iran accepted Islam as their religion and became Persianized. The situation in the Arab world was quite different. Iraq had greatly declined as it was no longer the seat of the central government; its vital system of canals was partially destroyed and Bedouin tribes encroached on the arable lands. Thus this old center was no longer in a position to regain a continued productive state, especially as it was now only a province of a Persian kingdom with no direct ties with the rest of the Arab world. On the other hand the Mamlûk kingdom regarded the Mongols as its arch enemies so that everything Far Eastern was anathema. The historical situation explains the abortive nature of the Mamlûk attempt to make use of Far Eastern esthetic principles. On the whole, only certain specific features were taken over and these lived on as foreign bodies in a highly conservative and rather limited art. This is also the reason why the Far Eastern elements appear only at second hand. In the last analysis the Mongol invasion was a negative force, hastening the demise of what had been only a short time earlier a flourishing and highly creative art.

THE FORMALIZATION OF MINIATURE PAINTING
(THE BAHRÎ MAMLÛK PERIOD, 1250-1390)

The last period which produced a specific sustained style is that of the first dynasty of Mamlûk rulers of Egypt and Syria, the so-called Bahrî Mamlûks. The two Mamlûk or Slave dynasties received their designation because the heads of state or their forefathers had begun their careers as foreign slaves, chiefly of Turkish origin, serving in the royal bodyguards. All the high functionaries or emîrs had likewise been such "mamlûks" and had been promoted to their positions on the basis of their abilities. The rigid feudal organization for both civil and military offices consisted of a hierarchy of many grades and functions with all the affairs of state centered in Cairo and to a lesser degree in Damascus.

This structural system is mirrored in two aspects of the art of this period. It is the most rigidly composed art of the Islamic world. Complex geometric configurations cover not only the mosque walls and domes, but also the pulpits, doors, and shutters, and many of the metal objects, the bookbindings, Koran illuminations, and carpets as well. Illustration page 174 The other significant point is that one of the main forms of decoration, sometimes even the only one, is the calligraphic presentation of a sultân's or emîr's name with all his elaborate titles and his coat of arms. This preoccupation with strict order and rigid formality explains why the official painter of the Mamlûk period could not have produced a realistic, genrelike art with psychological implications, let alone an art of social satire— that is to say an art on the order of the Leningrad and Paris *Maqâmât* manuscripts. Illustrations pages 106-122

As far as subject matter is concerned the manuscripts of the Mamlûk period adhered more or less faithfully to the traditions established by the art of the book in Upper and Lower Iraq, and in Syria. We encounter again both illustrated scientific treatises and works of *belles-lettres*. There was a greater interest in books on military subjects, as can be seen from several treatises on military exercises and on the construction and use of military machines of which manuscripts have survived. Most of these date from the end of the fourteenth and the fifteenth century and are of little artistic significance.

The earliest example of the Mamlûk style is a unique manuscript dated 1273 of *The Banquet of the Physicians (Da'wat al-Atibbâ)*, a book of dialogues directed against medical charlatans written by the eleventh century physician and Christian theologian of Baghdad, Ibn Butlân (Milan, Biblioteca Ambrosiana, A. 125 Inf.). The most important of its eleven miniatures shows an old doctor who on waking from his sleep expresses his Illustration page 144 surprise on seeing his servant, his student and an entertainer gorging themselves with his food and drink. Several characteristic features of the new style are revealed: the painting has a schematic frame with arches indicating an interior; it strives after visual clarity, with little overlapping of figures; and it establishes a near-symmetrical balance by means of the two corresponding trays and the identical arches at either side, and by organizing the composition around the central axis formed by the striking figure of the red-capped Negro slave. The orderly structure of the painting does not preclude a rather

Illustration page 144 lively spirit, which is expressed by such details as the vivid gesture of the old man on the left, the surprised glance of the servant, who has abruptly turned his head, and the look of the bearded student on the right who listens with some astonishment to the sick man's speech. Indeed, the realistic animation of the scene, with the graphic gestures and glances which serve to tie the two parts of the composition together, reminds one of similar scenes in the *Maqâmât*. It seems that a universal iconographic language had been evolved, which could be used for many subjects. That the *spirit* of the *Maqâmât* could survive into these early decades of the Mamlûk period is, however, the most important aspect of the miniature.

Another significant feature of this painting is the use of folds of two particular kinds on the garments of all figures, composed of large ovoid shapes with darker shades along the lower edges and "ripply wrinkles." These are supposed to represent two types of folds, and in earlier paintings of this century—for instance in the dresses of the two Illustration page 121 servant girls in the "Childbirth Scene" of the Paris *Maqâmât*—we still find them drawn

The Banquet of the Physicians (Risâlat Da'wat al-Atibbâ') of al-Mukhtâr ibn al-Hasan ibn Butlân:
The Awakening Doctor finds a Dinner Party taking place in his House. Probably Syria, 1273 (672 A.H.). (116×165 mm.)
MS. A. 125 Inf., folio 35 verso, Biblioteca Ambrosiana, Milan.

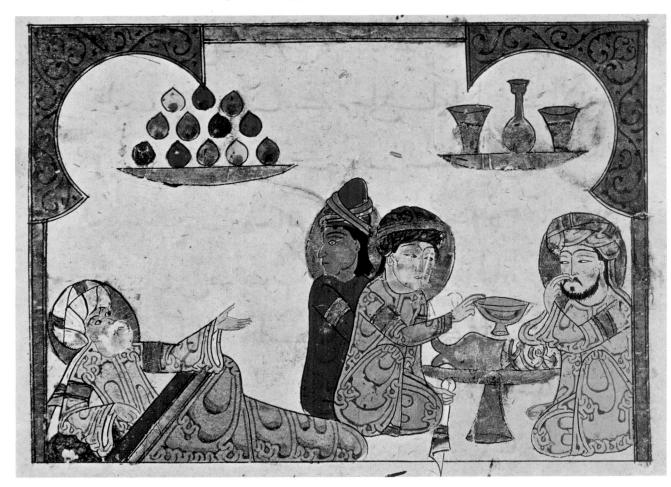

in a more natural manner; but as the massing of folds of the second type on the shoulders of the old man lying in bed indicates, they have lost their natural appearance and have become a stylized pattern. During the Mamlûk period these two forms of stylized folds often occurred together in the drawing of one garment; but the type with the large units can also be used by itself. The ripply wrinkles are a kind of hallmark of Mamlûk painting and, as we shall see, were even used to indicate the markings in material other than textiles. As in the preceding period, the artists usually combined garments having such fold patterns with other costumes decorated either with geometric designs or arabesques, but without any indication of folds.

Illustration page 144

As K. Holter has shown in his basic study of this school, the peculiar manner of representing garments occurred first in the paintings of the Mosul school, particularly in *The Book of Antidotes* in Vienna, although the treatment is already foreshadowed in the Syriac *Lectionary* of 1220 in the Vatican Library. This feature is not the only connection of the Milan manuscript with the North Iraqi school, as we find the same semicircular arch set on a bias in the frontispiece of the Vienna *Book of Antidotes*, which also contains a similar "floating" tray arrangement. As we know from signatures on inlaid brass vessels, families of metalworkers of the Mosul region first fled in the middle of the century to Damascus and some moved later on to Cairo. A certain number of the painters who sought escape from the Mongol hordes must have taken the same route and it was they who brought these motifs and mannerisms to the Mamlûk kingdom.

Illustration page 91
Illustration page 94

Illustration page 91

Another aspect of Mamlûk painting is apparent in a miniature illustrating the "Twenty-eighth Maqâma" in an undated manuscript of the *Maqâmât* in the British Museum (Add. 22.114). This miniature shows al-Hârith listening spellbound to a sermon delivered by Abû Zayd in the Mosque of Samarkand. H. Buchthal was the first to recognize that this miniature is based on a similar treatment of the scene in the Paris *Maqâmât* of 1237. The important difference between the two renditions is that in the later version the constituent elements are reduced so that there remain only three persons in the congregation; the prayer niche and the elaborate battlements of the roof have also been eliminated. This concentration on a few figures rendered in a rather large scale and on a few details of the *mise en scène* is another characteristic feature of the Mamlûk style. Buchthal likewise pointed out that a further influence on the eighty-four miniatures of this richly illuminated manuscript can be traced to the Syrian iconography of the *Maqâmât* manuscript of 1222 in the Bibliothèque Nationale. The manuscript is thus seen to be rather eclectic, and in view of the fact that it shows again the ripply wrinkles, it can be said to contain elements of all the main pre-Mongol Arab schools—Baghdad, Mosul, and Syrian.

Illustration page 146

There is even a detail of historical significance in this painting. Black had been the traditional color of the 'Abbâsid caliphs. When the heretical Fâtimid rulers of Egypt were overthrown, the preachers of their orthodox successors donned black dress for the Friday service and also used black flags and a black sword as signs of their allegiance to the established figurehead of Islam, although he now wielded very little political power. Even after the 'Abbâsid caliphate in Baghdad was abolished by the Mongols, the custom

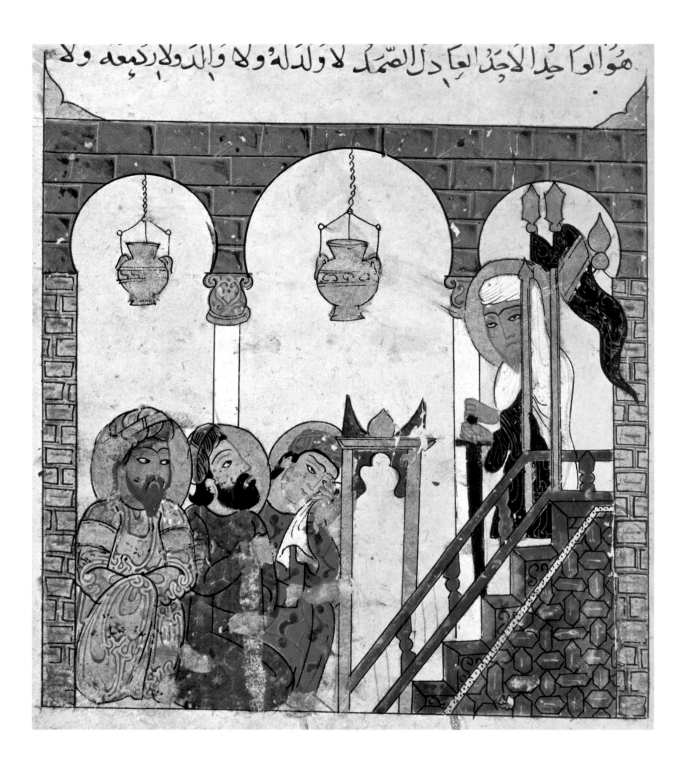

Assemblies (Maqâmât) of al-Harîrî: Abû Zayd preaching in the Mosque of Samarkand (Twenty-eighth Maqâma).
Probably Syria, c. 1300. (174×159 mm.) Add. 22.114, folio 94 recto, British Museum, London.

continued—as can be seen here—owing to the fact that in 1261 Sultân Baibars installed a member of the 'Abbâsid family as caliph in Cairo, where he and his successors, all puppets of the Mamlûk rulers, continued to reside till the end of the second dynasty. Illustration page 146

Since the treatment of the folds of the garment worn by the listener on the left is rather like that found on the two figures to the right in the Milan manuscript dated 1273, we may assume that the London *Maqâmât* is not much later and that it can be placed around 1300. Buchthal proposed a Syrian origin for the London *Maqâmât*, an attribution which by analogy would also apply to the Milan manuscript. Such a connection with Syria is supported by a stylistically related but unfortunately badly mutilated and "repaired" *Maqâmât* manuscript dating from about this time (British Museum, Or. 9718). It was painted by one Ghâzî ibn 'Abd al-Rahmân, the Damascene, that is to say by an artist who was himself a native of Damascus or whose family had come from there. His style can, therefore, be assumed to represent the Damascus tradition although as might be expected it shows Mosul influence as well. Illustration page 144

What may probably be called the outstanding manuscript of the Mamlûk school is the *Maqâmât* executed in 1334 and now in the Nationalbibliothek in Vienna (A. F. 9). It opens with a formal type of frontispiece showing a ruler cup in hand and surrounded by his courtiers, the whole framed by an elaborate colorful arabesque border. As has already been shown, this type of representation is ultimately based on Persian prototypes going back to Sasanian times. Its more immediate models were frontispieces of the Mosul school, one in *The Book of Songs* of about 1215-1219 in Istanbul which also had an elaborate arabesque border, the other in *The Book of Antidotes* in Vienna. The fourteenth century example is even more rigid than the more formal of the two earlier versions, where the ruler held a bow and arrow in what seemed a momentarily arrested action. Indeed, the figures of this *Maqâmât* frontispiece look as if they were devoid of any vitalizing spirit, movement or emotion and had become petrified. Even the acrobat in front of the throne, who has twisted his body into a complicated position, lacks all sense of motion or even of inner tension to indicate that his pose is only a momentary contortion. The same observation applies to the musicians on either side and to the angels who hold a garland over the ruler's head. Even such details as the harsh, untextile-like treatment of the folds, which further exaggerate the well-established Mamlûk pattern, and the gold edges of the garments so precisely outlined that they might have been drawn with a compass, contribute to the impression of utter rigidity. Another Mamlûk feature appears here for the first time, the gold background, which gives a rich appearance to this and to the other miniatures of the manuscript and ties the spottily applied colors together far better than the paper ground had done. Illustration page 148

Illustration page 65
Illustration page 91

Unlike the figures in the other Mamlûk manuscripts so far discussed, the ruler and members of his court are represented as of an ethnic type which is non-Arab. Most of the Mamlûk rulers and emîrs were of Turkish and occasionally of Mongol origin and it is apparently a Turkish or Mongoloid type from Central Asia which is here represented. In addition to the characteristic round face and the slanted eyes, we note the side ringlets and beauty spots, both features of special attraction of which the Persian poet Hâfiz has

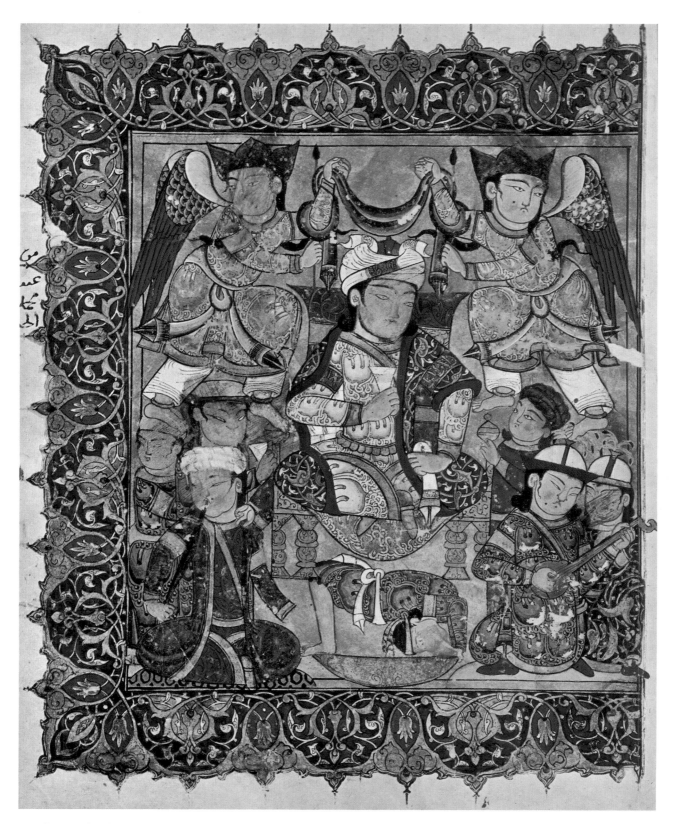

Assemblies (Maqâmât) of al-Harîrî: Frontispiece with Enthroned Prince. Probably Egypt, 1334 (734 A.H.).
(Painting: 192×175 mm.) A.F. 9, folio 1 recto, Nationalbibliothek, Vienna.

sung in his famous *ghazals*. The foreign aspects of this court are also clearly revealed by Illustration page 148
the costumes worn. The two musicians on the right have donned a plumed cap related
to Mongol headgear; the ruler, as well as the second largest figure, who has assumed the
ruler's pose and is therefore his son (or favorite), and the lute player on the right are
dressed in Turkish coats which close from right to left. The son's surcoat shows the over-
long narrow sleeve which also occurs in Mongol Iran. Both he and the ruler wear gold
belts belonging to the insignia of the Turkish military aristocracy; the prince's is the
richer of the two and is made up of a series of roundels. The prince, however, wears Arab
headgear, a big turban with "horns" of a type which in the miniatures of the manuscript
is worn by only one other dignitary, a governor. A form of this peculiar turban was
characteristic for the rulers of Egypt—as was the crown for Iran. It is therefore revealing
that the two angels are crowned, a last trace of the Persian origin of this iconographic
feature and of the whole setting.

The sixty-nine illustrations in this manuscript present Mamlûk painting possibly at
its most characteristic. In the illustration of the "Eighth Maqâma" in which Abû Zayd Illustration page 150
pleads his case before a cadi, the painter depicted a scene in an interior. Following an old
Byzantine tradition this setting is designated by the triangular curtain which aptly fills
the empty space between the heads of the two main figures. The picture is dominated
by the eloquent figure of the petitioner, otherwise all the other persons appear to be
immobile as they look on passively though their hands are raised in gestures. Actually all
the gestures and even the exaggerated body movement of Abû Zayd have become stereo-
typed and occur many times in the manuscript. Speech as the main feature of the illus-
tration is also stressed in the miniature illustrating the "Twenty-sixth Maqâma," which Illustration page 151
shows the destitute al-Hârith talking to Abû Zayd, who, for once, is opulent. The outdoor
scene takes place at night as indicated by the symbolic segment of a sky with crescent
and stars, another feature borrowed from the Mosul school. Without achieving the genre
character of the Baghdad miniatures, the artist is here concerned with the setting,
showing Abû Zayd in his tent with two servants nearby and two animals visible in the
rear. But there is no interest in landscape for its own sake, which, if represented at
all in the other paintings, includes only the most rudimentary symbols for plants, moun-
tains, and water.

In the two miniatures illustrated here all the figures have become standardized Illustrations pages 150-151
types: the judge with a scarf over his turban, Abû Zayd, al-Hârith, the youth, the
Negro servant, the bystanders. All are short-bodied, with particularly large heads;
in other words, the human shapes are a product of the same esthetic feeling which was
responsible for the more compact, nearly square format of the miniatures. Although
these squat figures are particularly striking in this volume, they are not a new feature,
but had occurred in earlier manuscripts, for instance in one of the *Maqâmât* of the Illustration page 146
British Museum (Add. 22.114).

Certain other mannerisms, characteristic for this manuscript, can be noted in the
drawing of the faces, for instance the sharply pointed or broad-backed noses, the big
red dots in the cheeks, the latter another coarsened feature derived from the Mosul school.

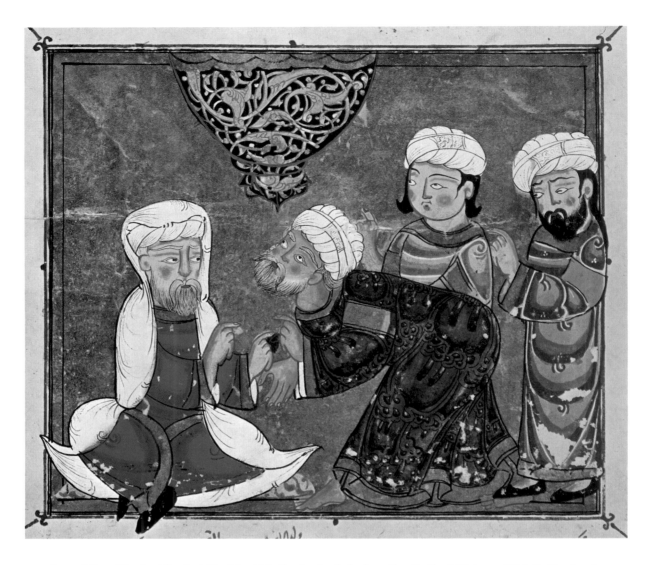

Assemblies (Maqâmât) of al-Harîrî: Abû Zayd pleads before the Cadi of Ma'arra (Eighth Maqâma). Probably Egypt, 1334 (734 A.H.). (126×147 mm.) A.F. 9, folio 30 verso, Nationalbibliothek, Vienna.

The garments are shown with the two typical fold patterns which now no longer seem to belong to soft textiles, but rather to something metallic. The only genrelike touch in these two paintings is the camel and the horse with its feedbag appearing behind the tent, but this is a motif developed by the *Maqâmât* painters of the thirteenth century. The camels and horses are also the only parts of the design that are allowed to protrude to a larger degree from the enclosing frame, as if they were not able to grasp the meaning of restraining laws; but this is also a feature of contemporary Persian painting, where this protrusion signifies, however, the motion of the animals. Yet, after all these tendencies toward formalization and coarsening of the earlier styles have been enumerated, one has to stress also that, owing to their extreme stylization and their many mannerisms, the paintings have a distinctive, even impressive style of their own, one that expresses

grandeur and monumentality. As every feature is reduced to its most essential and most telling elements, the general effect of these brightly colored scenes placed on a brilliant gold ground is not unlike that of mosaic.

We have already referred to the slightly later *Maqâmât* manuscript of 1337 in connection with the floral background decoration of Chinese derivation in the illustration of the "Twenty-seventh Maqâma" (Bodleian Library, Marsh 458). Although this floral Illustration page 152 design is drawn in a more spirited and colorful fashion than the rather insignificant, heavy-leaved plants in the Vienna *Maqâmât*, and the human figures are less squat and shapeless, the manuscript represents in other respects a further step in the formalization of this style. The faces are still more standardized and in fact offer only one set of features,

Assemblies (Maqâmât) of al-Harîrî: al-Hârith talks to Abû Zayd in his Tent (Twenty-sixth Maqâma).
Probably Egypt, 1334 (734 A.H.). (137×158 mm.) A.F. 9, folio 87 verso, Nationalbibliothek, Vienna.

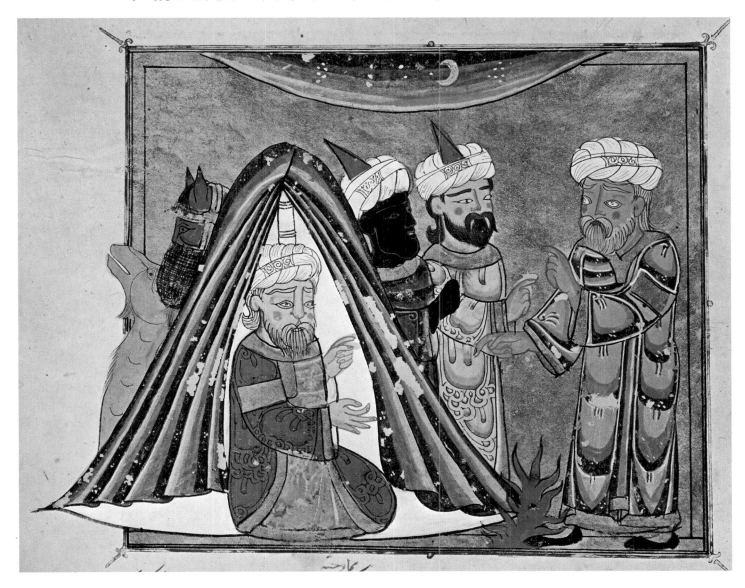

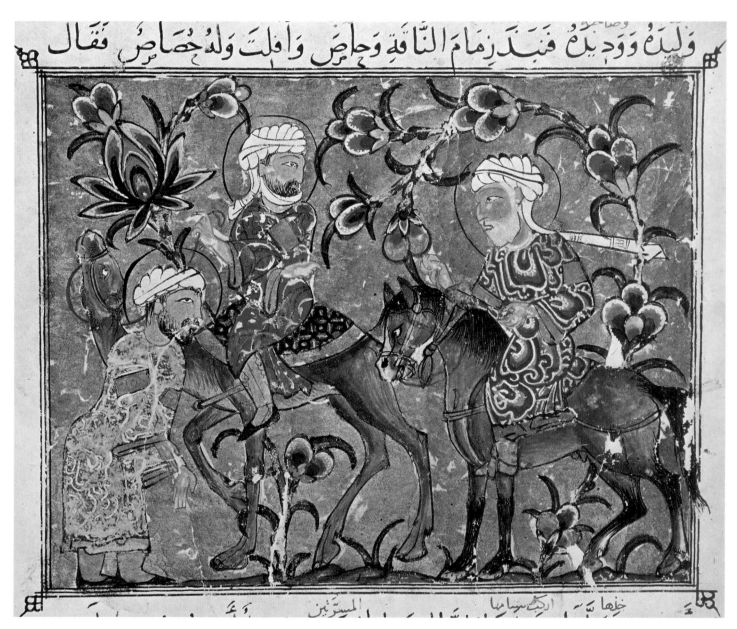

Assemblies (Maqâmât) of al-Harîrî: Abû Zayd helps al-Hârith to regain his Stolen Camel (Twenty-seventh Maqâma). Probably Egypt, 1337 (738 A.H.). (135×170 mm.) Marsh 458, folio 45 recto, Bodleian Library, Oxford.

Illustration page 152 the main difference being the color of the hair. The drawing of the garments, too, has further advanced so that the designs indicating folds have no possible connection with the natural fall of a fabric. The folds actually look more like patterns on watered silk. Moreover, unlike nearly every miniature in the Vienna manuscript the heads are again surrounded by gold haloes, although against the gold background this feature hardly performs its original function of emphasizing the head. Such signs of stylistic recrudescence are paralleled by iconographic inaccuracy. The text says that before the arrival of Abû Zayd, al-Hârith, the figure on the left, has pulled a man down from the back

of the camel he had appropriated; Abû Zayd then threatens the thief with a lance. Illustration page 152 Neither of these details of the story is indicated; the painter has limited himself to depicting the three main figures, al-Hârith on foot, the thief on the camel, and Abû Zayd on the horse. In the general formal presentation by means of approximately square units with gold ground, carefully delineated framing lines and special corner decorations, the Oxford *Maqâmât* belongs to the same class as the al-Harîrî manuscript in Vienna, even Illustrations pages 150-151 though not to the same studio or school. As the iconography and style of both manuscripts are different from those tentatively attributed to Syria, it may well be that these more spectacular and costlier manuscripts represent the art of Cairo, the capital of the sultanate. The Oxford copy is the only manuscript which had a direct connection with a high Mamlûk official, since it is inscribed as having once been in the library of a certain emîr. As such it has a formal frontispiece of the type imitated by other manuscripts with no specific aristocratic connection. The right section, which originally contained the figure of the enthroned prince, is now lost; the left part shows that the scene must have been a splendid one, as it presents a host of attending functionaries—among others the groom with the horse carrying an emblematic palanquin and the keeper of the cheetah caring for his charge.

Inasmuch as it is a Mamlûk painting showing human and animal figures, it seems appropriate to return here briefly to the miniature of the "Elephant Clock" in the Metro- Illustration page 93 politan Museum of Art discussed on an earlier page. As then pointed out, this miniature has become detached from a manuscript dated 1315 of *The Book of Knowledge of Mechanical Devices* by al-Jazarî. It must be regarded as a very conservative rendering on two accounts, first as involving a scientific illustration and secondly as the product of an archaizing school. Actually there is nothing in the treatment of the folds (usually a good clue to the date of a painting) which would seem to betray an early fourteenth century date. Only the rather coarse ornamental forms and the choice of certain designs, as well as the manner of presenting the figures, indicate that this is a later copy. All the miniatures of this set have a marked style of their own, with faces, bodies, and garments revealing the artist's unusually strong plastic sense. No other manuscript of a non-scientific character has so far been found that employs the same stylistic features. Owing to its unique nature this manuscript is difficult to place, but no cogent argument has thus far been raised which could discredit the usual attribution to Syria, possibly to Damascus.

While the formalization of figural scenes gives the Mamlûk miniatures of the fourteenth century an entirely different look from those of the thirteenth, the same cannot be said about the animal paintings in *Kalîla and Dimna* manuscripts. Being apparently based on old Persian iconographic patterns of a formal nature, the animal pictures had already reached a high degree of stylization when first encountered in the Illustrations pages 62-63 surviving manuscripts of the early thirteenth century. Compared with these the fourteenth century versions look stylistically little changed and, in contrast to the scenes Illustrations pages 154-155 with human figures, show nothing that can be called recrudescence. Sometimes the actions of certain animals are rendered so tellingly and the scenes are so successfully composed that truly monumental pictures result. Thus the refashioned scene in which

Illustration page 155

Illustration page 154

the crows burn their enemies, the owls, as they huddle in their rock cave is dramatic; at the same time it has enduring qualities that make it more than the picture of a fleeting moment (Bibliothèque Nationale, Arabe 3467). Only when the animal seems to take on a human expression, as in the case of the hare facing the elephant, do we find that petrified aspect noted in the figural scenes of the period (Bodleian Library, Pococke 400). As a whole, however, the miniature may still have a droll appearance. In addition there are certain secondary elements which betray the later date of these paintings. Thus the symbol for water has lost all its natural fluidity and turned into a solid-looking allover pattern reminiscent of the cellular units of enameled designs. Here the ripply wrinkle-fold

Kalîla and Dimna (Kalîla wa-Dimna) of Bidpai: The Hare and the King of the Elephants at the Well of the Moon. Probably Syria, 1354 (755 A.H.). (172×244 mm.) Pococke 400, folio 99 recto, Bodleian Library, Oxford.

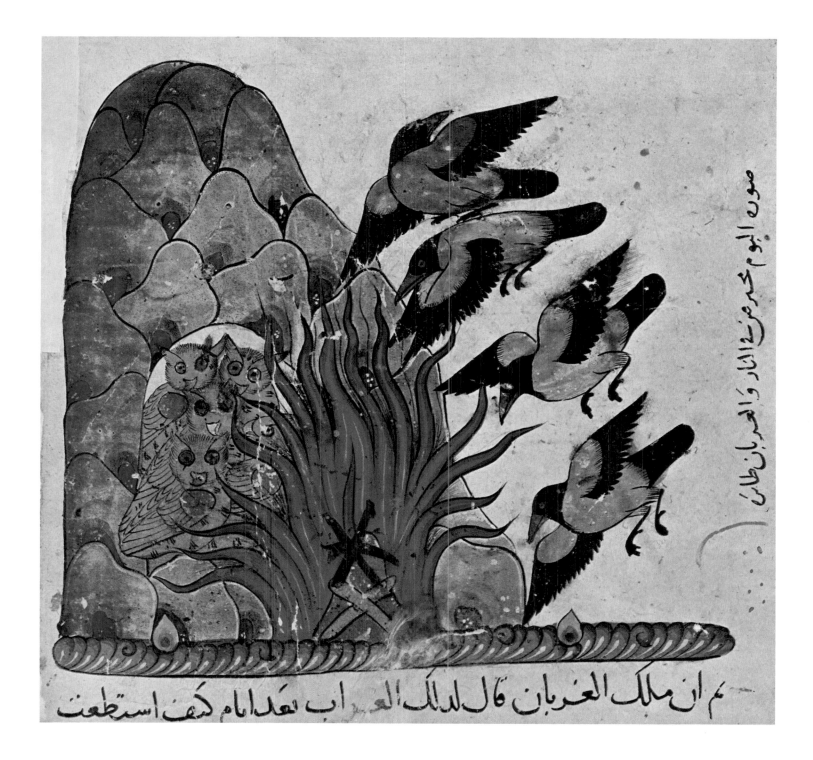

Kalîla and Dimna (Kalîla wa-Dimna) of Bidpai: The Crows using their Wings to fan the Fire with which they kill their Enemies, the Owls. Probably Syria, second quarter of the fourteenth century. (163×179 mm.)
MS. arabe 3467, folio 78 verso, Bibliothèque Nationale, Paris.

pattern is applied also to tree trunks to indicate their patterns. In the Escorial manuscript of *The Usefulness of Animals* this mannerism even spreads to the bodies of certain animals and occurs, for instance, on the backs of the crabs and the horn of the unicorn.

Illustrations pages 154-155

The relative date and country of origin of the two iconographically identical Bidpai manuscripts in Paris and Oxford (and of a related one in the Staatsbibliothek, Munich, C. arab. 616) have been the subject of much discussion. It seems that the rather crude and not too well preserved Munich copy is the oldest of the three, followed by the one now in Paris, while there is no problem with the Oxford manuscript as it is dated 1354. This leads one to assume a date in the second quarter of the fourteenth century for the Paris manuscript. As in some cases it is iconographically close to the thirteenth

Illustrations pages 62-63

century copy, which has been attributed to Syria (Bibliothèque Nationale, Arabe 3465), the same country seems to be the most likely source for the fourteenth century version.

While the illustrators of *Kalîla and Dimna* stories had the challenging task of presenting dramatic scenes from various fables, the painter who illustrated zoological handbooks faced a simpler assignment. He could usually concentrate on one or two animals and in presenting them he successfully blended three artistic tendencies: his natural ability to grasp and reproduce the vital aspects of an animal, his decorative disposition, and

Illustration page 157

his sense for the monumental. A characteristic example from a unique manuscript of al-Jâhiz's *Book of Animals (Kitâb al-Hayawân)* dating from the middle of the fourteenth century (Milan, Biblioteca Ambrosiana, AR. A.F. D 140 Inf.) is the charming picture of an ostrich brooding on eggs. The author's ironic commentary that the eggs are probably not the bird's own because in its stupidity it is inclined to sit on other eggs which it may come upon while foraging, has been overcome by the illustrator who shows the giant bird in monumental serenity. It is placed in a stylized landscape, the lateral elements of which form an ideal frame delicately following the outlines of the bird's body. Although a Mamlûk origin is certain for this manuscript it is more difficult to attribute its paintings to a specific country or school. They did not follow any established iconographic canon, but were made expressly as illustrations for this particular text and, in spite of the rather heavy hand of the Mamlûk painter, they fit it perfectly.

Illustrations pages 154-155

In view of the general stylistic resemblance with the Bidpai manuscripts in Paris and Oxford and the near-identity of such specific patterns as those used for water, plants and architecture, we may tentatively ascribe the Milan manuscript to Syria as well.

Illustration page 146

As it is stylistically more advanced than the *Maqâmât* in London (Add. 22.114) and

Illustration page 154

certainly not as much as the Bidpai of 1354 in Oxford, we may attribute it to the second quarter of the fourteenth century.

A further stage in the development of Mamlûk painting has been reached in a unique manuscript probably executed shortly after the middle of the fourteenth century.

Illustrations pages 158-159

This is Ibn Ghânim al-Maqdisî's *The Disclosure of the Secrets (Kashf al-Asrâr)*, which deals with the existential purpose of flowers, birds, and other animals (Istanbul, Süleymaniye, Kala Ismail 565). Its pictures combine the formal display customary in Mamlûk painting with a decorative arrangement and also with a new gracefulness, commensurate with their comparatively small size.

The picture of the "Duck" presents its main subject like a painted metal form, Illustration page 158 and it is rendered in the same monumentalized manner that had been employed for the "Ostrich" in the Milan al-Jâhiz manuscript. Another Mamlûk feature is the device Illustration page 157 used for depicting the water in the stone-rimmed pool—again the same resemblance to cloisonné already found in the "Elephant and Hare" scene in the Bidpai of 1354. Illustration page 154 While the miniature thus reveals the stylized mannerisms of Mamlûk painting, it also includes features which go beyond the customary aspects of that style. The composition is built up symmetrically and, as the plants and other corresponding elements indicate, with greater strictness than is usually the case. There was no textual necessity for introducing the lateral arches with their flower vases; such decorative accretions to the subject matter are in fact foreign to the Mamlûk style, which insists on an uncluttered dramatic presentation of the theme. Moreover, the ambiguity with regard to the character of the locale in which the scene takes place—it seems to be half indoors and half outdoors—is non-Mamlûk.

Book of Animals (Kitâb al-Hayawân) of al-Jâhiz: An Ostrich sitting on Eggs. Probably Syria, second quarter of the fourteenth century. (116×189 mm.) Ar. A.F.D. 140 Inf., folio 10 recto, Biblioteca Ambrosiana, Milan.

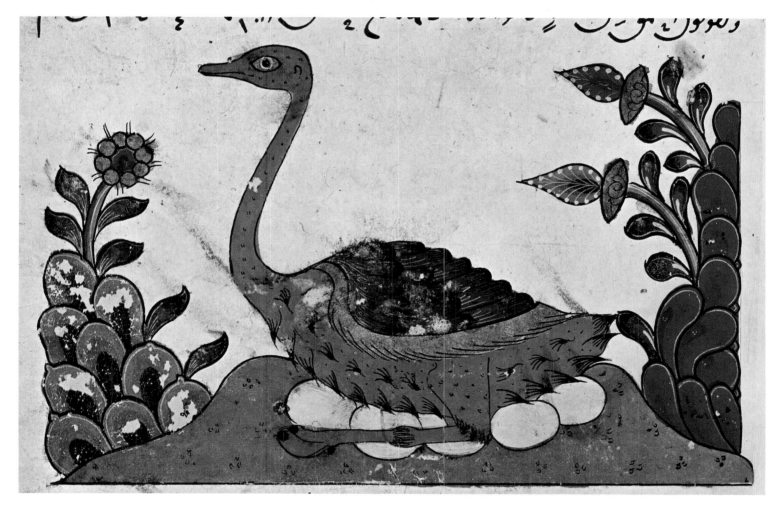

The Disclosure of the Secrets (Kashf al-Asrâr) of Ibn Ghânim al-Maqdisî: The Duck.
Probably Syria, middle of the fourteenth century. (70×117 mm.)
Kala Ismail 565, folio 29 verso, Library of the Süleymaniye Mosque, Istanbul.

All these mutations are due to Iranian influence. Persian art is imbued with a decorative spirit; it prefers a balanced symmetrical composition; and its scenes take place in open *eyvân* recesses or near pavilions, both in close proximity to gardens or surrounding nature. Even some lesser details bear out this influence: the framing corner arches which in Arab painting originally indicated an interior occur as part of an outdoor scene in Persian animal miniatures of the early fourteenth century; while the *semé* of grass behind the flower vases, so different from the gold ground for the duck itself, appears first in a realistic manner in the Morgan *Manâfi'* manuscript from the end of the thirteenth century and then in a more decorative fashion in a Persian *Kalîla and Dimna* manuscript of 1343 (in the Egyptian National Library, NO. 61, Litt. pers.) to become a common feature of Iranian painting after that date. The result of this mixture of Mamlûk and Persian elements is a delightfully decorative picture, more like a vignette than a full-fledged painting; yet the miniature has paid a price for its overall appeal because its illustrative function is weakened. Addressing the earth-bound rooster, in the text, the duck boasts of mastering air, land, and water. "I march on the earth, I float on the rolling waves and I fly freely in ethereal regions. The sea especially is the source of my power and the mine of my treasures; I throw myself into its limpid and

The Disclosure of the Secrets (Kashf al-Asrâr) of Ibn Ghânim al-Maqdisî: The Myrrh Plant.
Probably Syria, middle of the fourteenth century. (77×112 mm.)
Kala Ismail 565, folio 6 verso, Library of the Süleymaniye Mosque, Istanbul.

transparent waves; I discover the precious pearls which it conceals and I penetrate the mysteries and marvels of God." But, alas, in spite of this assertion, we find the duck nearly immobilized in a tiny pool of solid-looking water.

The miniature illustrating the chapter on the "Myrrh"—actually a discussion Illustration page 159 between this fragrant herb and the rose about their existential philosophies—reveals certain artistic aspects which are thoroughly in character, while others are new. Here, again, is a tripartite composition with the vase and plant placed centrally in the same setting; the combination of stones of two colors and the gold background, as well as the three horse-shoe arches and the ornaments above them, are also typically Mamlûk. But, as happened earlier in the Dioscorides manuscript of 1224 (Ayasofya, NO. 3703), the artist Illustration page 87 has added human and operational elements not demanded by the text. On the left an ornate furnace with a flask suspended under an alembic indicates that the aromatic resin is being distilled from the leaves, while the seated figure on the right seems to be admiring the plant or possibly talking about it. It will be noted that the folds of his garments are not rendered in the usual Mamlûk fashion but rather more in the classical tradition. Folds of the classical type are found particularly in Syria, and indicate a possible Syrian origin for the manuscript. Such an assumption is strengthened by the miniature

of the "Bats," which is quite unlike the representation of these mammals in the Escorial manuscript on *The Usefulness of Animals*, attributed to Cairo. There only the ferocious-looking creatures themselves are presented, while in the Istanbul illustration they appear as tiny flying shapes at the side of a large domed building, which even partly hides two out of the four shown. Such an elaborate architectural composition was not demanded by the text nor does it occur in any other Mamlûk painting. It is actually surprising in this context, especially in view of the limited space given to the animals.

This interest in architecture can serve us as a clue to the origin of the manuscript. Buildings have always formed a favorite subject matter in Syria, Palestine, and Trans-jordan, first found in a fifth century floor mosaic in Antioch, then in the floor mosaics of sixth century churches and finally in the early eighth century in the wall mosaics of the Great Mosque in Damascus. After this early use they occur again in the decorations of the Madrasa Zâhiriya of 1277 and are then to be found on pottery and metalwork dating as late as the fifteenth century. The distinct character of the al-Maqdisî miniature would thus be due to Syrian or Palestinian predilections combined with features of Cairene origin.

It is tempting to compare the early and late architectural renditions and to see what conclusions can be drawn from them. What in the Great Mosque of Damascus had been a vital feature of a vast ensemble, striking a grand political keynote, has now become an unnecessary motif in a small miniature purporting to illustrate an allegorical homily, but mainly serving a decorative purpose. Yet in both cases the theme is expressed in architectural terms, and the buildings represented have a monumental air whether rendered on a large scale or on a more intimate one. The pictorial language in which ideas can be realized thus has a permanent character. More than this even—this tradition itself is so powerful that the main subject, be it the grand concept of universal power or the allegorical picture of an animal, becomes secondary. In the persistence of this mental attitude the time span from classical to late medieval times is bridged, just as, in the courtly pictures of the enthroned ruler surrounded by his attendants, a Sasanian concept survives throughout the Islamic period.

ON STYLES AND PRODUCTION CENTERS

It can be assumed that the preceding survey of artistically the most important manuscripts has produced two impressions on the reader: that this is a rich and expressive art; but that in its versatility and on account of the mixture of styles, cross-currents, and mobility of artists it is also a bewildering one. Although some explanations concerning the place of origin and schools have been given in specific cases it seems appropriate to sum these up and round out the picture.

To date four early focal points of manuscript illumination have been established: Syria, Northern (or Upper) Iraq, Central and Southern (or Lower) Iraq, Spain and Morocco. Although signs of earlier activities in Egypt exist, that country seems to have become an active fifth center only in the second quarter of the fourteenth century. In Syria the classical approach to the human figure and the architectural setting were preserved longer and to a higher degree than anywhere else. Unfortunately it is not certain whether the finest manuscript in this tradition, the Dioscorides of 1229 in Istanbul, was executed in Northern Iraq or Syria; but this is an unusual case as it represents in part such a close copy that it can be called an Arab-Muslim variation on Byzantine themes. The Muslim as well as the Christian manuscripts produced in or attributed to Northern Iraq revealed that this was the region most strongly influenced by Persia; such a dependency is particularly shown by the static throne effigies of Sasanian derivation and the more mobile scenes which are close to the action pictures in the *Varqeh and Gulshâh* manuscript of contemporary Seljûk Iran. Here the additive principle of putting one figure next to the other was the most evident, and, as in Syria, architecture and landscape had merely a symbolic value. In Baghdad and possibly in other towns of Lower Iraq we find the freest and most realistic of all the schools. Here figures and their settings are well integrated and both the landscapes, which are sometimes descriptively rendered, and the architectural framework play a significant part. It is the one school that is also preoccupied with transitory phenomena, with psychological observations, and the effects of social classification that appear behind the outward trappings. This school presented also several outstanding examples of paintings that depict a continuous action, so that various stages of an episode are shown, each with the same framework or landscape setting and with the principal figures repeated wherever the story demanded it.

Three illuminated manuscripts, two of them with a limited scientific iconography, are unfortunately not enough to provide a proper insight into the scope of painting in the Maghrib or Western Islam, particularly in Spain and Morocco. The choice of subjects and the styles used indicate, however, that the miniatures were definitely connected with the schools of painting in the Eastern Mediterranean and Iraq, but the themes are treated differently and typically Hispano-Moresque elements are added.

The art of Syria as the northern region of the Mamlûk sultanate appears as an off-shoot of the North Iraqi school where the iconography becomes more limited, the figures more squat, and the setting more schematic. These tendencies toward reduction of form

Illustrations pages 75-77, 79

Illustrations pages 68-73

Illustrations pages 65, 84, 85, 91, 94

Illustrations pages 87, 97-99, 106-122

Illustrations pages 126, 127, 129, 130

Illustrations pages 93, 144, 146, 154, 155, 157-159

and nearly arrested movement reach their apogee in what is considered to be the art of Egypt in the fourteenth century. The impression of immobility and lifelessness made by its rigid, blocklike figures is heightened by the awareness that the persons represented exist in the abstract space of brilliant gold. Faces are set and bodies frozen into their positions. But as all is reduced to its very existence and to the basic gestures of speech or action, these brilliantly colored figures on gold are also the most monumental.

Illustrations pages 148-152 and title page

This short résumé lists the main schools. The scarcity of the preserved documents and the limited research so far done leaves a great deal else in flux and our conclusions must remain hypothetical. In view of the close ties between Northern Iraq and Northern Syria (which are much stronger than those between Northern Iraq on the one hand and Central and Southern Iraq on the other), it is not even certain whether at least some of the workshops of the so-called Mosul school may not have been located in Northern Syria, for instance in the important city of Aleppo. If this should prove not to have been the case, the question arises whether there were groups of painters in both Aleppo and Damascus and if so whether they worked in different styles. We would also like to know all the North Iraqi towns that produced illuminated manuscripts and to be informed what their local idiosyncrasies may have been. It is certain that alongside the studios in Mosul (if indeed they existed there) some other local workshops were in operation in that general region; the original illustrated books on Automata by al-Jazarî were executed in Âmid on the Tigris (now the town of Diyârbakr in Southeastern Turkey) and there are also two manuscripts with drawings, the *Treatise on the Fixed Stars* by as-Sûfî, dated 1135 in Istanbul (Fatih 3422), and the apocryphal *Gospel of the Infancy of Jesus*, dated 1299 (in the Laurentian Library in Florence), both of which were executed in Mârdîn (now also in Southeastern Turkey). Another indication of our present state of uncertainty is the fact that we have not yet been able to establish with a high degree of exactitude

Illustrations pages 84-85

Illustration page 82

Illustrations pages 126-129

the place of origin of certain important manuscripts, such as *The Book of Antidotes* of 1199 and the undated thirteenth century *Maqâmât*, both in the Bibliothèque Nationale (Arabe 2964 and Arabe 3929), and *The Story of Bayâd and Riyâd* in the Vatican Library, although tentative attributions have been made for all three. Even in the al-Qazwînî

Illustrations pages 138-139

manuscript in Munich there are still unexplained stylistic aspects, although we know that it was painted in Wâsit; actually, since its style is still rather isolated, the possibility of such an origin would never have been suspected, had there not been specific information to support it. By contrast we can hope to find out more about some manuscripts which we do possess. There exist potential clues for the proper localization of at least three important manuscripts as they mention dignitaries, not as yet fully identified, for

Illustrations pages 68-73, 75-77

whom they were made: the Dioscorides of 1229 and the al-Mubashshir volume, both in the Topkapu Sarayı Müzesi in Istanbul (Ahmet III, 2127 and Ahmet III, 3206), and the

Illustration page 152

Maqâmât of 1337 in the Bodleian Library (Marsh 458). Once these have been securely located, they in turn will be helpful for the proper placing of other manuscripts.

THE TURKISH ELEMENT IN MANUSCRIPT PAINTING

In the earlier parts of this book the complex nature of the medieval Arab civilization has been stressed. This has brought out not only the interplay of the cultural strains of which it was composed, but also the main course of its political history, and the various effects of social and economic conditions. The themes of universal power in Umayyad art and of pleasure in 'Abbâsid art, the sudden awareness of everyday life in the Fâtimid period, the development of richly varied genre painting in Baghdad, and the appearance of Chinese motifs—to name just a few characteristic developments—can all be easily explained. There is, however, one element which, in spite of its obvious reflection in the miniatures, still defies precise definition. This is the contribution of the Turkish overlords. First in the ninth century in the 'Abbâsid capital of Baghdad and then in various near-autonomous regions throughout the Near East, they played such an important role that they impressed their institutions even on non-Turkish courts like those of the Kurdish Ayyûbids of Egypt and Syria and of the Armenian Badr ad-Dîn Lu'lu' of Mosul. Egypt was and is a mainstay of the Arab world, yet the laws of the Mamlûk period made mandatory the rule and administration by foreigners—mainly, that is, by Turks. In the paintings the facial cast of these Turks is obviously reflected and so are the special fashions and accoutrements they favored. As the ruling and military class they often (but not always) seem to have preferred monumental forms of expression, scenes with little action, and rather strident color combinations. In this respect they are at the opposite pole from the artistic propensities of the Arab urban population in Central Iraq, whose disdain for the Turkish governors was one of the keynotes in the Leningrad and Paris *Maqâmât*. How far the Turkish rulers actually tried to influence the styles of artists working for them in Arab countries we do not yet know. Once again we lack sufficient evidence and can only lament the havoc which the depredations of history have wrought on an art that was so easily defaced or destroyed.

Illustrations pages 65, 91, 148

Illustrations pages 150-152

Illustrations pages 106, 114

Beyond the Material World

4

KORAN ILLUMINATIONS
FROM THE LATE 9th TO THE 14th CENTURY

IN addition to images made at the courts and in the urban centers, there existed a third branch of painting, the history of which runs parallel with that of the other two. This is represented by the purely decorative illumination of manuscripts, particularly of the sacred Koran. It is mainly an art of geometric ornament, with vegetal patterns as secondary motifs. From the eleventh century onward, calligraphic writing also was integrated into the design. Although illumination became a well-established form of Koran decoration, it met at first with certain objections from the theologians, but these offered no great obstacle to its development.

The earliest Koran decorations were ornaments separating the verses. Later came the designs that separated chapters *(Sûras)*, first without and then with a caption. Marginal ornaments indicating the fifth and tenth verses, the passages where ritual prostration was required, and the various sections of the text were also introduced. Finally, full-page decorative frontispieces appeared as either single- or two-page compositions, and similarly ornamented counterparts were occasionally added at the end of the manuscript. These large-scale designs are the most ambitious projects in Koran illumination. Unfortunately, many of those that survive have been detached from the original manuscripts, and since we know very little about date and provenance, even from a paleographical point of view, the attributions given them are usually hypothetical.

Typical for the decorative frontispiece is a sheet that is now owned by the Chester Illustration page 168 Beatty Library in Dublin (MS. 1406). Like most early manuscripts this one was written on parchment. It exhibits also the horizontal layout which is found much more frequently than either the nearly square form or—least common of all—the upright format. The reason for this orientation is still a matter of conjecture, and it may be due to several causes. According to theological concepts, Koran manuscripts were supposed to be large and to differ from the ordinary book form, which we may take to have been vertical like the older Roman diptychs and codices. The horizontal layout, like the large format, may have resulted from these requirements. It is also possible that early monumental inscriptions which included quotations from the Koran may have had a formative influence, as inscriptions of this type were written on horizontal rectangular tablets. Such a derivation would be corroborated by the monumental aspect of the script, characteristic even for

Koran, Frontispiece. Possibly Syria, c. 900. (Parchment, 120×285 mm.)
MS. 1406, The Chester Beatty Library, Dublin.

small Koran pages. Finally, it might be significant that during communal prayer the rows of worshippers are aligned in width (and not in depth as in a Christian church). A horizontal orientation may in this way have come to be associated with the sacred book.

Illustration page 168 The decoration of the page in the Chester Beatty Library consists of a rectangular field, in which the center section is stressed, and a marginal motif. Since in nearly all early Koran pages there is some form of interlace ornament, this element is indicated in the Beatty frontispiece by the looped corners of the two squares and the over-and-under crossing of the sides. But the interlace element is overshadowed by the geometric aspect of the design—the second basic method of constructing such decorative pages, and the one which came to be preferred in later periods.

The origin of a particular Koran frontispiece is often difficult to trace. However, the Beatty piece is obviously a Muslim version of the dedicatory page of the famous Byzantine Dioscorides manuscript of about 512, now in the National Library in Vienna (or of a similar page). In the Vienna manuscript the geometric framework enclosed a portrait of Princess Juliana Anicia and several allegorical figures. These are here replaced by an innocuous rosette, for in a Koran there could be no compromise through Islamiza-Illustrations pages 68, 69, 71 tion of the figures like that found, for instance, in the frontispieces of the Dioscorides manuscript of 1229 in the Topkapu Sarayı Müzesi. The relationship with the Vienna manuscript makes it fairly certain that, generally speaking, these frontispieces took the

place of the dedication pages of the earlier secular manuscripts, which showed either the portrait of the Maecenas or the author. The derivation from a Byzantine model also provides a clue to the place of origin of the Beatty fragment, for this Koran must have been made in a country where such Greek prototypes were available. Greater Syria seems to be the most likely region. This is corroborated by the use of the same motif of squares within a circle in a manuscript presently to be discussed made in Tiberias (Palestine) in 895. Approximately the same date may be proposed for the Beatty leaf.

Since the Byzantine Dioscorides manuscript had been square in form, the Muslim artist had to supply additional decorations to fill his larger rectangular space. This he Illustration page 168 achieved by adding, at the sides of the central design, panels with a foliate pattern executed in sepia. This dark brown pigment, even at its original strength, does not have as much weight and brilliance as the gold used for the central motif and frame. The inspiration for such a composition in two different tones with the concomitant effect of spatial difference is probably derived from the bookbindings developed by the Copts and made also in Syria. In that medium geometric layouts and interlacing were not only the favored designs, but in addition cut-out patterns were placed in contrast with gilded designs and sections in blind tooling, thereby creating different designs on various levels.

In addition to its rectangular ornamentation the Beatty frontispiece, like all other decorative pages, shows in the outer margin a composition of stylized leaves within the outline of a larger leaf. This design is also of gold and in its complexity and more pronounced vegetal character is curiously at variance with the more purely abstract nature of the central design, a fact that points to two differing sources of inspiration. The *functional* origin of this marginal decoration may be the handle *(ansa)* customarily found on the top or at the sides of a Roman inscription panel *(tabula ansata)*, except that here the handles are ornamentally transfigured into vegetal compositions in Irano-Iraqi style. Amulets, cartouches, and writing tablets for school children, all in the form of the *tabula ansata*, indicate that this feature was known in the Islamic world. It has been suggested also that the model for this peculiar motif with its small leaves within a large leafy outline was the leafy finial attached to the ornamental stripe *(clavus)* found on late classical garments, for instance on the shirts worn by Copts. Be that as it may, this leaf or palmette form is actually only one of many marginal features in Koran manuscripts where they denote specific verses, sections, or places of prostration. In certain cases these marginal designs occur at the side of undecorated Sûra captions, where their character as "markers" is evident. Such was the conservative character of these sacred books that once these appendices were accepted as part of the ornamentation, they became a permanent feature of the decorative pages and panels, though at times in the shape of roundels or triangles.

The lack of fully documented and complete Muslim manuscripts before the year 900 is somewhat compensated for by the existence of a few illuminated Hebrew manuscripts made in the Near East that in many respects are very close to their Muslim counterparts. A codex of the *Prophets* written in Tiberias in 895 and for more than eight hundred years Illustration page 191 the property of the Karaite Congregation of Cairo is a good example of this group.

Illustration page 191 The use of a Muslim type of decoration in these manuscripts is not surprising in view of the extensive use of Arabic by the Jewish community in the Arab-Muslim world; even Hebrew Bibles were sometimes written in Arabic letters, to which only the more numerous Hebrew vowels were added. The Cairo manuscript has twelve decorative frontispieces and finispieces. Lack of comparative material does not permit us to say whether this is merely an unusually rich codex for which there existed parallels among the contemporary Korans or whether the astonishing number and variety of decorative pages in the Hebrew manuscript reflects a greater use of such decoration in the Jewish community at an earlier period. The designs used in the Tiberias Codex include the two overlapping squares, carpetlike allover patterns made of interlaces, and several compositions with rosettes made up of stylized vegetal elements. The latter are clearly derived from Sasanian patterns of the type found among the circular stucco panels of the Sasanian palace at Ctesiphon. Such an eastern orientation might be explained by the close connection with Iraq and Persia of the Karaite community, for one of whose members, a native of Babylonia, this manuscript was written. However, the cultural situation reflected by this congregation was not unusual. It has already been pointed out that the composite floral designs in the margins have an eastern aspect, Illustration page 191 just as the contemporary painting of Samarra and its derivatives are in Irano-Iraqi style.

Illustration page 191 The four leaf compositions in the corners of the Hebrew Codex are related to marginal designs. Their placing and relationship to the central medallion foreshadow similar arrangements in bookbindings. In still another respect this page heralds a later development, for it gives greater prominence than heretofore to the color blue, and thereby uses a two-color combination that becomes more general from the eleventh century on.

Illustration page 171 Many new principles were used in a Koran manuscript whose colophon states that it was written in the year 1000 by ʿAlî ibn Hilâl in Baghdad. This manuscript in the Chester Beatty Library (MS. 1431) thus claims to be the work of the most illustrious of the early medieval Muslim calligraphers, better known as Ibn al-Bawwâb, who was also active as decorator, illuminator, and bookbinder. Unfortunately the imitation of the handwriting of famous calligraphers was a not uncommon practice in the Near East (as is still true); the art of forging was even officially accepted though with cautious reservation. Thus, about eighty years after the date given in the Beatty volume, the royal author of the *Qâbûs-nameh* admonishes his favorite son: "Commit no forgery for a *trivial* object, but reserve it for the day when it will be of real service to you and the benefits substantial. Then, too, if you practise it rarely no one will suspect you." In this spirit Ibn Bawwâb himself forged manuscripts, just as in turn his own were imitated soon after his death. It is, therefore, hardly possible to prove at this time that the Beatty Koran, remarkable as it is, is definitely the work of the celebrated master. However, it is safe to say that the volume dates from the first half of the eleventh century and that, as D. S. Rice has shown, calligrapher and illuminator were probably the same person.

Within the series of illuminations here discussed, the Beatty Koran represents a work of innovation, not only artistically, but also technically, since it is written on paper and is of vertical format. Compared to the earlier frontispieces an equilibrium

Koran, Decorative Page, possibly by 'Alî ibn Hilâl, called Ibn al-Bawwâb. Baghdad (Iraq), eleventh century.
(dated 1000/391 A.H.). (Paper, page: 177×135 mm., rectangular area: 134×91 mm.)
MS. 1431, folio 285 recto, The Chester Beatty Library, Dublin.

between the principles of interlacing and geometric design has now been reached. There is also a high degree of integration of the vegetal patterns into the resulting framework. Other features become obvious when individual designs are analyzed. In the illustrated

Illustration page 171 left section of a pair of finispieces, for instance, one finds a vivid interplay of various elements resulting in a dynamic design. Thus, while the two large circles along the vertical axis are self-contained and static, the lateral half circles are open toward the sides, which implies a complementary extension beyond the frame. The floral patterns, too, have a centrifugal direction. At the same time the six-pointed stars and Y-shaped figures serving as small space-filling elements in the interstices not only create different

Koran, Decorative Page. Valencia (Spain), 1182 (578 A.H.). (Parchment, page: 175×185 mm.)
MS. A. 6754, folio 1 verso, University Library, Istanbul.

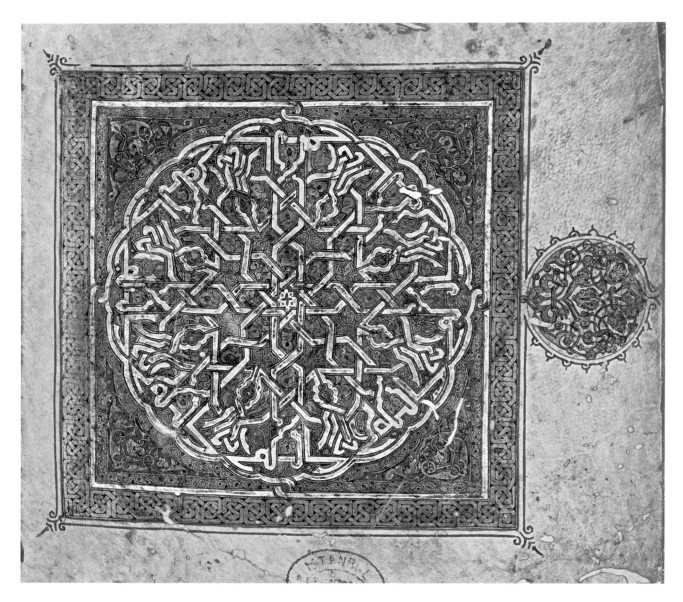

surface patterns and textures, but also give a vibrant quality to the design. In keeping with the geometric aspect of the page, the floral patterns, too, are purely formal and, especially in the two arabesque compositions along the vertical axis, achieve shapes of special distinction. We find here as well an effort to tie the marginal palmette to the decorative field by esthetic means. This is achieved by repeating both the general outline of the large palmette and its composition in the two lotus flowers placed along the horizontal axis. A three-dimensional feeling is again produced by means of the overlapping of the circles, the graduated tinting of the lotuses, and the light edges of the marginal palmette. Although this quality is somewhat indefinable in its spatial relationships, it exists and can even be regarded as a specific feature of Islamic art since it is found in many other media. Coloristically, too, the page represents an advance over previous examples because of its greater color range.

From the middle of the eighth century, when one of the members of the Umayyad caliphal family managed to escape from Syria to Spain and then founded the Emirate of Cordova, Hispano-Moresque art has reflected a preference for Syrian forms and, hence, a certain archaism. This is evident in the Koran written in Valencia in 1182, now in the University Library, Istanbul (MS. A. 6754). It has the square format of the very early Illustration page 172 Korans and is written on parchment even though in the eastern part of the Islamic world paper had become the standard material by the eleventh century. The basic unit from which the total design develops is again the pattern of two overlapping squares known to us from the Beatty frontispiece. This simple core is, however, transformed into a Illustration page 168 complex design that provides constant surprises. The delineating bands frequently change direction and even alter circular segments into straight lines and vice versa, with the result that every inch of the available space is evenly filled. This central medallion appears as a network of narrow white ribbons set against a textured background, a manner of presentation developed earlier in the eastern caliphate. The roundel forms a vivid contrast to the floral pattern in the corners and the interlace in the border, which has already been met in the Ibn al-Bawwâb Koran. The marginal pattern is again tied to the main design by esthetic means, for it repeats the central configuration on a smaller scale and contains abstract leaf patterns related to those in the four spandrels.

In the second half of the twelfth century a new international style based on complex star configurations arose within the Muslim world. This style reached its apogee in the mid-fourteenth century. In that century the rulers and high officials of the Mamlûk sultanate of Egypt and Syria commissioned the copying and decorating of particularly large and beautiful Korans that not only attested to their piety, but also demonstrated in the places of public worship their power and station in the realm.

A particularly fine example is represented by the frontispiece of a large Koran in Illustration page 174 the National Library of Egypt bearing the name Arghûn Shâh, which dates the manuscript between 1368 and 1388. Here the sixteen-pointed star formation is found in the center of the page, where it fills the central square with an extended array of polygonal configurations. Above and below are bands of inscriptions that demonstrate how writing —here in the archaic form of *Kûfic*—has now been integrated with the whole design.

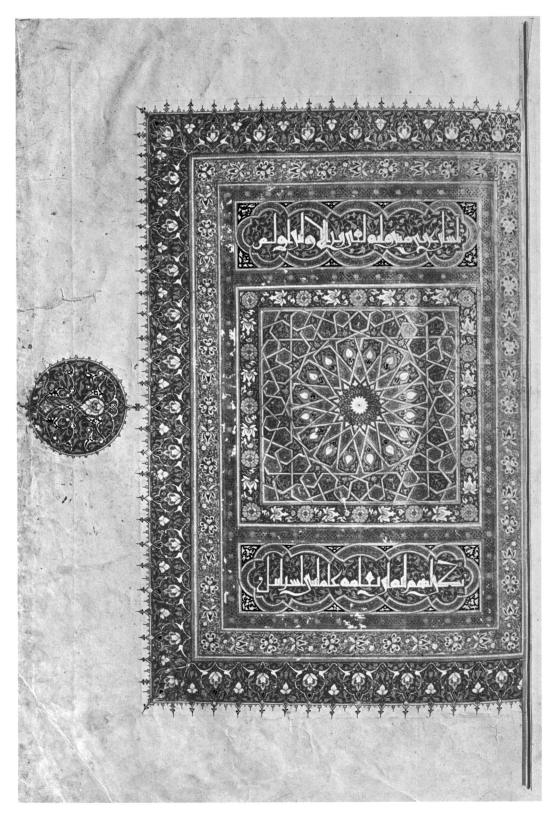

Koran of Arghûn Shâh: Decorative Page. Egypt, c. 1368-1388 (770-790 A.H.). (705×509 mm.)
MS. NO. 54, National Library, Cairo.

Another important element of this frontispiece is offered by the various frames which, Illustration page 174 with the exception of one cable border, consist of floral and arabesque arrangements. The flowers used are the Chinese lotus and peony, both of them favorites since the Mongol invasion brought Far Eastern elements into Near Eastern art. The marginal design is again esthetically tied to that of the main field, first by echoing in outline the round core of the central star design, and secondly by using as internal decoration arabesques and stylized flowers similar in character to the decorative elements within the outer border.

These decorative pages represent the highest form of non-objective painting in the Arab-Muslim world. Although their vibrant discs and starlike polygons were genetically associated with the sun—as is evident from the Arabic designation, *shamsa*, from *shams* (sun)—these products of abstract thinking and geometry have gone beyond the concrete shapes of the material world. These configurations made of straight lines and segments of circles have reached a higher, more basic form of esthetic perfection, a kind of Platonic ideal "whose beauty is not relative like that of other things"; as Socrates says in *Philebus*, "they are always absolutely beautiful." In this stage and context these designs have undoubtedly acquired a definite spiritual connotation; yet owing to their variability they never became recognized symbols of a religious nature.

These decorative pages are also most important from an historical point of view. They are the only paintings that had an uninterrupted, universal development which can be followed step by step. On the other hand, it was these abstract motifs rather than the creations of the figural painters which exerted an influence on the West. Western pattern books made use of "Moorish" designs. Their imprint is to be noted even in the work of some of the most famous masters of the Renaissance. Thus compositions like the twelfth century frontispiece of Valencia are indirectly models for the knot designs Illustration page 172 of the "Academia Leonardi Vinci," which in turn inspired Dürer's *Sechs Knoten*. What one might call a cross between the rosette of the Valencia Koran and the star of the Koran of Arghûn Shâh appears with pseudo-Kûfic inscriptions on the early twelfth century bronze door of the funerary chapel of Boemund at the cathedral of Canosa di Puglia in Apulia, Southern Italy. The star of the Koran of Arghûn Shâh continued to Illustration page 174 be popular in the Mudéjar art of Spain. The wide appeal of these abstract patterns would not have astonished Muslim believers of the time, since it was this type of painting which was officially and instinctively regarded as *the* characteristic form of their art and therefore the one appropriate to the decoration of their sacred book.

The Final Phase

5

The Wonders of Creation ('Ajâ'ib al-Makhlûqât) of al-Qazwînî: The Archangel Isrâfîl. Probably Iraq, c. 1370-1380. (Painting: 175×161 mm.) 54.51 verso, Freer Gallery of Art, Washington, D.C.

LAST VENTURES IN ARAB PAINTING

WHAT happened to Arab painting after 1350? In the field of Koran illumination the characteristic style continued till the conquest of Egypt by the Ottoman Turks in 1517. We find the same splendor and similar themes, though at times they were coloristically harsher and less well executed. Even after the fall of the Second Mamlûk dynasty the decorative features of Mamlûk illumination are occasionally still to be found. But Turkish designs in the Persian manner became increasingly the vogue and replaced the geometric layouts in particular.

The picture for miniature painting is more complex. What appears to be the last outstanding manuscript was probably executed about 1370-1380 in Iraq. This is a large-size, extensively illustrated *Wonders of Creation* by al-Qazwînî, once in the Sarre Collection, and now in the Freer Gallery of Art in Washington (54.33-114). The drawing of certain animals and the fashion in clothes and headgear of the figures shown are in late Mongol style and betray the fact that the manuscript was executed in the last period of Mongol rule when Iraq and Western Iran were governed by the Persianized Jalâ'irid sultâns. Still, there is a great deal of the earlier tradition in these paintings, and some motifs are iconographically akin to those of the Munich manuscript. In any case the boldness of the design of the "Archangel Isrâfîl" and its few aptly combined colors are entirely in the Arab manner, as is the concentration on the main subject to the exclusion of any background pattern. The dynamic force within this angel as he steps forward and on divine command blows his trumpet is particularly evident when it is compared with the heavy, static angels of the frontispiece miniature in the Vienna *Maqâmât* of 1334. However, this earlier example gives us a clue for one curious eye-catching detail in the composition: the double-pointed ends of the angel's fluttering sash. In the Mamlûk version these were the small tips of an inwardly curled band, a motif which has now been enlarged out of all proportion; also, instead of having a functional meaning, the detail has turned into a mere element of design. This volume became the archetype which was copied in other near-contemporary and later manuscripts (Leningrad, Academy of Sciences; Dublin, Chester Beatty Library; Vienna, Nationalbibliothek; and New York Public Library).

After this final effort Arab-Muslim painting is either overpowered by non-Arab styles or it sinks to a lower artistic level. Thus a Persian work, also entitled *The Wonders of*

Illustration page 178

Illustrations pages 138-139

Illustration page 148

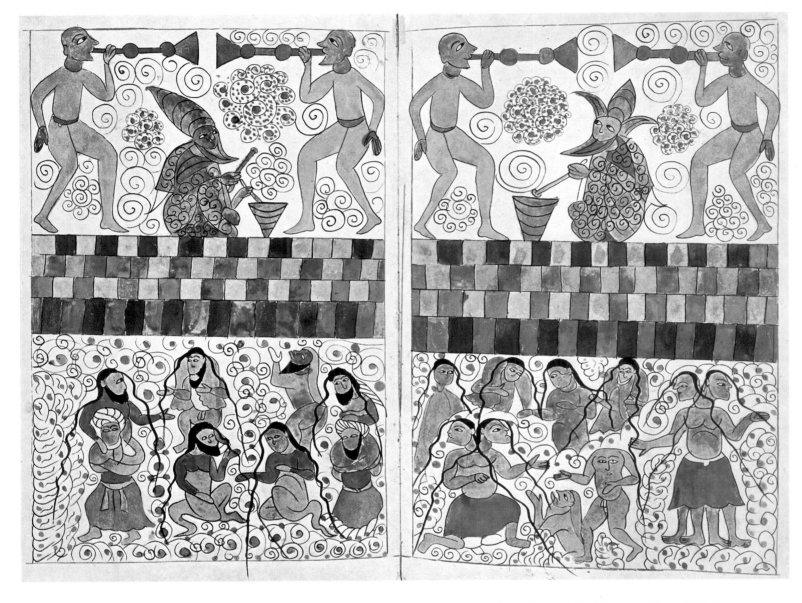

The Order of the World and her Wonders (Qânûn ad-Dunyâ wa-'Ajâ'ibhâ) of Shaykh Ahmad Misrî:
The Wild People at the End of the World. Syria or Egypt, 1563 (970 A.H.). (Each page: c. 260×192 mm.)
Revan 1638, folios 118 verso and 119 recto, Library of the Topkapu Sarayı Müzesi, Istanbul.

Creation, by at-Tûsî, which was executed in 1388 for the Jalâ'irid Sultân Ahmad, is already in a much more pronouncedly Persian style (Bibliothèque Nationale, Pers. 332) and later Jalâ'irid manuscripts carry the trend still further. Actually a celebrated Jalâ'irid manuscript of Khwâjû Kirmânî's *Quintet (Khamseh)* illustrated by Junayd in Baghdad in 1396 is so entirely Iranian in spirit and execution (British Museum, Add. 18.113) that its style prefigures the quintessence of the mature Persian manner of the Timurid period. (For illustrations see Basil Gray, *Persian Painting*, pp. 46 and 47.) Another and later Baghdad manuscript, the *Quintet* of Jamâlî, dated 1465, is equally

indistinguishable from Persian painting (Indian Office Library, Ethé, No. 1284). Both volumes demonstrate that Iraq was now permanently lost as a center of Arab painting.

In the Eastern Mediterranean world, after the artistic low ebb of miniature painting under the Second or Burjî Mamlûk dynasty, a certain brief revival seems to have taken place in the sixteenth century. In evidence of this, we have a richly illuminated cosmographic work dated 1563 entitled *The Order of the World and her Wonders (Qânûn ad-Dunyâ wa-'Ajâ'ibhâ)* by Shaykh Ahmad Misrî in the Topkapu Sarayı Müzesi (Revan 1638). Its title page is still in Mamlûk style and indicates that the manuscript was executed in Egypt or, to judge from the many architectural renditions, more probably in Syria; most of the miniatures reveal aspects of Arab, Persian, and Turkish styles, while some even show Indian and European features. A typical painting from this manuscript is

Illustration page 180

The Wonders of Creation ('Ajâ'ib al-Makhlûqât) of al-Qazwînî: The Zodiacal Figure of Taurus.
Probably eighteenth century. (125×122 mm.)
C. arab. 463, folio 27 verso, Bayerische Staatsbibliothek, Munich.

a two-page composition, each part of which shows a drummer and two trumpeters above a scene of monsters from which they are separated by a wall. This illustrates a belief from the Alexander Legend and is referred to in the Koran (Sûra XVIII, verses 91-98). According to it the Yâjûj and Mâjûj, two evil peoples, are shut up behind a strong wall built by the great conqueror. Until the trumpets of the Last Days sound, these hordes are, therefore, prevented from devastating the world. As the theme in the lower left page indicates, the painting combines this eschatological concept with accounts of other strange creatures. The motif of soft-legged men riding on the shoulders of unsuspecting Muslim victims is of course well-known from an episode in "Sindbad's Fifth Voyage"; but it also occurs in al-Qazwînî's *Wonders of Creation* and in other texts. An even wider iconographic range characterizes the monsters shown in the lower right, where double-headed men are seen, as well as a headless man with his face between his shoulders, men without mouths and another with enormous ears. As shown by R. Wittkower, not only do these monsters populate the last pages of al-Qazwînî's *Wonders of Creation*, but since their first descriptions by Ktesias of Knidos (early fourth century B.C.) and Megasthenes (c. 300 B.C.), they have occurred, as "Marvels of the East," in manuscripts on geography and the natural sciences, in encyclopedias and cosmographies, and in maps and cathedral sculpture as well.

The execution of this double-page illustration indicates that this painting, like others in the volume, is achieved with aggressive directness, revealing at the same time a crude boldness of design and disdain for non-essential detail that is appealing to the modern viewer. However, when it is compared with the earlier compositions, certain inner changes are clearly noticeable. The figures are all absolutely flat, their outlines being filled with flat wash or patterns; there is hardly any overlapping of the figures, and in their loose, spaceless arrangement the individual elements are displayed like a decorative design such as one would find on a textile or painted chest. This ornamental aspect is further emphasized by the spirals which occupy every empty space between the figures; while this feature attests to the *horror vacui* characteristic of this art, it also gives the paintings a vibrant quality. There is no doubt that the rational composition schemes and the corporeal qualities of the earlier, more professional-looking paintings of the thirteenth and fourteenth centuries are lost, or that the compulsion to be purely decorative and to fill every empty area increases the folkloristic aspect.

By contrast to the many influences apparent in the work just described, the painted wall decorations from the reception hall in a house in Aleppo (Syria) dated 1603 (in the Staatliche Museen, Berlin) are entirely in a Turkish-Persian idiom with no trace of Arab features; they are here of special interest only insofar as they demonstrate the complete victory of the new imperial art. They also show that the Christian owner insisted on having Christian religious subjects like a Madonna and Child, a Last Supper, and Salome's dance added to the secular themes. Christian subjects are also treated in a number of manuscripts. Other manuscripts and wall decorations were in a more popular vein and bring us close to the purely folkloristic or decorative, while in the painted woodwork of the Syrian houses of the eighteenth and nineteenth centuries, borrowings from European art are also encountered, especially in the rendering of town vistas.

The effect of many of these trends can be studied in a copy of al-Qazwînî's *Wonders of Creation*, possibly of the eighteenth century, in the Staatsbibliothek in Munich (C. arab. 463), a typical example of the group which, as scientific works, most faithfully preserved the old pictorial tradition. One of its miniatures which depicts the zodiacal figure of Illustration page 181 "Taurus" seems unusual and yet symptomatic (fol. 27 verso). It shows the symbolic design in a richly colored setting of flowery branches executed in a kind of peasant style which could be the product of any number of folk arts. Instead of the whole animal as seen in many other Muslim figures of the zodiac, only the forequarters are shown, in obvious conformity with the tradition first found in Muslim iconography in the manuscript dated 1009 of as-Sûfî's *Book of the Fixed Stars* in the Bodleian Library (Marsh 144). But while there the bull had been still a vigorous animal with a massive body, well-proportioned head, and long horns, we see it here not so much as a protoma, but as a dismembered beast with all-too-short legs, pitifully small horns and most important of all with a large, slightly distorted head from which mournful eyes look into the infinite. The whole makes a tortured, anguished impression and though in a simpler key, to a modern eye is irresistibly reminiscent of Picasso's "Guernica." This deformed, mutilated, and sorrowful figure could indeed serve as a symbol of the sad end of Arab painting.

Why did Arab painting die out prematurely, long before the other Arab-Muslim crafts deteriorated? Three major reasons seem to be responsible for this development. The first factor is the effect of foreign domination. During the Mamlûk period, Egypt and Syria were under the rule of Turkish sultâns and administered by Turkish and other foreign emîrs, all of them of slave origin and some of them hardly able to speak Arabic. In addition, certain features of its feudal organization worked in a negative fashion: the land grants were given only for life and the emîrs did not reside on their estates, but in Cairo or other administrative centers. As Bernard Lewis has pointed out, this system made the rise of an Arabized class of landed aristocracy impossible, and did not produce châteaux of the type which under the Umayyads had given such splendid scope to the painters. During the same period Iraq, now only a marginal province of Iran, was governed by Mongol, then by Turkish rulers and separated from the rest of the Arab world. Finally, all three of the major Arab countries—Egypt, Syria, and Iraq—came under Ottoman-Turkish domination. Their provincial status in the vast sultanate further accelerated the decline, since the quite different cultural patterns developed in the imperial capital of Constantinople were now superimposed upon the old traditions and everywhere imitated without the resulting benefit of a new synthesis.

The second factor is a general economic and social decline in the Mamlûk sultanate from the fourteenth century on. This was due to despotic misrule, to an inefficient and corrupt administration, disastrous monopolistic and fiscal policies, exploitation of the lower classes, and finally to the bypassing of Egypt as the trade route to India and the Far East by Vasco da Gama's discovery of the passage around the Cape of Good Hope.

The third factor was the victory of orthodoxy. This not only meant a more intolerant attitude toward figural art, but even toward art as such. When the most famous theologian and thinker of Islam Ghazâlî (died 1111) was asked by students during the last period of his life which sciences he would advise them to study and which to disregard, he answered in a letter: that they should occupy themselves with those subjects which they would think worthwhile if they were to live only for one more week. He specifically excluded not only medicine, astronomy, and poetry, but even dogmatic theology and canon law. He also counseled them to acquire only so much of this world's goods as they would need if they were to live for only one more year. This attitude may have been exceptional in its ascetic, otherworldly tendency, but the spirit of formal orthodoxy led inexorably to a suppression of individual initiative, a stifling of intellectual activities and finally to spiritual decadence. In practice this meant in particular the reliance on well-established, safe patterns, to the exclusion of the novel and individual. The traditional arts and crafts for home use, formal royal display, and religious buildings could continue, though in an ever more limited fashion, but there was no longer a place for the forbidden activity of figural painting with its suspect predilection for individual inventiveness. Only in the field of scientific and technical literature did illustrating have an acknowledged function, though only in a limited, derivative and quasi-artistic manner.

These comments on the causes of the death of Arab painting have given this Epilogue something of the character of an obituary notice. That being so, it seems appropriate at this point to view the development of this art from a higher vantage point and to see whether a sense of purpose and oneness can be established for its history. The question is all the more appropriate in that artistic production prior to the twelfth century appears at first glance to be very different from that of the later centuries.

A certain inner consistency in the history of Arab painting is demonstrated by the same sequence, in both the early and high Middle Ages, of two disparate styles. There is an open, dynamic, and realistic style which leads directly or indirectly to monumental, barely moving, and often closed forms. This transformation is evident first in the change from Umayyad to 'Abbâsid art and later on in the shift from the late 'Abbâsid modes of Iraq to those of Mamlûk Egypt and Syria. This polarity is the result of Islam's inheritance of two conflicting artistic principles: those of the classical and oriental worlds. At certain times dynastic aspirations and political dependence dictated the preference for one art form; at others the mental make-up of the leading group, be it the court or the rising middle class in the cities, led to the particular choice of an appropriate artistic expression.

But one unifying element was inherent even in this dichotomous development, since Arab painting is to a large extent derived from the late classical pictorial arts. Such an origin applies not only to designs which follow Hellenistic, Roman, or Byzantine models, but even to the most important of the oriental strains, the Sasanian, since this too represents late classical art though in an Eastern mutation. This classically based legacy guaranteed a certain permanence of forms, of which the specific stylization of folds or the gestures of speech represent telling aspects.

The unity of Arab painting seems also indicated by the presence of three major themes. Two of these are current throughout the active history of painting as a cultural expression, while the third represents a basic and natural development. The first theme is that of royalty and dominion. This already forms a keynote in Umayyad art and is still to be found in Mamlûk frontispieces. Both in its autocratic connotations and its iconographic settings it is—from the 'Abbásid period on—essentially pre-Islamic Persian, but it was entirely appropriate for a medieval society that was often governed by despotic rulers.

The second theme is the scientific one. It, too, occurs first in the Umayyad period, in the scientific rendition of the starry sky in the domed chamber of the bath in Qusayr 'Amra, then in the astronomical manuscripts of the 'Abbâsid period, especially the illustrated texts of as-Sûfî, to reach its highest and most diversified forms in the many illustrated books of the thirteenth and fourteenth centuries. This is essentially a survival of the classical tradition and reflects a major cultural achievement of Islamic civilization: to have been the active transmitter of Greek science to the Latin West.

The third theme is speech itself. Representations of speaking animals or persons may have existed in a rudimentary fashion in the now lost early illustrations of *Kalîla and Dimna*. But in view of the basic and all-powerful role of the Arabic language within the Arab-Muslim civilization it was natural that its signal character should eventually have demanded and found expression in the field of painting, especially by means of gestures. This applies in particular to the miniatures accompanying a major elocutionary achievement, al-Harîrî's *Maqâmât*, but also to many other Arabic books. Already in Roman art the speech of philosophers, consuls, and senators had been rendered by specific gestures, and this symbolism was followed by Christianity in representations of the teaching Christ or acclaiming saints. The Islamic language of gesture was thus based on classical precedent. Owing to the early domination of Arab countries by foreigners, this visual apotheosis of the Arabic language could only be reached when the middle class in the Arab cities was able and ready to employ artists to illustrate their major books and thus give outer symbolical form to what they regarded as their pre-eminent cultural achievement. In spite of its classical origin the rendering of speech thus represents the Arab theme *par excellence* in Arab painting. Hence, while it may seem curious to a Westerner that these miniatures so frequently contain scenes of talking persons and even of talking animals, the profusion of such paintings and the associations they evoke show their special significance.

Not only do style sequences and major themes attest to the internal cohesion of Arab painting and in particular to the interconnection between early and high Middle Ages; so also does what may be called the intention of this art, its ultimate purpose. When the Umayyad artist rendered his themes he proclaimed the universal power of his caliphal masters and of the "House of Islam." His images were symbolic expressions of a political doctrine. When later on the thirteenth century artist illustrated extensive handbooks, the most popular of which dealt with the whole cosmos, he not only reproduced pictures of stars, animals, and plants, but as is made clear by the accompanying

text, he also postulated symbolically the scholar's attempted mastery over the physical world. This control had now a scientific basis, due to recognition or practical application. In both early and late instances the paintings reflected a grand, intellectually conceived view of mundane matters. The one served an authoritarian state operating through world-wide conquests, the other professional men who were part of a larger urban middle class economically supported by world-wide trade.

By contrast, when the 'Abbâsid caliphs and other later rulers charged their painters with the task of decorating their palaces, their intent was quite different. By depicting the royal pastimes they symbolically portrayed the sumptuous life at court and the royal prerogatives. These pleasures were mostly sensual; some, like the hunt, were also of a physical nature, but while this implied the ruler's unexcelled prowess in sports, it had no world-wide significance. Later on the middle class, too, wished to portray its own forms of entertainment. Some of these were again sensuous, but the significant contribution, as we have pointed out, now has an intellectual foundation. Here again the rendition was to a large extent symbolic, as it stood for more than is shown by the actual image. The complex nature of the poetry could not be visualized, but had to be expressed by implication. Gestures of speech were needed to symbolize the language of the poet; only for the simple-minded did the mere "story" suffice.

In the very function of the art, then, we have another parallelism between the early and high Middle Ages: on the one hand, applied to the larger purposes of the public sphere; on the other, to the various forms of enjoyment in private life. On this level of analysis Arab painting is not merely a mirror of civilization, a self-image of medieval Islam; it stands for vaster concepts: it has a symbolic function.

The esthetic aspects of Arab painting, too, speak for its cohesion, and this in spite of the presence of unintegrated elements and the occasional conflicts in stylistic tendency. For a modern viewer there are many obvious characteristics: a strong sense of composition has organized decoratively effective arrangements in which the various parts are grouped simply and often lack any specific framing device. The colors used are bold, though of a rather small range. The artists were not unaware of space, which is, however, narrowly confined, while the indications of the locality are usually (that is, with the exception of four more explicit manuscripts) rather limited in number and often given in stylized form. The human figures are rather shapeless, with their body structure hardly felt under the voluminous robes; but the faces are stressed, though they reproduce types, not individual persons. The major concern in the delineation of the human figure is with eyes, beards, and hands. The portrayal of animal forms reveals a fine comprehension of the significant features of each, whether brought out in realistic or stylized versions. At the same time a remoteness from nature is shown in the treatment of vegetation and landscapes, which often are mere stylized symbols. All these features remain remarkably stable over the centuries and throughout the vast regions in which this type of painting was practised.

After all the specific qualities of Arab painting have been enumerated, it is, however, still necessary to take some note of its limitations. These negative aspects, too, belong

to the picture and no final judgment is possible without an awareness of them. Indeed, these limitations may have been troubling the reader's mind. By its very nature this art has no religious function. It could not have been used for epic or dramatic poetry as in the contemporary Byzantine world, for the simple reason that these literary forms did not exist in Islam, if we disregard the popular theatrical arts. Neither was it customary to illustrate historical accounts, legends, or allegories. It never gave expression to lyrical or visionary feelings. There were of course no portraits. The human body, the basis of classical art, was unappreciated. Women played only a minor role. Finally, there was hardly any reflection of the refined beauty that we find in the contemporary decorative arts. Would not all this lead one to wonder whether in its very limitations Arab painting is after all of only minor importance? That is, would one perhaps have to regard it as an *art manqué*? Here the paintings will have to speak for themselves. We can only support whatever claims they have by saying that in the ready manner with which the artist could translate royal, political, scientific, and poetical themes into visual forms, in his skill in assimilating foreign elements, in his ability to compose powerful images, some of them quite unforgettable—and above all in his willingness to do this under the ever disapproving eyes of his spiritual betters and even in the face of eternal damnation— he has few equals. It is certain that he gave of his best. Thus his works, even in the limited number in which they survive, have bequeathed to us one of the truest and most revealing mirrors of a brilliant civilization that has long since passed away.

Appendix - Bibliography

Index of Manuscripts - General Index

List of Illustrations - Table of Contents

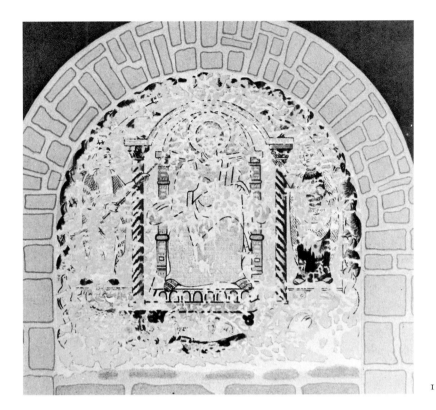

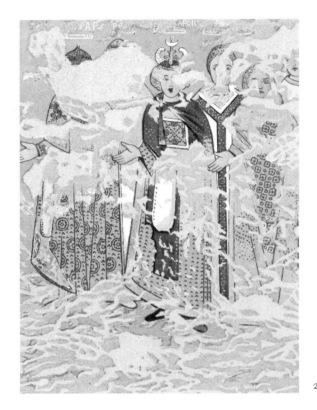

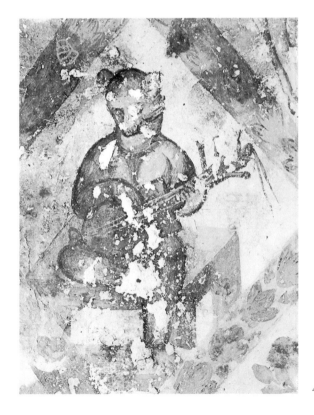

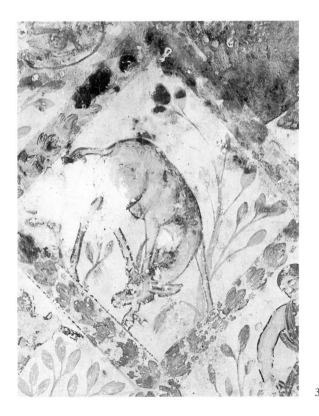

1

2

3

4

5

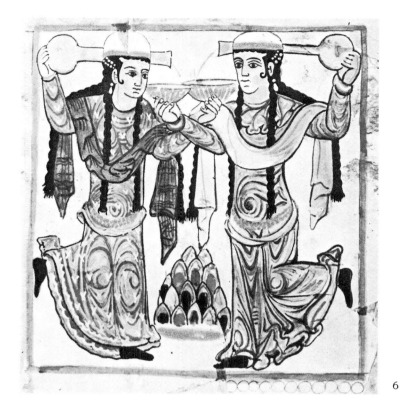

6

Appendix

1. The World Ruler. Painting (now destroyed) originally on the Main (South) Wall of the Central Alcove in the Reception Hall, c. 724-743. Qusayr ʿAmra (Jordan). Copy made in 1901 by A. L. Mielich.

2. The Kings of the World Acclaiming the World Ruler. Painting (now destroyed) on the West Wall of the Reception Hall, c. 724-743. Qusayr ʿAmra (Jordan). Copy made in 1901 by A. L. Mielich.

3. Antelope. Detail of the Painted Vault Decoration in the Disrobing Chamber of the Bath, c. 724-743. Qusayr ʿAmra (Jordan).

4. Bear Playing a Musical Instrument. Detail of the Painted Vault Decoration in the Disrobing Chamber of the Bath, c. 724-743. Qusayr ʿAmra (Jordan).

5. Priest (?). Middle of the Ninth Century. Painting on a Wine Jar in the Jawsaq Palace, Samarra (Iraq). Reconstruction by Ernst Herzfeld.

6. Two Dancers, 836-839. Wall Painting in the Domed Chamber of the Harem in the Jawsaq Palace of the Caliph Muʿtasim, Samarra (Iraq). Reconstruction by Ernst Herzfeld.

7. The Codex of the Prophets by the Masorete Moshe ben Asher. Frontispiece. Tiberias (Palestine), 895. (Parchment, page about 384 × 415 mm.) Karaite Congregation, ʿAbbâsiye, Cairo.

7

BIBLIOGRAPHY

BACKGROUND LITERATURE

Political, Cultural and Social History

Philip K. HITTI, *History of the Arabs*, London 1937.

Gustave E. VON GRUNEBAUM, *Medieval Islam: a Study in Cultural Orientation*, Chicago 1946.

S. D. GOITEIN, *From the Mediterranean to India: Documents on the Trade to India, South Arabia, and East Africa from the Eleventh and Twelfth Centuries*, Speculum, vol. 29, p. 181-197, 1954.

S. D. GOITEIN, *The Rise of the Near-Eastern Bourgeoisie in Early Islamic Times*, Cahiers d'Histoire Mondiale, vol. 3, p. 583-604, 1957.

H. RITTER, *L'Orthodoxie a-t-elle une part dans la décadence?*, in R. BRUNSCHVIG and G. E. VON GRUNEBAUM, *Classicisme et déclin culturel dans l'histoire de l'Islam*, Actes du Symposium International d'Histoire de la Civilisation Musulmane (Bordeaux, 25-29 juin 1956), Paris 1957, p. 167-183.

B. LEWIS, *The Arab History*, Arrow Books, London 1958.

Literary History

Reynold A. NICHOLSON, *A Literary History of the Arabs*, New York 1907.

Paul KAHLE, *Islamische Schattenspielfiguren aus Ägypten*, Der Islam, vol. 1, p. 264-299, 1910; II. Teil, p. 145-195, 1911.

Georg JACOB, *Geschichte des Schattentheaters im Morgen- und Abendland*, Hanover 1925.

H. A. R. GIBB, *Arabic Literature, an Introduction*, London 1926.

Paul KAHLE, *Das arabische Schattentheater im mittelalterlichen Ägypten*, Wissenschaftliche Annalen, vol. 3, p. 748-776, 1954.

Translations of Illuminated Arabic Texts Discussed in this Book

[*Historia de los*] *Amores de Bayâd y Riyâd, una Chantefable Oriental en Estilo Persa* (Vat. Ar. 368), by A. R. Nykl, New York 1941.

BIDPAI: *Kalila and Dimna, or The Fables of Bidpai*, translated from the Arabic by the Rev. Wyndham Knatchbull, Oxford 1819, reprinted 1905.

DIOSCORIDES: *The Greek Herbal of Dioscorides, Illustrated by a Byzantine A.D. 512, Englished by John Goodyer A.D. 1655, Edited and First Printed A.D. 1933 by Robert T. Gunther*, Oxford 1934.

AL-HARÎRÎ: *The Assemblies of al-Harîrî*, translated from the Arabic by T. Chenery and F. Steingass, Oriental Translation Fund, n.s. v. IX, III, 1867-1898.

IBN BUTLÂN: *Un Banquet de médecins au temps de l'émir Nasr el-Dawla ibn Marwân (Daâwat al-atibba d'Ibn Batlane)*, French translation by Mahmoud Sedky Bey, Cairo 1928.

AL-JAZARÎ: Eilhard Wiedemann in collaboration with Fritz Hauser, *Über die Uhren im Bereich der islamischen Kultur*, Nova Acta, Abh. d. Kaiserl. Leop.-Carol. Deutschen Akademie der Naturforscher, vol. c, No. 5, Halle 1915.

AL-MAQDISÎ (Mocaddéci): *Les Oiseaux et les Fleurs*, in H. S. V. Garcin de Tassy, *Allégories, récits poétiques et chants populaires traduits de l'arabe, du persan, de l'hindoustani & du turc*, p. 1-71, Paris 1876.

AL-QAZWÎNÎ: *Zakarija ben Muhammed ben Mahmud el-Kazwîni's Kosmographie nach der Wüstenfeldschen Textausgabe*, translated from the Arabic by Hermann Ethé, t. I, Leipzig 1868.

The Place of Painting in Islam

Thomas W. ARNOLD, *Painting in Islam, a Study of the Place of Pictorial Art in Muslim Culture*, Oxford 1928.

A. J. WENSINCK, *Sūra*, The Encyclopaedia of Islam, vol. 4, p. 561-563, Leyden-London 1934.

Zaky M. HASSAN, *The Attitude of Islam towards Painting*, The Bulletin of the Faculty of Arts, Fouad I University, vol. 7, p. 1-17, Cairo, July 1944.

K. A. C. CRESWELL, *A Bibliography of Painting in Islam* (Publications of the Institut Français d'Archéologie Orientale du Caire, *Art Islamique*, tome I), Cairo 1953.

André GRABAR, *L'Iconoclasme byzantin. Dossier archéologique*, Paris 1957.

Rudi PARET, *Textbelege zum islamischen Bilderverbot*, in *Das Werk des Künstlers. Hubert Schrade zum 60. Geburtstag*, p. 36-48, Stuttgart 1961.

THE EARLY MEDIEVAL PERIOD

The Umayyad Style

Alois MUSIL and others, *Kusejr 'Amra*, 2 vols., Vienna 1907.

Marguerite VAN BERCHEM, *The Mosaics of the Dome of the Rock at Jerusalem and of the Great Mosque at Damascus*, in K. A. C. CRESWELL, *Early Muslim Architecture*, vol. 1, p. 149-252, Oxford 1932.

Fritz SAXL, *The Zodiac of Quṣayr 'Amra*, in K. A. C. CRESWELL, *Early Muslim Architecture*, vol. 1, p. 338-350, Oxford 1932.

E. HERZFELD, *Die Könige der Erde*, Der Islam, vol. 21, p. 233-236, 1933.

J. SAUVAGET, *Remarques sur les monuments omeyyades*, I: *Châteaux de Syrie*, Journal Asiatique, vol. 231, p. 1-59, 1939 (Quṣayr 'Amra, p. 13-15).

Daniel SCHLUMBERGER, *Deux fresques omeyyades*, Syria, vol. 25, p. 86-102, 1946-1948.

Oleg GRABAR, *The Painting of the Six Kings at Quṣayr 'Amrah*, Ars Orientalis, vol. 1, p. 185-187, 1954.

Enno LITTMANN, *Mukaukis im Gemälde von Kusair 'Amra*, Zeitschrift der Deutschen Morgenländischen Gesellschaft, vol. 105, p. 287-288, 1955.

Hamilton A. R. GIBB, *Arab-Byzantine Relations under the Umayyad Caliphate*, Dumbarton Oaks Papers, No. 12, p. 219-233, 1958.

Oleg GRABAR, *The Umayyad Dome of the Rock in Jerusalem*, Ars Orientalis, vol. 3, p. 33-62, 1959.

R. W. HAMILTON, *Khirbat al Mafjar*, with a Contribution by Oleg Grabar, Oxford 1959.

The Early 'Abbâsid Style

Joseph HOROVITZ, *Die Beschreibung eines Gemäldes bei Mutanabbi*, Der Islam, vol. 1, p. 385-388, 1910.

Ernst HERZFELD, *Die Malereien von Samarra*, Berlin 1927.

Basil GRAY, *Islamic Charm from Fostat*, The British Museum Quarterly, vol. 9, p. 130-131, 1935.

Gaston WIET, *Un Dessin du XIe Siècle*, Bulletin de l'Institut d'Egypte, vol. 19, p. 225-227, 1937.

Basil GRAY, *A Fâtimid Drawing*, The British Museum Quarterly, vol. 12, p. 91-96, 1938.

J. SAUVAGET, *Remarques sur les monuments omeyyades*, II, Mélanges asiatiques (Journal asiatique), 1940-1941, p. 52-56.

R. ETTINGHAUSEN, *Painting in the Fatimid Period: a Reconstruction*, Ars Islamica, vol. 9, p. 112-124, 1942.

Ugo MONNERET DE VILLARD, *Le pitture musulmane al soffitto della Cappella Palatina in Palermo*, Rome 1950.

R. ETTINGHAUSEN, *Early Realism in Islamic Art*, in *Studi orientalistici in onore di Giorgio Levi Della Vida*, vol. I, p. 252-273, Rome 1956.

D. S. RICE, *Deacon or Drink: Some Painting from Samarra Re-examined*, Arabica, vol. 5, p. 15-33, 1958.

D. S. RICE, *A Drawing of the Fatimid Period*, Bulletin of the School of Oriental and African Studies, vol. 21, p. 31-39, 1958.

André GRABAR, *Image d'une église chrétienne parmi les peintures musulmanes de la Chapelle Palatine à Palerme*, in *Aus der Welt der islamischen Kunst, Festschrift für Ernst Kühnel*, p. 226-233, ed. R. Ettinghausen, Berlin 1959.

Emmy WELLESZ, *An Early al-Sûfî Manuscript in the Bodleian Library in Oxford*, Ars Orientalis, vol. 3, p. 1-26, 1959.

THE HIGH MIDDLE AGES

General Treatment

Fredrik R. MARTIN, *The Miniature Painting and Painters of Persia, India and Turkey, from the eighth to the eighteenth century*, London 1912.

Philipp Walter SCHULZ, *Die persisch-islamische Miniaturmalerei*, 2 vols., Leipzig 1914.

Ernst KÜHNEL, *Miniaturmalerei im islamischen Orient*, Die Kunst des Ostens, vol. 7, Berlin 1923.

Edgar BLOCHET, *Les Enluminures des Manuscrits orientaux — turcs, arabes, persans — de la Bibliothèque Nationale*, Paris 1926.

Thomas W. ARNOLD and Adolf GROHMANN, *The Islamic Book, a Contribution to its Art History from the seventh to the eighteenth century*, n.p., 1929.

Edgar BLOCHET, *Musulman Painting, Twelfth-Seventeenth Century*, translated from the French by Cicely M. Binyon, London 1929.

Arménag BEY SAKISIAN, *La Miniature persane du XIIe au XVIIe siècle*, Paris-Brussels 1929.

Laurence BINYON, J. V. S. WILKINSON and Basil GRAY, *Persian Miniature Painting*, London 1933.

Eustache DE LOREY, *La peinture musulmane de l'école de Baghdad*, Gazette des Beaux-Arts, 6th per., vol. 10, p. 1-13, 1933.

Ivan STCHOUKINE, *La Peinture iranienne sous les derniers 'Abbâsides et les Il-Khâns*, Bruges 1936.

Kurt HOLTER, *Die islamischen Miniaturhandschriften vor 1350*, Zentralblatt für Bibliothekswesen, vol. 54, p. 1-34, 1937.

Eustache DE LOREY, *Peinture musulmane ou peinture iranienne*, Revue des arts asiatiques, vol. 12, p. 20-31, 1938.

H. BUCHTHAL, O. KURZ, and R. ETTINGHAUSEN, *Supplementary Notes to K. Holter's Check List of Islamic Illuminated Manuscripts before A.D. 1350*, Ars Islamica, vol. 7, p. 147-164, 1940.

Bishr FARÈS, *Distinction des deux tendances syrienne et iranienne dans la miniature de l'Ecole de Bagdad*, in *Actes du XXIe Congrès International des Orientalistes*, p. 332-333, Paris 1949.

Kurt WEITZMANN, *The Greek Sources of Islamic Scientific Illustrations*, in *Archaeologica Orientalia in Memoriam Ernst Herzfeld*, p. 244-266, ed. George C. Miles, Locust Valley 1952.

R. ETTINGHAUSEN, *Interaction and Integration in Islamic Art*, in *Unity and Variety in Muslim Civilization*, p. 107-131, ed. Gustave E. VON GRUNEBAUM, Chicago 1955.

Bishr FARÈS, *Figures Magiques*, in *Aus der Welt der islamischen Kunst, Festschrift für Ernst Kühnel*, p. 154-162, ed. R. Ettinghausen, Berlin 1959.

Ernst J. GRUBE, *Materialien zum Dioskurides Arabicus*, in *Aus der Welt der islamischen Kunst, Festschrift für Ernst Kühnel*, p. 163-194, ed. R. Ettinghausen, Berlin 1959.

Salahuddin AL-MUNAJJED, *Le manuscrit arabe jusqu'au Xe s. de l'H.*, vol. I: *Spécimens*, Ligue des Etats Arabes, Institut des Manuscrits Arabes, Cairo 1960.

Individual Illuminated Manuscripts
(in the order of their occurrence in the text)

Bishr FARÈS, *Une miniature religieuse de l'école arabe de Bagdad. Son climat, sa structure et ses motifs, sa relation avec l'iconographie chrétienne de l'Orient*, Mémoires de l'Institut d'Egypte, vol. 51, Cairo 1948.

Bishr FARÈS, *L'Art sacré chez un primitif musulman*, Bulletin de l'Institut d'Egypte, vol. 36, p. 619-677, 1955.

Bishr FARÈS, *Vision chrétienne et signes musulmans autour d'un manuscrit arabe illustré au XIIIe siècle*, Mémoires de l'Institut d'Egypte, vol. 56, Cairo 1962.

E. KÜHNEL, *Review of B. Farès, Une Miniature religieuse de l'école de Bagdad*, Oriens, vol. 4, p. 171-173, 1951.

D. S. RICE, *The Aghani Miniatures and Religious Painting in Islam*, The Burlington Magazine, vol. 95, p. 128-134, 1953.

S. M. Stern, *A New Volume of the Illustrated Aghânî Manuscript*, Ars Orientalis, vol. 2, p. 501-503, 1957.

A. Süheyl Ünver, *Istanbulda Dioscorides Eserleri*, Istanbul 1944.

Florence E. Day, *Mesopotamian Manuscripts of Dioscorides*, Bulletin of the Metropolitan Museum of Art, New Series, vol. 8, p. 274-280, 1950.

Hugo Buchthal, *"Hellenistic" Miniatures in Early Islamic Manuscripts*, Ars Islamica, vol. 7, p. 125-133, 1940.

Bishr Farès, *Le Livre de la Thériaque*, Art Islamique, tome 2, Cairo 1953.

Hugo Buchthal, *Early Islamic Miniatures from Baghdad*, The Journal of the Walters Art Gallery, Baltimore, vol. 5, p. 16-39, 1942.

Kurt Holter, *Die Galen-Handschrift und die Makamen des Harîrî der Wiener Nationalbibliothek*, Jahrbuch der Kunsthistorischen Sammlungen in Wien, special number No. 104 (Jahrbuch, n.F. XI, 1937).

Mehmet Aga-Oglu, *On a Manuscript by al-Jazari*, Parnassus, vol. 3, No. 7, p. 27-28, New York 1931.

Ivan Stchoukine, *Un manuscrit du traité d'al-Jazari sur les automates du VIIe siècle de l'hégire*, Gazette des Beaux-Arts, 6th per., vol. 11, p. 134-140, 1934.

G. de Jerphanion, *Les miniatures du manuscrit syriaque No. 559 de la Bibliothèque Vaticane*, Vatican City 1940.

Hugo Buchthal, *The Painting of the Syrian Jacobites in its Relation to Byzantine and Islamic Art*, Syria, vol. 20, p. 136-150, 1939.

Ivan Stchoukine, *Les Manuscrits illustrés musulmans de la Bibliothèque du Caire*, Gazette des Beaux-Arts, 6th per., vol. 13, p. 138-158, 1935.

Bishr Farès, *Philosophie et jurisprudence illustrées par les Arabes. La querelle des images en Islam*, in *Mélanges Louis Massignon*, p. 77-109, Institut Français de Damas, 1957.

D. S. Rice, *The Oldest Illustrated Arabic Manuscript*, Bulletin of the School of Oriental and African Studies, University of London, vol. 22, p. 207-220, 1959.

Ugo Monneret de Villard, *Un Codice arabo-spagnolo con miniature*, Bibliofilia, vol. 43, p. 209-223, 1941.

The Final Periods

The Mamlûk Styles

Ananda K. Coomaraswamy, *The Treatise of al-Jazari on Automata, Leaves from a Manuscript of the Kitâb fi Ma'arifat al-Hiyal al Handasiya in the Museum of Fine Arts, Boston, and Elsewhere*, Museum of Fine Arts, Boston, Communications to the Trustees, No. 6, 1924.

K. A. C. Creswell, *Dr. F. R. Martin's M. S. "Treatise on Automata"*, The Year Book of Oriental Art and Culture, 1924-1925, p. 33-40, 1925.

Rudolf M. Riefstahl, *The Date and Provenance of the Automata Miniatures*, The Art Bulletin, vol. 11, p. 206-215, 1929.

Eustache de Lorey, *Le Bestiaire de l'Escurial*, Gazette des Beaux-Arts, 6th per., vol. 14, p. 1-11, 1935.

Kurt Holter, *Die frühmamlukische Miniaturenmalerei*, Die Graphischen Künste, n.s., vol. 2, p. 1-14, Vienna 1937.

Hugo Buchthal, *Three Illustrated Harîrî Manuscripts in the British Museum*, The Burlington Magazine, vol. 77, p. 144-152, 1940.

Leo A. Mayer, *A Hitherto Unknown Damascene Artist*, Ars Islamica, vol. 9, p. 168, 1942.

Oscar Löfgren, *Ambrosian Fragments of an Illuminated Manuscript Containing the Zoology of al-Gâhiz*, with a Contribution, *The Miniatures: Their Origin and Style*, by Carl Johan Lamm, Uppsala Universitets Årsskrift 1946: 5, Uppsala-Leipzig 1946.

Leo A. Mayer *Mamluk Costume*, Geneva 1952.

Bishr Farès, *Un Herbier arabe illustré du XIVe siècle*, in *Archaeologia Orientalia in Memoriam Ernst Herzfeld*, p. 84-88, ed. George C. Miles, Locust Valley 1952.

Sofie Walzer, *An Illustrated Leaf from a Lost Mamlûk Kalîlah wa-Dimnah Manuscript*, Ars Orientalis, vol. 2, p. 503-505, 1957.

Sofie Walzer, *The Mamlûk Illuminated Manuscripts of Kalîla wa-Dimna* in *Aus der Welt der islamischen Kunst, Festschrift für Ernst Kühnel*, p. 195-206, ed. R. Ettinghausen, Berlin 1959.

Sami K. Hamarneh, *Drawings and Pharmacy in al-Zahrâwi's 10th-Century Surgical Treatise*, United States National Museum Bulletin, 228, p. 81-94, Washington 1961.

Other Styles

Manuel Gómez Moreno, *Pinturas de Moros en la Alhambra*, Granada 1916.

Friedrich Sarre, *Bemalte Wandbekleidung aus Aleppo*, Berliner Museen, Berichte aus den Preussischen Kunstsammlungen, vol. 41, cols. 143-158, 1919-1920.

Leopoldo Torres Balbás, *Arte almohade, arte nazari, arte mudéjar*, Ars Hispaniae, Historia Universal del Arte Hispánico, Madrid 1949, p. 191-193.

J. Leroy, *Un Nouveau manuscrit arabe-chrétien illustré du roman de Barlaam et Joasaph*, Syria, vol. 32, p. 101-122, 1955.

Koran Illumination

B. Moritz, *Arabic Palaeography. A Collection of Arabic Texts from the First Century of the Hidjra till the Year 1000* (Publications of the Khedivial Library, Cairo, No. 16), Cairo 1905.

D. S. Rice, *The Unique Ibn al-Bawwâb Manuscript in the Chester Beatty Library*, Dublin 1955.

R. H. Pinder-Wilson, *The Illuminations in the Cairo Mosche-t.-Asher-Codex of the Prophets, Completed in Tiberias in 895 A.D.*, with Contributions by R. Ettinghausen, in Paul Kahle, *Der hebräische Bibeltext seit Franz Delitzsch*, p. 54-59 (German trs.), 95-98 (English trs.), Stuttgart 1961.

Iconographic Studies

Fritz Saxl, *Beiträge zu einer Geschichte der Planetendarstellungen im Orient und im Okzident*, Der Islam, vol. 3, p. 151-177, 1912.

Erwin Panofsky and Fritz Saxl, *Classical Mythology in Mediaeval Art*, Metropolitan Museum Studies, vol. 4, p. 228-280, 1933.

Rudolf Wittkower, *Marvels of the East*, Journal of the Warburg and Courtauld Institutes, vol. 5, p. 159-197, 1942.

H. P. L'Orange, *Studies on the Iconography of Cosmic Kingship in the Ancient World*, Oslo 1953.

INDEX OF MANUSCRIPTS

BOLOGNA, Biblioteca Universitaria:

Cod. ar. 2954 Dioscorides, *De Materia Medica*, Arabic version, dated 1244 66.

CAIRO, Karaite Congregation:

Codex of the Prophets, in Hebrew, Tiberias 895 169, 170, 191.

CAIRO, Egyptian National Library:

Adab 579 *Kitâb al-Aghânî (Book of Songs)* by Abu'l Faraj al-Isfahânî, vols. II, IV, XI, the latter dated 1217 61, 62;

No. 8f, Khalîl Aghâ *Kitâb al-Baytara (Book of Farriery)* by Ahmad ibn al-Husayn ibn al-Ahnaf, Baghdad 1209 100;

No. 61, Litt. Pers. *Kalîla and Dimna*, of Bidpai, Persian manuscript, dated 1343 158;

MS. 54 *Koran of Arghun Shâh*, Egypt, c. 1368-1388 174, 175.

COPENHAGEN, Royal Library:

No. 168 *Kitâb al-Aghânî (Book of Songs)* by Abu'l Faraj al-Isfahânî, vol. XX, dated 1219 62.

DUBLIN, Chester Beatty Library:

MS. 1406 Frontispiece of a *Koran*, on parchment, possibly Syria, c. 900 167/169, 173;

MS. 1431 *Koran*, written 391 A.H. (1000 A.D.) in Baghdad, signed by 'Alî ibn Hilâl, called Ibn al-Bawwâb 170, 171, 173; *'Ajâ'ib al-Makhlûqât (The Wonders of Creation)* by al-Qazwînî, after 1370 179.

EDINBURGH, University Library:

No. 161 *al-Athâr al-Bâqiya 'Ani'l-Qurûn al-Khâliya (Vestiges of the Past)* by al-Bîrûnî, possibly written 1307 in Baghdad (Iraq) 137.

ESCORIAL Library (Madrid):

Ar. 898 *Kitâb Manâfi' al-Hayawân (Book on the Usefulness of Animals)* by Ibn ad-Durayhim al-Mawsilî, probably Egypt, dated 1354 3, 141, 142, 156, 160; *Book on Chess, Dice and Draughts*, 1283, written for Alfonso X, the Learned 132.

FLORENCE, Laurentian Library:

Med. Pal. 387 *Gospel of the Infancy of Jesus*, Mârdîn, Southeastern Turkey, dated 1299 162.

ISTANBUL, Library of the Archeological Museum:

No. 344 *Kalîla and Dimna* of Bidpai, probably 18th century 81;

No. 1574 *Muzhaf as-Suwar (Book of Images)*, dated 1270 59, 60.

ISTANBUL, Ayasofya:

No. 3703 Dioscorides, *De Materia Medica*, Arabic translation, Baghdad, Iraq, 1224 88/90, 110, 159;

No. 3704 Dioscorides, *De Materia Medica*, Arabic translation, 13th century 66.

ISTANBUL, Millet Kütüphanesi Library:

Feyzullah Efendi 1565/66 *Kitâb al-Aghânî (Book of Songs)* of Abu'l Faraj al-Isfahânî, vols. XVII and XIX, c. 1218-1219 58, 62/65, 92, 103, 147.

ISTANBUL, Süleymaniye Mosque:

Esad Efendi 2916 *Maqâmât (Assemblies)* of al-Harîrî, Baghdad, written between 1242-1258 105, 109, 123, 124;

Esad Efendi 3638 *Rasâ'il Ikhwân as-Safâ (Epistles of the Sincere Brethren)*, Baghdad 1287 98/102, 136;

Fatih 3422 *Kitâb Suwar al-Kawâkib ath-Thâbita (Treatise on the Fixed Stars)* by as-Sûfî, Mârdîn, Southeastern Turkey, 1135 162;

Fatih 3609 *Kitâb al-Baytara (Book of Farriery)* by Ahmad ibn al-Husayn ibn al-Ahnaf, Baghdad, late 12th or early 13th century 100;

Kala Ismail 565 *Kashf al-Asrâr (Disclosure of the Secrets)* by Ibn Ghânim al-Maqdisî, probably Syria, mid-14th century 156/160.

ISTANBUL, Topkapu Sarayı Müzesi:

Ahmet III, 2115 *Kitâb al-Baytara (Book of Farriery)* by Ahmad ibn al-Husayn ibn al-Ahnaf, Baghdad 1210 97, 100;

Ahmet III, 2127 Dioscorides, *De Materia Medica*, Arabic translation for Shams ad-Dîn Abû'l Fadâ'il Muhammad, dated 1229 67/74, 161, 162, 168;

Ahmet III, 3206 *Mukhtâr al-Hikam wa-Mahâsin al-Kalim (Choicest Maxims and Best Sayings)* by al-Mubashshir, probably Syria, first half of 13th century 74/78, 80, 130, 162;

Ahmet III, 3472 *Kitâb fî Ma'rifat al-Hiyal al-Handasiya (Book of the Knowledge of Mechanical Devices)* of al-Jazarî, dated 1254 95;

Hazine 841 *Varqeh and Gulshâh*, Seljuk Persian school, early 13th century 92, 161;

Revan 1638 — *Qanûn ad-Dunyâ wa-'Ajâ'ibhâ (The Order of the World and her Wonders)* by Ahmad Misrî, Syria or Egypt, dated 1563 180/182.

ISTANBUL, University Library:

A. 6754 — *Koran*, with illuminations, Valencia 1182 172, 173, 175.

LEIDEN, University Library:

Or. 289, Warn. — Dioscorides, *De Materia Medica*, Arabic translation written in 1083 87, 88.

LENINGRAD, Academy of Sciences (Institute of Oriental Studies):

S 23 — *Maqâmât (Assemblies)* of al-Harîrî, Baghdad, Iraq, c. 1225-1235 104/113, 123, 130, 138, 143, 163;
'Ajâ'ib al-Makhlûqât (The Wonders of Creation) by al-Qazwînî, after 1370 179.

LONDON, British Museum:

Add. 7170 — *Lectionary of the Gospels*, written under Patriarch John and Mafrian Ignatius, 1216-1220, in Mosul region 96;

Add. 18.113 — *Khamseh (Quintet)* of Khwâjû Kirmânî, painted by Junayd, Baghdad 1396 180;

Add. 22.114 — *Maqâmât (Assemblies)* of al-Harîrî, probably Syria, c. 1300 (Mamlûk period) 145/147, 149, 156;

Or. 2784 — *Na't al-Hayawân (Description of Animals)* allegedly the Arabic version of a work by Aristotle, possibly Baghdad, before 1258 136;

Or. 9718 — *Maqâmât (Assemblies)* by al-Harîrî, painted by Ghâzî ibn 'Abd al-Rahmân of Damascus, probably Syria, c. 1300 147.

LONDON, India Office Library:

Ethé No. 1284 — *Khamseh (Quintet)* by Jamâlî, painted in Baghdad, 1465 180, 181.

MADRID, National Library:

Vit. 14.1-2 — *Biblia Hispanense* (or *Codex Toletanus*), first half of 10th century 132.

MILAN, Biblioteca Ambrosiana:

A. 125 Inf. — *Da'wat al-Atibbâ (Banquet of the Physicians)* by Ibn Butlân, probably Syria, 1273 143/145, 147;

AR.A.F.D. 140 Inf. — *Kitâb al-Hayawân (Book of Animals)* by al-Jâhiz, probably Syria, mid-14th century 156, 157.

MUNICH, Bayerische Staatsbibliothek:

C. arab. 463 — *'Ajâ'ib al-Makhlûqât (The Wonders of Creation)* by al-Qazwînî, probably 18th century 181, 183;

C. arab. 464 — *'Ajâ'ib al-Makhlûqât (The Wonders of Creation)* by al-Qazwînî, Wâsit 1280 138/140, 162, 179;

C. arab. 616 — *Kalîla and Dimna* of Bidpai, probably Syria, first quarter of 14th century 156.

NEW YORK, Metropolitan Museum of Art:

No. 57.51.21 — Leaf showing a Pharmacy, from Dioscorides, Arabic translation of *De Materia Medica*, Baghdad, Iraq, 1224 87, 88, 92, 105, 120, 159;

No. 57.51.23 — Leaf of *The Elephant Clock*, from al-Jazarî, *Kitâb fî Ma'rifat al-Hiyal al-Handasiya (Book of the Knowledge of Mechanical Devices)*, probably Syria, 1315 93, 95, 153.

NEW YORK, Pierpont Morgan Library:

M. 500 — *Manafi' al-Hayavân (Book on the Usefulness of Animals)* by Ibn Bakhtîshû', Marâgheh, 1294-1299 134/141, 158.

NEW YORK, Public Library:

— *'Ajâ'ib al-Makhlûqât (The Wonders of Creation)* by al-Qazwînî, after 1370 179.

OXFORD, Bodleian Library:

Marsh 144 — *Kitâb Suwar al-Kawâkib ath-Thâbita (Treatise on the Fixed Stars)* by as-Sûfî, written by his son, 1009 51, 52, 131, 183;

Marsh 458 — *Maqâmât (Assemblies)* by al-Harîrî, probably Egypt, 1337 142, 151/153, 162;

Pococke 400 — *Kalîla and Dimna* of Bidpai, probably Syria, 1354 154, 156, 157.

PARIS, Bibliothèque Nationale:

Arabe 2850 — Dioscorides, *De Materia Medica*, Arabic translation, Spain or Northwest Africa, 13th century 131;

Arabe 2964 — *Kitâb ad-Diryâq (Book of Antidotes)* by Pseudo-Galen or Pseudo-Joannes Grammatikos, Arabic translation, probably Northern Iraq, 1199 83/86, 90, 92, 110, 162;

Arabe 3465 — *Kalîla and Dimna* of Bidpai, probably Syria, 1200-1220 61/64, 80, 136, 156;

Arabe 3467 — *Kalîla and Dimna* of Bidpai, probably Syria, second quarter of 14th century 154/156;

Arabe 3929 — *Maqâmât (Assemblies)* of al-Harîrî, second quarter of 13th century 82, 83, 162;

Arabe 5847 — *Maqâmât (Assemblies)* of al-Harîrî, or *Schefer Harîrî*, written and painted by Yahyâ ibn Mahmûd al-Wâsitî, Baghdad 1237 104, 105, 109, 111, 114/124, 136, 138, 140, 143/145, 163;

Arabe 6094 — *Maqâmât (Assemblies)* of al-Harîrî, probably Syria, dated 1222 79, 80, 83, 130, 145;

Copte 13 — *Coptic Gospels*, Damietta (Nile Delta) 1180 59, 96;

Pers. 332 — *'Ajâ'ib al-Makhlûqât (The Wonders of Creation)* by at-Tûsî, written in Baghdad, 1388, for the Jalâ'irid Sultân Ahmad 179, 180.

PATNA (India), Khudabakhsh Library:

No. 2146 — Surgical Treatise (Thirtieth Chapter of his *at-Tasrîf liman 'ajiza 'ani't-ta'âlîf*) of Abulcasis (az-Zahrâwî), dated 1188 138.

TURIN, Biblioteca Reale:

Manuscript with Old Testament prophets 78.

VATICAN Library:

Arab. 368 — *Hadîth Bayâd u Riyâd (Story of Bayâd and Riyâd)*, Maghrib (Spain or Morocco), 13th century 125/131, 162;

Ross. 1033 — *Kitâb Suwar al-Kawâkib ath-Thâbita (Treatise on the Fixed Stars)* by as-Sûfî, Ceuta, Morocco, 1224 130, 131, 136;

Siriaco 559 — *Lectionary of the Gospels*, monastery of Mar Mattaï, near Mosul, 1220, Syriac manuscript 94, 96, 130, 145.

VENICE, Biblioteca Marciana:

Cod. gr. 479 — Pseudo-Oppian, *The Chase with Dogs*, 11th century Byzantine manuscript 90.

GENERAL INDEX

LIST OF ILLUSTRATIONS

FOURTEENTH CENTURY

PUBLISHED MARCH 1977

PRINTED BY
IMPRIMERIE COURVOISIER
LA CHAUX-DE-FONDS

PHOTOGRAPHS BY

Maurice Babey, O'ten (pages 18, 21, 23, 24, 25, 27, 31 35, 37, 39, 45, 46, 48, 49, 58, 65, 68, 69, 71, 72, 73, 75 76, 77, 89, 94, 97 98, 99, 101, 126, 127, 129, 130, 158, 159, 172, 180), the Bibliothèque Nationale, Paris (pages 62, 63, 79, 82, 84, 85, 114, 116, 117, 118, 119, 121, 122, 155), Henry B. Beville, Washington (pages 87, 93, 134, 141, 178), the Nationalbibliothek, Vienna (pages 91, 148, 150, 151), the Bodleian Library, Oxford (pages 51, 152, 154), the Bayerische Staatsbibliothek, Munich (pages 138, 139, 181), the Biblioteca Ambrosiana, Milan (pages 144, 157), Browne & Nolan Ltd, Dublin (pages 168, 171) Zoltán Wegner, London (page 146), and La Photothèque, Paris (page 3). The reproductions on pages 55, 107, 108, 111, 112, 113, and 174 were made from material kindly placed at our disposal by the author.

PRINTED IN SWITZERLAND